SKETCH YOUR WORLD

First Published in the UK in 2014 by
Apple Press
74-77 White Lion Street
London N1 9PF
UK
www.apple-press.com

10 9 8 7 6 5 4 3

Manufactured in China

ISBN: 978-1-84543-514-1

Commissioning Editor: Isheeta Mustafi
Presentation Editor: Jacqueline Ford
Assistant Editor: Tamsin Richardson
Art Director and book design: Emily Portnoi
Art Editor: Jennifer Osborne
Layout: Lisa Batswick-Miller & Lucy Smith
Cover design: Lucy Smith
Tool photography: Neal Grundy

Image credits
Front cover: James Hobbs. Piccadilly Circus,
London, UK.

Back cover (top to bottom): Colin Moore. Del Mar
Motel, Las Vegas, USA; Alex Raventós. Portrait;
James Hobbs. Market, Amandola, Italy.

SKETCH YOUR WORLD

ESSENTIAL TECHNIQUES FOR DRAWING ON LOCATION

JAMES HOBBS

APPLE

CONTENTS

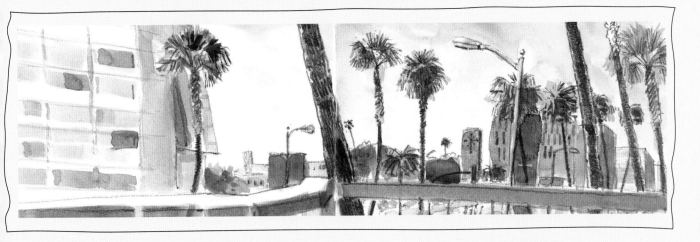

Top: Virginia Hein. Sunset Boulevard, Los Angeles, USA.
Bottom: George Butler. Signs, Lashkar Gar, Afghanistan.

INTRODUCTION

A sketchbook can change your view of the world. That is, admittedly, quite a big claim for a few bound sheets of paper and perhaps a pen or pencil, but that is how it seems for people who regularly draw in one. A sketchbook is an intimate, personal space in which to express yourself, to explore your surroundings and record your experiences using the simplest materials. But it is about more than just the drawings: the act of looking and absorbing what is around you enables you to seize the moment so the sketchbook fills up with memories in a most vivid way. It is the chance to stop, look and appreciate things that you never would have otherwise, to make time and allow your senses to take over.

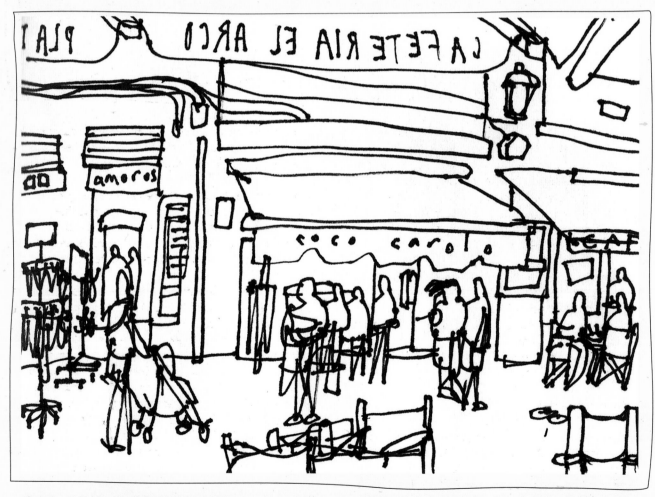

Above: James Hobbs. Ciutadella, Menorca, Spain.
Opposite: Poppy Skelley. City skyline, Cambridge, UK.

One of the great things about a sketchbook is that it is yours and yours alone. It doesn't matter what anyone thinks about what you do, and there is no need to please anyone but yourself. You are not working to a brief, and there no one will pass judgement. Every sketchbook contains successes and failures, and often it is when we dare to fail that we make our best work.

There are many ways to use a sketchbook, but this book focuses on taking it out of the house to draw or paint from observation. That can be sitting at a café table in your hometown, exploring new places around the world, or simply making use of the time spent on a train or in a waiting room. The works they contain tell a story of our lives and give an insight into our worlds.

My own journey with sketchbooks began at art school when we went down to the beach, lit a fire from driftwood and drew it as it blazed and was eventually extinguished by the incoming tide. After college, I lived in a tiny Fiat van for six months with a bunch of pencils and a collection of homemade sketchbooks as I travelled around England, with time to draw from dawn to dusk. It was on that trip that my work really changed – a total immersion in drawing is a surefire way to see your work develop. I have never been far from a sketchbook ever since.

What I missed then, though, was a community of fellow sketchbookers. It was easy to assume that nobody else was doing the same: the nature of sketchbooks, after all, is that they close shut, and all too easily end up in a box under the bed, unshared.

But drawings in sketchbooks are easy to scan and show online, and with the arrival of blogs and social media it was apparent that, far from being alone, there were many other people going out with their sketchbooks, posting online those works that they were prepared to show, and offering support to other sketchbookers. The international network of artists, Urban Sketchers (urbansketchers.org), links thousands of sketchbookers from around the globe. Events like sketchcrawls, in which people meet up to draw in groups, offer the kind of encouragement and assurance that newcomers particularly need.

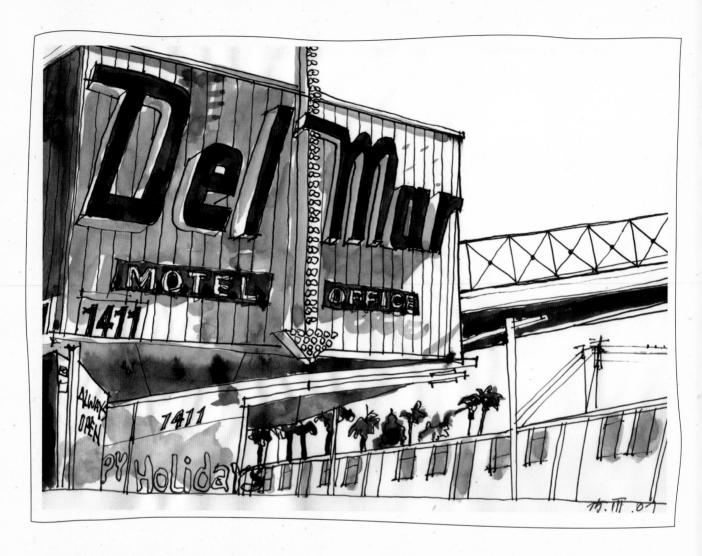

The works kindly lent for inclusion in this book are from experienced artists who have used sketchbooks for decades, students still at college, architects, digital artists, illustrators, an Oscar-winning animator, reportage artists and more. My sincere thanks go to them for their generosity. The works are usually bound in sketchbooks, and reproduced here warts and all, sometimes blotted, wrinkled and water damaged, sometimes across a double page so the binding shows, or with drawings ghosting through from the other side of the paper. The books can be battered and falling apart, knocked about by being carried around for months on end. But this makes sketchbooks what they are and is part of their narrative. However valuable such a book may be to us, it should never be too precious.

What is obvious from the work of this international community of sketchbookers, some of whom draw and paint with digital tablets or smartphones as well as with paper and paints, is that there is no right way or wrong way to do things, no subject that is off limits, and no ideal to be aimed for, certainly not photographic exactitude. The goal is to find our own way of working and our own voice, rather than mimicking someone else's. This can take time, but it is a process through which we start to see the world in a new way, and build a growing library of our experiences.

James Hobbs

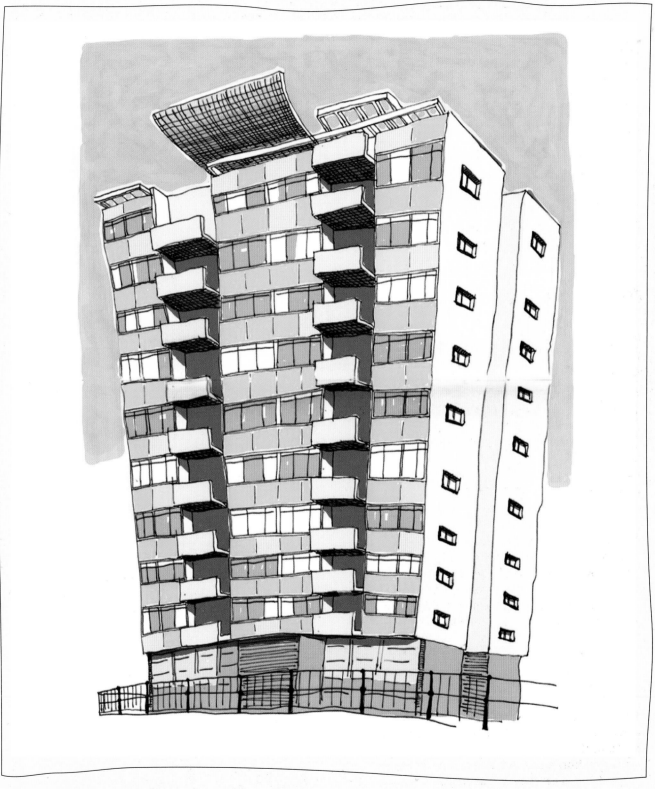

Opposite: Colin Moore. Del Mar Motel, Las Vegas, USA.
Above: Dave Black. Great Arthur House, London, UK.

PENCILS AND PENS

Pencils and pens are cheap, versatile, widely available and come in a wide range of grades and sizes. If you are starting out, they are the perfect media to use, the financial outlay being minimal. Along with a small sketchbook, they are all you really need to join the world of sketching.

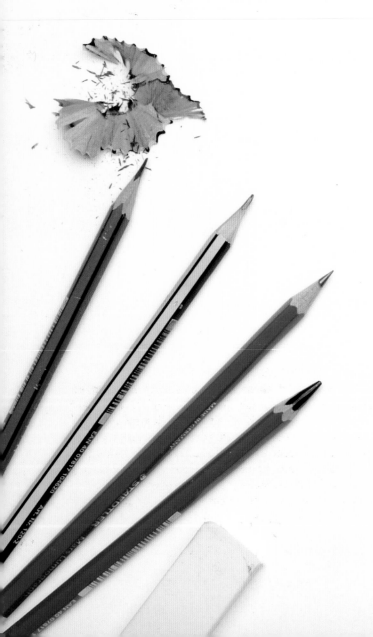

PENCILS

Graphite pencils range from the hardest and lightest 9H to the softest and darkest 9B (although these scales can vary), the middle of the range meeting at HB.

Finding which you prefer is a matter of experimentation and personal choice. Just one pencil, perhaps a 2B or 4B, may be enough as each grade can offer a remarkable range of tones and marks. The B (black) end of the range is best for fast, expressive drawings, the higher end of the H (hard) range being lighter and therefore taking longer to build up. But it can be worth trying a combination of different leads. As with most artists' products, pencils come in a range of qualities. Explore your local art materials shop, where you can test things out. Fixative will prevent your drawing rubbing off on to the back of the previous page in a sketchbook.

And don't forget a penknife or sharpener, unless you are using a mechanical clutch pencil, another popular choice with sketchers on the move.

PENS

Pens, like pencils, come in an impressive array of sizes and
ranges, from the finest point to the chunkiest marker. Although
the simplest and cheapest is a dip pen with Indian ink – nibs
are available for drawing, rather than calligraphy – the most
popular are fibre-tipped or marker pens, which have a variety
of nib sizes from the very fine to the very thick chisel shape,
as well as brush-style nibs. Choosing the right size can depend
upon the size of your sketchbook, or even the subject you are
drawing. Too thin, and it can take a while to build up marks,
too thick and it leaves little space for finer aspects of the subject.
If you try out a few, make a note of which you are using on each
drawing so you remember which works best.

Check the ink that comes in the pen. If watercolours are also
to be used in the drawings, select a pen with waterproof ink or
it will run as the brush passes over. Light-fastness – the rate at
which a medium or colour is affected when exposed to light –
may not be an issue if the drawings will remain in a closed
sketchbook, but pens with archive-quality ink are available.
Sketching pens, some of them refillable, are available in a range
of colours, and fountain pens are popular with some sketchbook
artists. With time, a particular pen will become a favourite, but
trying different ones can encourage new approaches and new
ways of working.

CHARCOAL PENCILS

Charcoal is a fantastic drawing medium, being easily smudged
and worked into with a kneaded eraser to make rich tones and
contrasts, but like pastels, it is not always the best medium to
use in a small sketchbook. Charcoal pencils are worth trying
because they are encased in wood and are thus strengthened
and cleaner to use than traditional charcoal. Charcoal drawings
need fixing, and will lose some of their sharpness over the
lifetime of a sketchbook. Sticks of charcoal usually demand
a scale beyond that of a pocket sketchbook.

PAINTS, INKS, BRUSHES AND COLOURED PENCILS

Working with colour opens up a realm of new possibilities, and although this inevitably means carrying more equipment, it doesn't have to mean being overburdened. There are compact versions of most materials that mean you can be drawing and painting on location within minutes, capturing the colour and life of a place in a way that can't be conjured up from memory.

WATERCOLOUR SETS

A box of watercolour pans, as opposed to tubes, is in the everyday equipment carried by many sketchbook users. A set of twelve colours, or maybe fewer, in a compact metal box can be enough. A range of qualities is on offer: it is best to try things out at the cheaper end of the scale to see if watercolour suits your way of working before splashing out on better ones, which will almost certainly be worth the investment.

Watercolours need water, brushes and a heavier paper to work on that can handle becoming wet without distorting and wrinkling. Some watercolour sets have a water bottle built in, along with a small brush, although additional brushes may be useful.

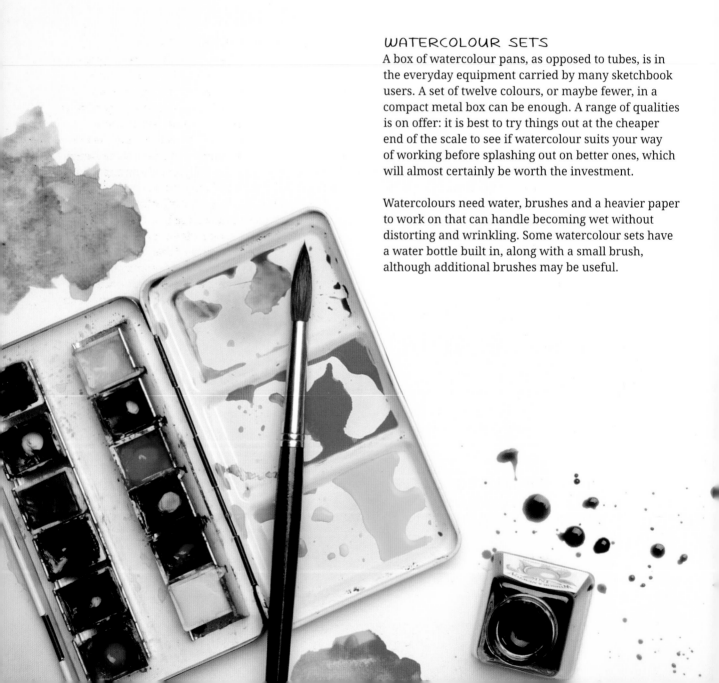

COLOURED PENCILS

The advantage of using coloured pencils is that it is possible to capture the true colours of a place without having to handle wet media. If the drawing is to be used to make a finished painting back in the studio, its colours, blended dry on the page, are likely to be more useful and faithful than those captured in a photograph. Some people see coloured pencils as a medium suitable only for children, but they are what you make them: they have a soft, delicate quality, but can also add an injection of colour in an expressive, urgent way.

WATER-SOLUBLE COLOURED PENCILS

Water-soluble pencils are another option for working in colour on the go, as they can be used as coloured pencils or, with the addition of water, blended on the page to create watercolour effects. This blending can be done with a conventional watercolour brush, or a waterbrush – a brush with its own reservoir in the handle. These pencils can also create interesting effects by being dipped into water before drawing on the paper, or by shaving off pigment from the point with a sharp knife onto wet paper. Like wax-based coloured pencils, they are available in a variety of colours, in sets or individually.

WATERCOLOUR BRUSHES

Watercolour brushes are essentially of three types – natural hair, the cheaper synthetic and a mixture of the two – and are available in an array of sizes, brush heads and handles. A defined point, a good flow so that paint continues across broad sweeps and a spring so that it returns to its shape during use are recognised as traditional marks of an excellent round watercolour brush. A few will probably be enough if you are travelling light: a larger brush with a good point can be very adaptable and effective for fine marks. Some artists cut down the handle if a brush is too long to transport comfortably, but compact retractable brushes are also available. You can also buy waterbrushes with refillable reservoirs that can be used with watercolours, water-soluble pencils and inks, which are handy if you don't want to carry water with you.

SKETCHBOOKS

The sketchbooks you choose to use say a lot about the kind of drawings you intend to make. From the binding and dimensions to the paper's weight and format, there are decisions to be made about the home your drawings will find themselves in. Expensive, lavishly bound books may inspire great drawings, or could have a stifling effect on creativity. Will you be using wet or dry media, and do you prefer landscape or portrait format? Do you want a consistent look as they sit on your bookshelf? Whichever it is, there is a sketchbook for you.

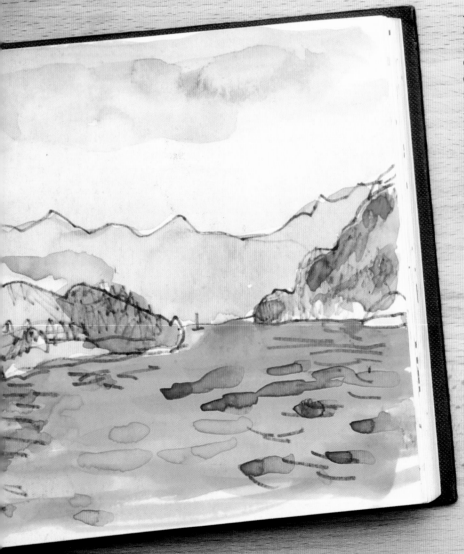

SIZE

Small sketchbooks are ideal for keeping in a bag or pocket for whenever the chance to draw may strike, and for quick drawings, snatched during a few spare moments. A small sketchbook that is carried everywhere is more likely to be used than a big, expensive one that is too large to be taken out regularly. However, large books allow you to make more detailed or expressive drawings, maybe with colour, so it is worth considering using more than one book. Concertina-style sketchbooks, which open into a long, unbroken panorama, such as the Japanese Moleskine, can add a new dimension to your drawings.

COVERS

Sketchbooks take a beating if they are carried around a lot, especially if they are not used often or if they have a lot of pages. A stiff, well-bound cover will protect the pages, but a flexible softback book can be slimmer and easier to fit into a jacket pocket. A simple, small, tear-out pad is cheap, but longevity is not its strength. The softback Moleskine is a favourite of many, with cream paper, a pouch in its back cover, and an elasticated ribbon to hold it closed.

BINDING

The binding of a sketchbook can affect the way you work: books with a traditional spine can be hard to lay flat, in contrast with those that are spiral-bound. The format – whether the pages are bound on the long side for a portrait format, or along the short side for a landscape format – can be simply a matter of personal preference, but a panoramic option is created if both pages of an opened sketchbook are worked across, particularly with a landscape format. Square sketchbooks are also available.

PAPER WEIGHT

The thickness, or weight, of a paper is important, particularly if you are using wet media which will buckle a surface that is too light. Sketchbook paper with a weight of 110gsm (50lb) is fine for dry media but look for watercolour sketchbooks –200gsm (100lb) or heavier, for instance – if that is what you are likely to use. A cold-pressed (or NOT) watercolour paper, recognisable by its slightly textured surface, is the most widely used and found in many watercolour sketchbooks.

HOW TO MAKE YOUR OWN SKETCHBOOK

The joy of making your own sketchbook is that you can choose exactly what you want it to be, including its paper, size, format, number of pages and cover design. They can be made from things as simple as cheap cartridge paper and cereal box covers backed with old brown envelopes as a cost-cutting measure, or specialist or homemade papers to take them to a different level of personal expression.

A specialist bookbinding shop can assist with a variety of bookcloths, acid-free self-adhesive tapes to strengthen the spine, adhesives that combine PVA and starch paste and linen sewing thread, all of which will enhance the finished object.

You will need:

- One or two large sheets of paper
- PVA glue
- Card for cover
- Backing paper for cover
- Linen strip
- Thread and needle
- Awl

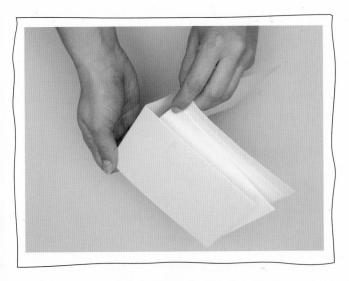

1. SIZE AND FORMAT

Fold a large sheet of paper into sixteen equal pieces. Create a section, or 'signature', of your sketchbook by folding four pieces together as shown. The rest of the paper is enough to create another three similar signatures. How you tear and fold the paper will dictate whether the book is portrait or landscape format: think carefully before you rip.

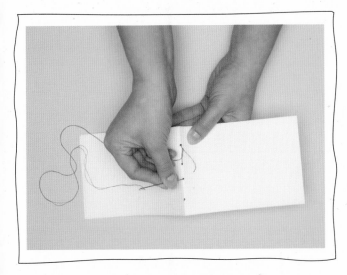

2. BINDING PAGES

Starting with the first of these signatures, make four evenly spaced marks along its outside folded edge and pierce through each with a large needle or awl – this makes sewing the paper together easier. Using a good length of thread, start to bind the first section together by passing the thread through from the outside. Leave a few inches outside, and tie it fast with the thread when it passes back out the first time. Then alternate in and out of the holes to join the four sheets.

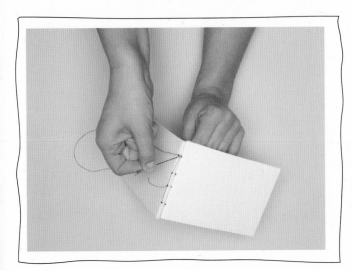

3. JOINING SIGNATURES

Line up the second signature with the first, and continue as you did for the first using the same line of thread, pulling the thread tight as you go. As you finish the second signature, weave the thread through the exposed loops on the outside of the spine of the first signature to hold them loosely together before starting on the third.

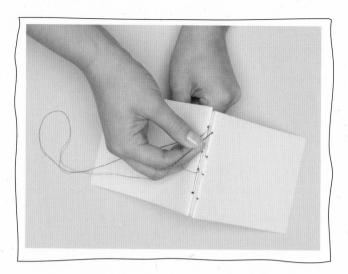

4. KEEPING THINGS TIDY

The inside of the centre pages of each signature should show neat lines of thread. The outside of the spine will be hidden later by the cover, so there is no pressure to keep it so tidy.

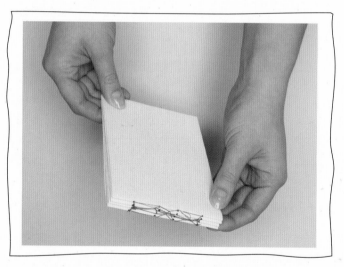

5. JOIN THE FINAL SECTION

Follow on in the same way with the other signatures until the thread holds all four together, and finish with a knot to secure the thread's end. It is not a disaster if you need to replenish the thread midway through: just tie up any loose ends, and continue with the new thread where you left off.

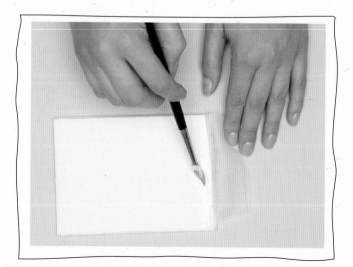

6. GLUE THE SPINE

A linen strip or other strong, flexible material glued with PVA along the spine of the book will give it greater strength. Allow it to dry by leaving the book under a heavy object or clamping the spine together.

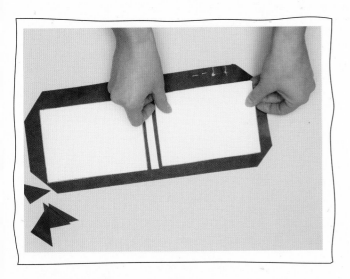

7. GLUE THE COVER

Cut two pieces of card a little bigger than the size of the bound paper, along with a thin section for the spine of the book, and glue these with PVA to the paper chosen for the cover, then fold and paste down the overlap, and leave to dry.

8. ATTACH THE COVER

Glue the end pages of the bound paper to the inside of the front and back cover – don't glue the spine of the pages to the spine of the cover as leaving space here will make the book easier to open. The positioning of this pasting process will dictate how easily the sketchbook will lay flat on a table. Leave it to dry under a heavy object.

One sheet of A1 paper (84.1 x 59.4cm, 33.1 x 23.4 ") will make an A6 (14.8 x 10.5cm, 5.8 x 4.1 ") sketchbook with 64 pages if you use both sides of a page.

DIGITAL TOOLS

Digital drawing and painting tools and software are developing so quickly that if you have ever tried and rejected them in the past, they are certainly worth reconsidering now. Smartphones and tablets are more popular than ever, and being able to work with digital versions of paper, pens, inks and paint without setting foot inside a shop can be a big plus in remote locations. This isn't to say that real paper and real ink isn't vastly superior in many ways, but the choice is there, and everything you may need to make a digital drawing could be right beside you as you read this.

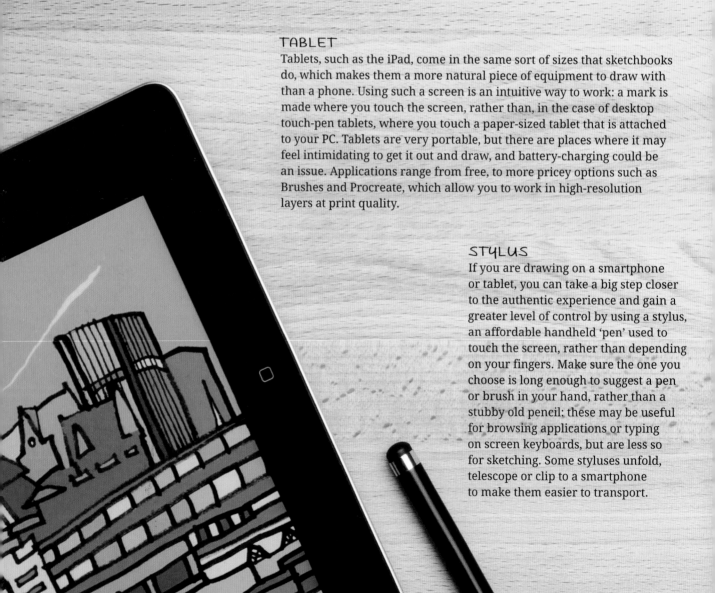

TABLET
Tablets, such as the iPad, come in the same sort of sizes that sketchbooks do, which makes them a more natural piece of equipment to draw with than a phone. Using such a screen is an intuitive way to work: a mark is made where you touch the screen, rather than, in the case of desktop touch-pen tablets, where you touch a paper-sized tablet that is attached to your PC. Tablets are very portable, but there are places where it may feel intimidating to get it out and draw, and battery-charging could be an issue. Applications range from free, to more pricey options such as Brushes and Procreate, which allow you to work in high-resolution layers at print quality.

STYLUS
If you are drawing on a smartphone or tablet, you can take a big step closer to the authentic experience and gain a greater level of control by using a stylus, an affordable handheld 'pen' used to touch the screen, rather than depending on your fingers. Make sure the one you choose is long enough to suggest a pen or brush in your hand, rather than a stubby old pencil; these may be useful for browsing applications or typing on screen keyboards, but are less so for sketching. Some styluses unfold, telescope or clip to a smartphone to make them easier to transport.

SMARTPHONE

The whole point of having a mobile phone is to keep in contact wherever we are, and this can mean in contact with our creative self as well as our family and friends. A cheap or free drawing application can turn your phone into a small but enjoyable sketch pad. Its major limitation is its size, but its portability means it is unlikely you will be without it, even if you have forgotten your sketchbook.

NEW TECHNOLOGY

Technology moves fast, bringing a new wave of products aimed at artists and designers on the move. Drawing in a sketchbook on site and then scanning at home has become the traditional method, but devices such as the Wacom Inkling are now available in which the marks and movements made using a pressure-sensitive digital pen on any paper or sketchbook are captured by a wireless receiver clipped to the paper and downloadable as layered vector or bitmap graphics on your computer at home. It is a process that will suit some artists better than others – the pen uses standard ballpoint ink cartridges, so the emphasis is on what you may do with the drawing digitally later on – but it is an example of how new ideas for artists on the move are being introduced.

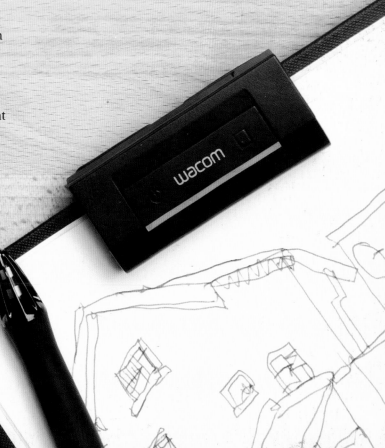

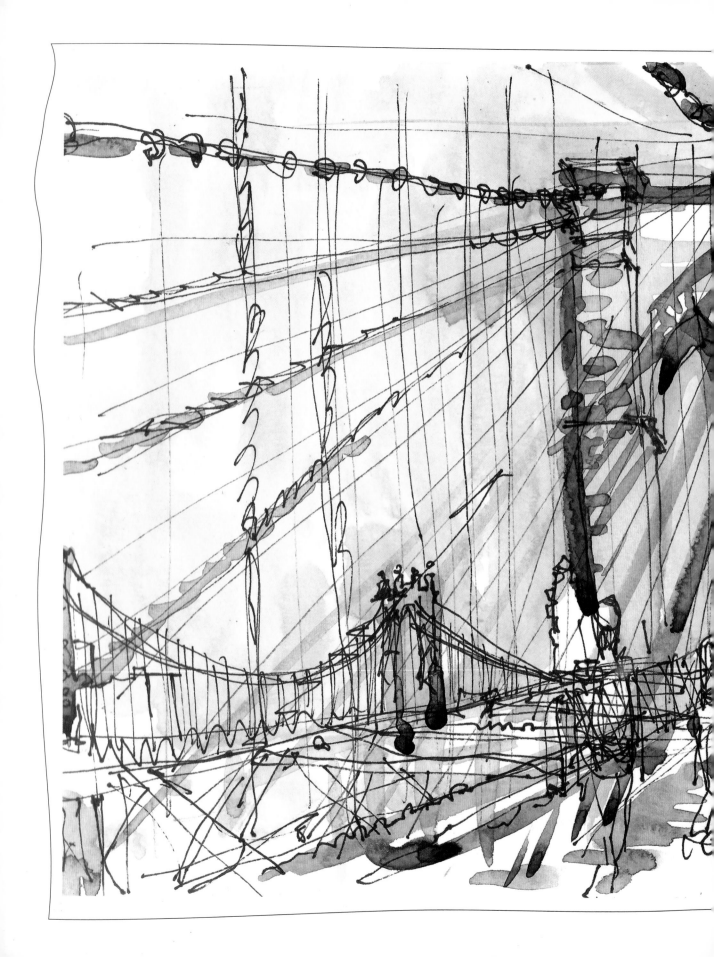

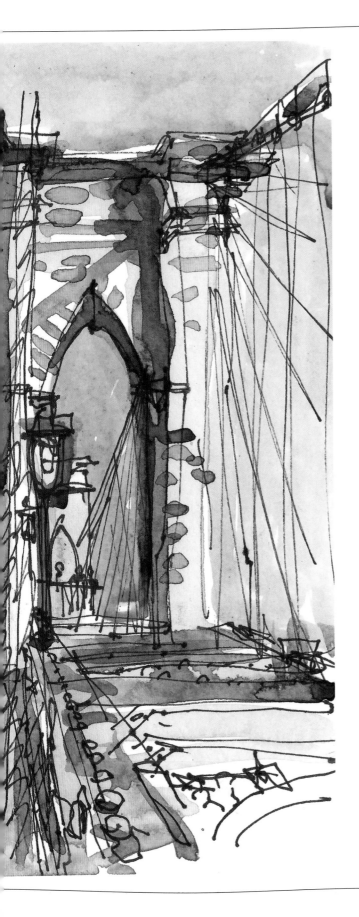

GETTING STARTED

Suhita Shirodkar. Brooklyn Bridge, New York, USA.

CHAPTER 1
SITTING COMFORTABLY

You have a sketchbook and materials to draw with. What next? The first time you
go out to draw can feel intimidating, as if you are about to sing on stage in front
of an audience of thousands. A sense of vulnerability as you stand with an open
sketchbook is a common feeling, especially on the first few occasions you head out.

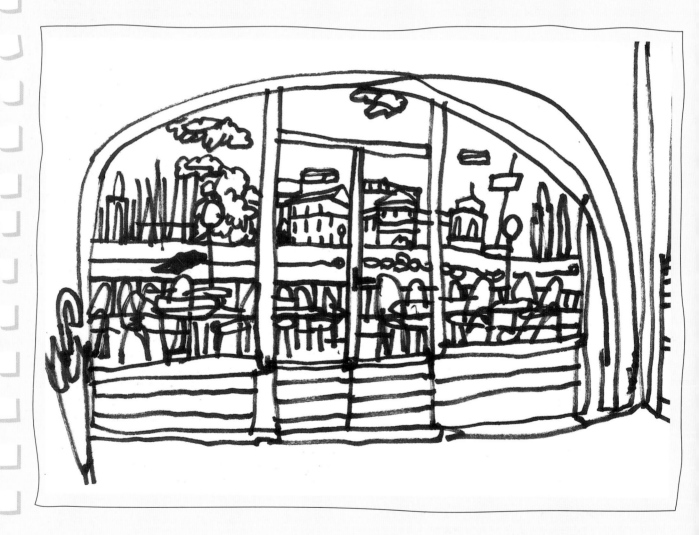

Above: James Hobbs. Café view at Lake Garda, Italy.
Opposite: James Hobbs. Domestic scene.

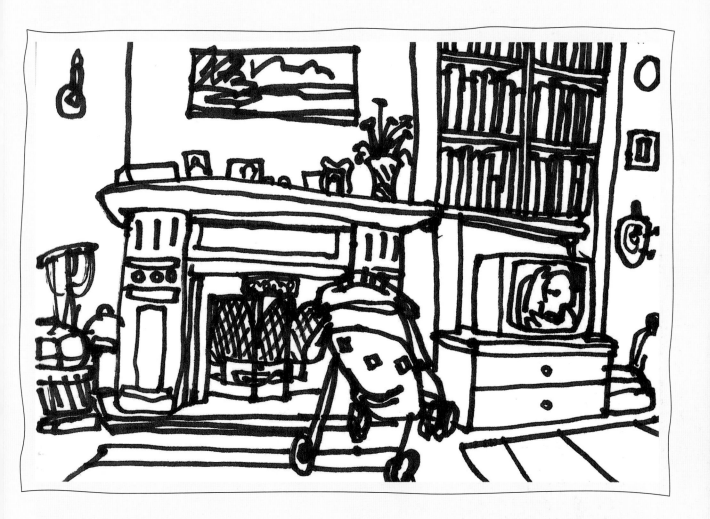

Although sketchbooks are a personal and sometimes private means of expression, some passersby feel entitled to look over your shoulders to see what you are doing. If this is an aspect of drawing outside that bothers you, be assured that it becomes less of a problem with experience and time. There are a variety of drawing-friendly venues and subjects that can ease you into the world of drawing on the go, and a few excursions with a sketchbook will prove that the general public aren't half as interested in what you are doing as you may imagine.

Home is an obvious place to limber up before heading farther afield. The most familiar scenes around the house may not seem the most inspirational material, but it is as possible to make a great sketch out of a mundane subject as it is to make a dull sketch of what seems to be a great subject.

But getting out and drawing the world is an exciting thing to do. Venues such as museums and art galleries are relaxed places that may even encourage their visitors to draw. Cafés and bars are great to draw in, not just because of the ready supply of food and drink, but also because tables and chairs keep onlookers at bay, and the scene is continually lively and changing. Rural locations and parks also have plenty of quiet places where you can work in peace. Before long, heading out with a sketchbook will seem like one of the most natural things you can do.

HEADING OUT

Feel a bit wary about going out drawing with your sketchbook? Ease yourself into the world of drawing in the great outdoors with these ideas for safe places and subjects to draw.

CAFÉS AND BARS

Cafés and bars are some of the most comfortable places to sketch in: there is space to relax and spread out, a changing cast of characters, and refreshments at hand – buy these in sufficient quantities so the patience of the staff is not unduly tested. A table creates a boundary that people are unlikely to pass to comment on the sketches you are making. If you are nervous about drawing the people around you, it is an opportunity to draw an interior, or the view from the window.

The Café do Monte, Lisbon, is such a regular haunt of Alexandre Esgaio that, he says: 'I can almost draw it with my eyes closed.' In the drawing below he has focused on the pattern of the floor tiles to the extent that no people nor even tables and chairs are included. Draw what you want to include, leave out what you don't: there are no rules.

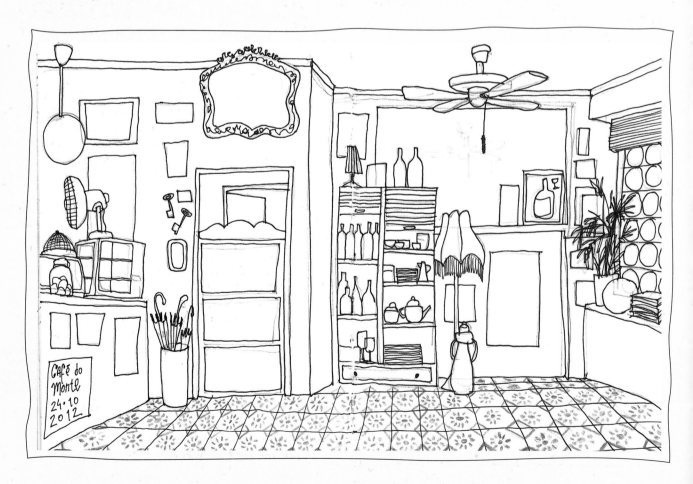

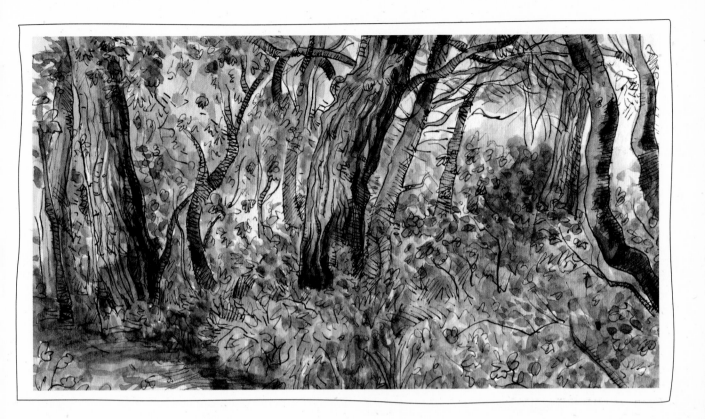

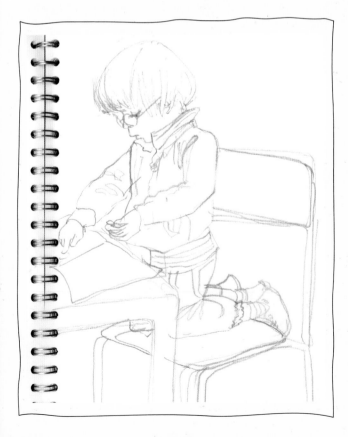

SCENES OF NATURE

The rural landscape provides space away from curious onlookers, as well as enough inspiration for a lifetime. These qualities may be found in a local park if getting out of the city is a problem. Adolfo Arranz's painting of pine trees in Quintanilla de Arriba, Spain, shows nature untouched by humankind.

FRIENDS AND FAMILY

Friends and members of your family are the easiest subjects to work with if you are preparing yourself to draw the public. Angela Charlton drew her young children relaxing after school. With time, drawings like these grow in personal value in a way that those of strangers never can. But portraiture is unforgiving to someone who has just started to draw: organic forms and scenes from nature can be a better route to follow at first.

Opposite: Alexandre Esgaio. Café do Monte, Lisbon, Portugal.
This page
Top: Adolfo Arranz. Pine trees, Quintanilla de Arriba, Spain.
Left: Angela Charlton. Family portrait.

27

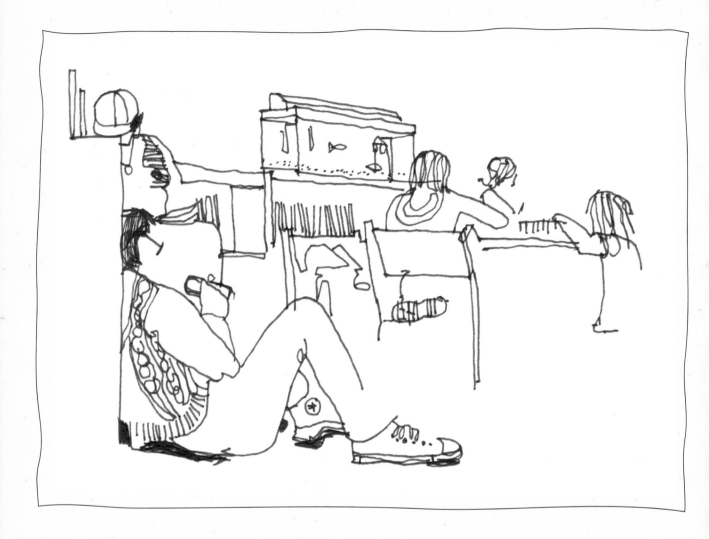

MUSEUMS AND GALLERIES

Museums and galleries are some of the most unthreatening places in which to draw and paint. They are places of learning and study, and drawing the artefacts on display in them is to explore them in the most scrutinising way. Many museums encourage visitors to draw, but check before using wet media, such as watercolour, which may be prohibited.

Think beyond just drawing the exhibits on display. The museum's architecture can be just as interesting. The crowds at popular exhibitions can also make fascinating subjects.

LIBRARIES

Libraries, because they are generally places of silence and learning where it is common for people to be working with a pen or pencil in an open book, are good places to draw, as Carol Hsiung did in Maplewood Library, New Jersey.

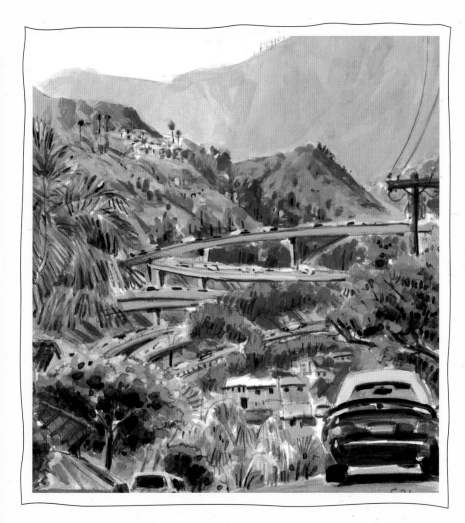

THE MOBILE STUDIO

Drawing from the window of a parked car offers a combination of the security of the home environment and getting out to find new views. What the view may lack – car parks don't always offer the most interesting side of a place – it may make up for in shelter, as a barrier from unwanted interest from the public and a comfortable seat. Virginia Hein sometimes uses her car as a 'mobile studio' in Los Angeles.

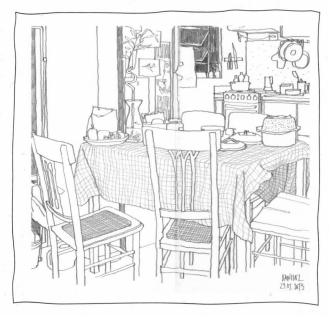

AROUND THE HOUSE

Drawing everyday scenes around the home is an excellent way to develop your hand–eye co-ordination in preparation for drawing expeditions farther afield. The artist Daniloz has made a series of drawings of his home with 7B graphite pencils, 'looking carefully at the things you don't properly notice during the daily routine.'

Opposite: Carol Hsiung. Maplewood Library, New Jersey, USA.
This page
Top: Virginia Hein. Freeway view, Los Angeles, USA.
Left: Daniloz. Domestic scene.

WHEN THE SUBJECT COMES TO YOU

There are times when you don't have to go looking for a subject: it just presents itself to you. Make sure you have a sketchbook and something to draw with every time you head out.

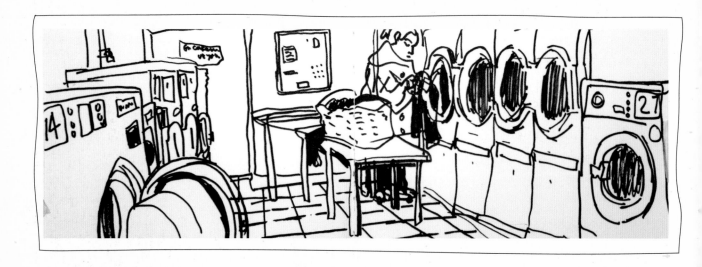

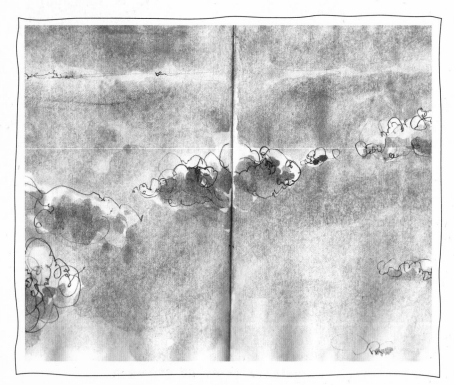

THE LONG WAIT
What better thing to do while waiting for your laundry to spin-dry than draw? Sketching turns the most mundane situation into an opportunity. Pippa Ridley had time to kill in a laundromat on her travels; she likes to use a marker pen because it is a 'fast, low-maintenance medium'.

ON THE TRAIN
There is plenty to draw on a train: apart from the other passengers, there's the view out of the window, even if its rapidly changing nature does present problems. The most constant element of the view is the sky, as drawn here by Rolf Schröter on an intercity train in Germany.

SPORTING ARENAS

If you have tickets to a sporting event, take a sketchbook. It has the perfect conditions for drawing: there is time, you are unlikely to attract attention because people are preoccupied and the atmosphere is intense – this energy can be brought to your drawings.

Watching the St Louis Cardinals play a day game is a favourite way for Michael Anderson to sketch in the summer. 'A big moment inevitably comes along, like a home run, or the runners load the bases, as in this iPad drawing, which is fun to capture in a sketch', he says.

Brendan Kelly drew a swimming event at the London 2012 Olympics Aquatics Centre on his iPhone, working quickly during one of the races. Using a finger to draw with may mean things go wrong in terms of making it realistic, he says, 'but it can work if it is judged in the spirit of the moment'.

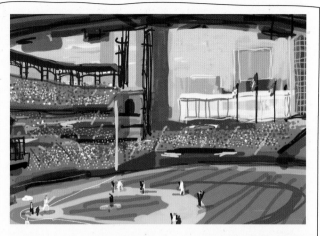

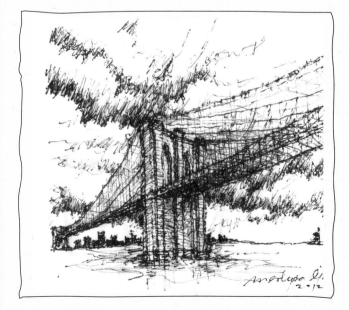

CAUGHT WITHOUT A SKETCHBOOK

What happens if you are caught without your sketchbook? Cafés can be a useful supplier of emergency materials: Merlyna Lim drew this image of the Brooklyn Bridge, New York, on a napkin from a nearby café.

Opposite
Top: Pippa Ridley. Laundromat.

Bottom: Rolf Schröter. Sky seen from a train.

This page
Top: Michael Anderson. St Louis Cardinals baseball game, Busch Stadium, St Louis, USA.

Centre: Brendan Kelly. Olympic Aquatics Centre, London, UK.

Left: Merlyna Lim. Brooklyn Bridge, New York, USA.

DEALING WITH ONLOOKERS

One of the main fears for many sketchbookers is the self-consciousness and vulnerability that drawing in public can create. Generally, however, people don't often approach someone drawing and, when they do, they are usually supportive and perhaps even impressed. Some sketchbookers even enjoy the conversations that can ensue. But if you want to avoid this contact, there are a few things you can do to make it less likely.

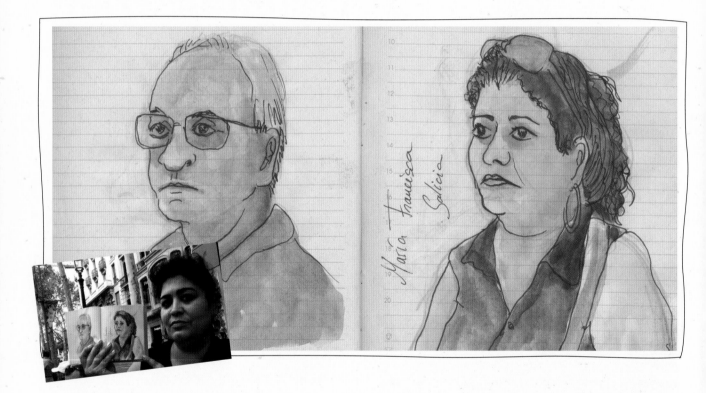

MEET THE PUBLIC

If you are drawing someone and they see what you are doing, show them what you have done – people are usually surprised or flattered. Alex Raventós takes photographs of his subjects if they spot what he is doing, which he then pastes into his sketchbooks. Alternatively, you could offer to email them a low-resolution photograph of the drawing.

KEEPING ONLOOKERS AT BAY

Draw with a friend or join a sketchcrawl (see page 166) as strength in numbers discourages contact with onlookers. Head for places where sketchbookers are more commonly seen, such as a museum, or draw on a tablet or smartphone, which can make you look less conspicuous. If people do comment on your work, remember that the drawing is for you, not to impress them, but learn to appreciate the criticism that could be useful to you.

THE SKETCHBOOK AS A SPRINGBOARD

For many, drawing in a sketchbook on location is an end in itself, but for others it is also a springboard for fresh creative ideas, its pages the place to turn to for works made from observation that can be incorporated into those made in the studio. Here is how three artists use their sketchbook drawings as a step towards new ideas and compositions.

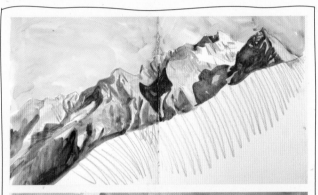

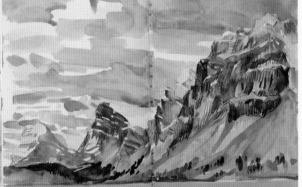

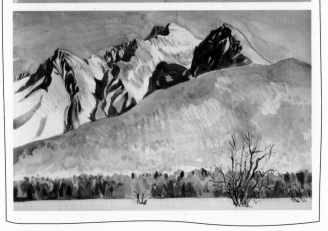

BRING THE LANDSCAPE INTO THE STUDIO

The artist Lachlan Goudie uses his sketches to create paintings in his London studio, but rather than working from one single image, he uses elements of several if they work together well graphically, even if these are scenes set hundreds of miles apart. The two colour sketches shown here are of different places he visited during his travels through the Canadian Rockies, but which he referred to – along with other images – to paint the final watercolour work of a scene, titled *Highland* (bottom), that isn't of one particular place.

The finished watercolour painting, completed in the studio, echoes elements of the sketches, such as the forest foreground and the extended mountain range. 'The high contrast palette of red, green, turquoise and blue is not a representation of what was there, but the colours that felt right when I drew the sketch. They were colours that I probably would never have arrived at otherwise in my studio', Lachlan says.

Opposite: Alex Raventós. Portraits and photograph.
This page
Top: Lachlan Goudie. Route 93, Rocky Mountains, Canada.
Centre: Lachlan Goudie. Route 93, Rocky Mountains, Canada.
Bottom: Lachlan Goudie. *Highland* (finished watercolour).

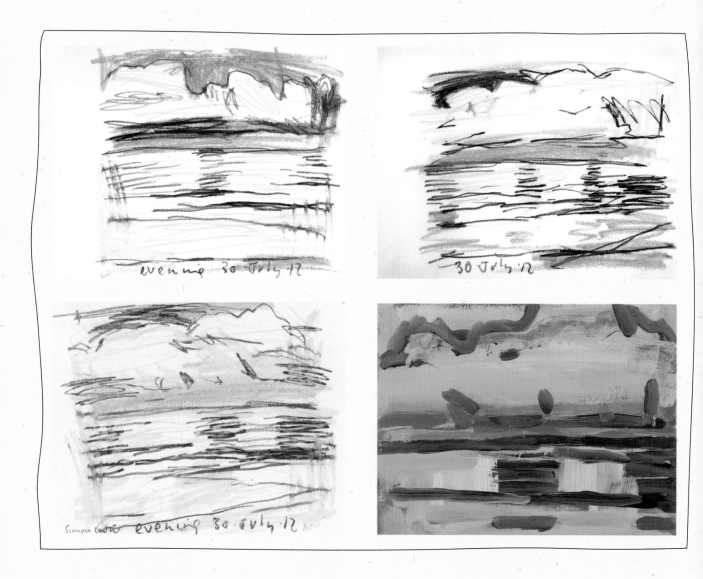

STUDIES IN QUICK SUCCESSION

On most days Simon Carter draws views of the Essex coast in England, taking a pad of paper, graphite sticks, grey oil pastels, pencils, a few crayons, a penknife and an eraser, to make source material for his paintings. 'I draw quickly without much premeditation and without many corrections, and prefer to make a number of drawings of the same subject in quick succession. I return to the same places again and again, learning the subject by repeated observation and recording.' These three drawings were made one evening when the clouds at sea caught the sun in a particularly dramatic way.

Simon then used the drawings as a source to make paintings back in his studio. He says that, although the sketches are used to create the paintings, the paintings can dictate the kind of drawings he makes. 'Sometimes I'm so hooked by something in a drawing or by seeing something in a particular way that it takes time and courage – or more usually a leap of faith – to get beyond that thing and let the painting develop as it wants to. Often you need much less in a painting than you think.' The energy of his drawings of that summer night are carried through to the larger acrylic painting, (bottom right) entitled *Evening 30 July I*.

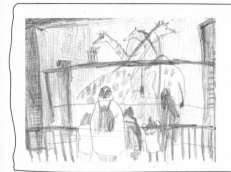 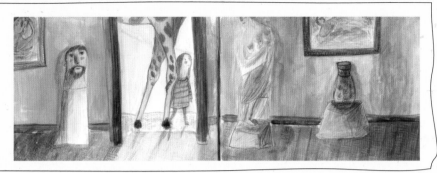

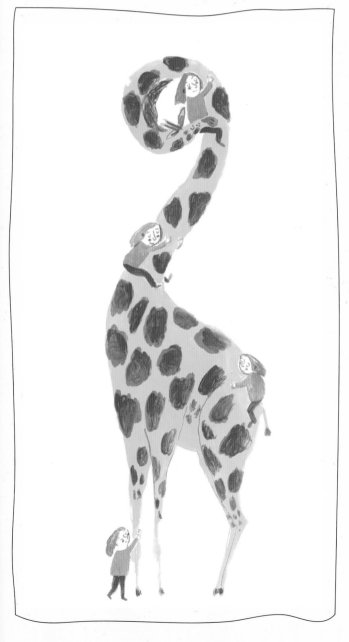

FROM ZOO TO PICTURE BOOK

Time spent drawing from observation at a zoo and at the Fitzwilliam Museum, Cambridge, UK, as part of Emma Carlisle's postgraduate course in children's book illustration led her to imagine what it would be like to find a giraffe in a museum. The pencil drawings done on location at the zoo became ideas in colour showing a giraffe with a girl in a museum, which then became the basis of a picture book.

Emma also developed the colour images into an idea for a screen print. 'I sketched out how I wanted the print to look, and then planned how it would fold into a book. I'd been thinking about the way the colours would work together, and made quick tests to figure out what area would be what colour. The plan from my sketchbook isn't far off how the final screen print (left) looks.'

Opposite
Top left, top right, bottom left: Simon Carter. Essex coast sketches.
Bottom right: Simon Carter. Acrylic painting *Evening 30 July I.*
(Bottom left and right images courtesy of Messum's Fine Art)
This page
Top: Emma Carlisle. Picture book idea sketches.
Left: Emma Carlisle. Final screen print.

CHAPTER 2
DRAWING SPEED

How long have you got? Time spent filling pages of a sketchbook can range from the quick, expressive, monochrome scribble done on the move to the relaxed exploration in colour of the finer points of a carefully chosen panorama. At one time or another, most artists on the move with a sketchbook will have tried these extremes, and the many shades in between.

But after a while, as with handwriting, we begin to find a rhythm and pace that feels natural to us, along with materials and a scale that suits what we are aiming to do. An approach suggests itself to us that may play to the strengths we recognise in our own drawings and the time we have to fit it into our lives.

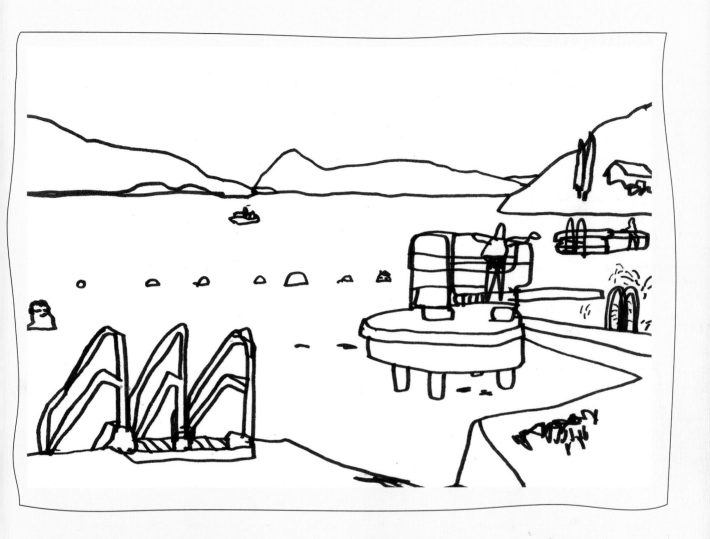

Small sketchbooks are perfect for the fleeting moment and the visual note, and for the occasions when you would never have expected to find time to draw. They are a gateway to saving something lasting and tangible that could otherwise be too easily short-lived and forgotten. They are the snapshots that need no developing.

With more time and bigger paper there is space for detail, broad, expressive marks and perhaps colour. Big sketchbooks are less portable, but they offer scope for looking at our surroundings with more reflection and intensity, and draw out, with time, a better understanding and appreciation of the everyday things around us that may otherwise be overlooked. But even large works do not have to be slow and laborious, just as small ones do not have to be fast and energetic.

Be selective. Ask yourself what attracted you to a subject, and then focus on that so you don't spend time on extraneous details. Is it the colour, or symmetry, the quality of light, or the receding lines? There can be a temptation at first to go for every detail, but whether you are working large or small, what you leave out is as important as what you include.

Opposite: Dave Black. Old Malootje.
Above: James Hobbs. Lake Annecy, France.

SMALL AND FAST

A small sketchbook slipped into a coat pocket or bag is the perfect vehicle for making the most of the unexpected moment or fleeting inspiration. You see something that moves you, or an event that needs recording, and the book can be out and a drawing done, all within minutes. Small, fast drawings can keep your marks relaxed, fresh and to the point. A drawing can never be too small or too quick.

FLEETING SUBJECTS

Drawing the view from a moving train means working fast, going for essential marks, and not being precious. This 14cm × 9cm (5½" × 3½") pencil drawing of the Bronx from a moving Metro North carriage took Craig Shannon just three or four minutes. 'I like to work quickly because it allows me to capture spaces and feelings that are fleeting', he says. 'Because I had to draw so quickly, I was only interested in getting a feel for the space and an impression of some of the architecture.'

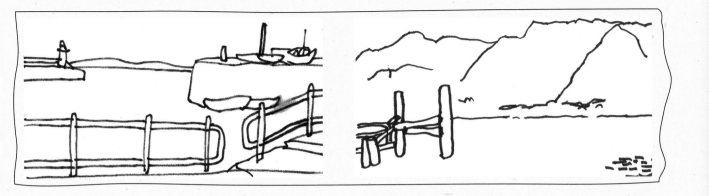

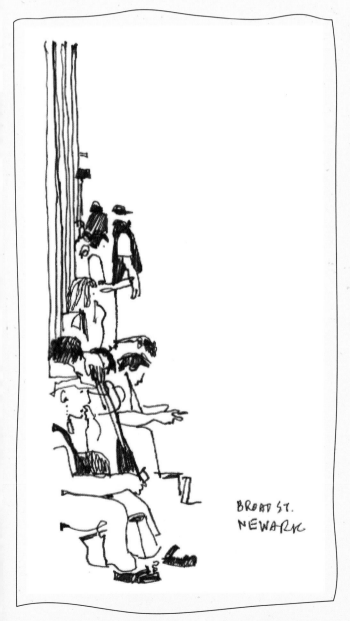

KEEPING IT SIMPLE

Sometimes a few lines can do all that is needed, a drawing's simplicity suggesting elements of the scene that have been left out. Stripping a scene down to its bare essentials with a series of lines is a freeing exercise that is ideally suited to those occasions when time for drawing is limited.

SNATCHED DRAWINGS

Carol Hsiung's daily commute meant that she had eight minutes to wait between trains, and spending it making a small, quick drawing (15cm × 10cm/6" × 4") became a great stress-releasing activity after work. The time restraint has not affected the steadiness and care of her line, and there is no sign of a rush. 'The transfer became a challenging event for me to find something to draw in that time, and I was kind of sad when I found a train with a better schedule to pick my son up from school', she says.

Opposite: Craig Shannon. The Bronx, New York, USA.
This page
Top left: James Hobbs. St Ives harbour, Cornwall, UK.
Top right: James Hobbs. Rotschuo, Lake Lucerne, Switzerland.
Left: Carol Hsiung. Commuters, Newark Broad Street, USA.

WORKING ON A BIGGER SCALE

Working large doesn't mean the drawings or paintings have to take a long time: you can include more fine details if you want to, but you can also make broad, expressive sweeps across the page that are impossible if working in a bijou-style sketchbook.

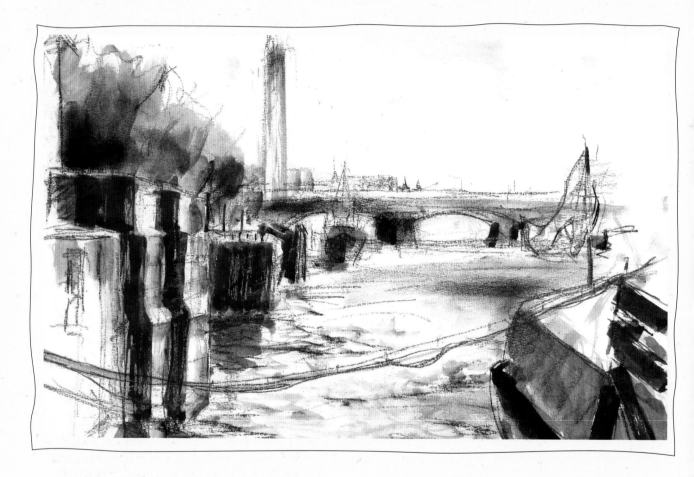

EXPRESSIVE, MIXED-MEDIA SWEEPS

Although this drawing, completed in under an hour by Barry Jackson, is quite small (42cm × 30cm/17" × 12") by his usual standards, it shows how he likes to spend time working on larger works in contrast to quick impressions in a sketchbook. 'One of the reasons I enjoy drawing at this scale is that I can use different media, and respond to tonal areas in the subject', he says. He uses carbon pencils, charcoal and lithographic crayon with layers of diluted fountain-pen ink in brush pens, all employed with a sweep and energy that is harder to harness in smaller works.

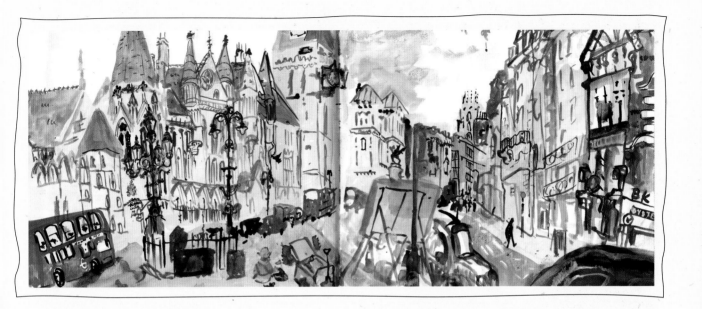

TAKING TIME

If you head out on a dedicated sketching mission, you may well be prepared to take more equipment with you, including a larger sketchbook and coloured media, and spend more time on a single work. Josephine Birch spent more than twelve hours making about fifteen drawings and paintings the day she created this scene of Fleet Street in London. Josephine worked across an open spread of her sketchbook with gouache, watercolour and inks, and took two hours to complete the 56cm × 28cm (22" × 11") drawing. 'Gouache is great for studies of buildings', she says. 'I use it to get down a block of flat colour and then build it up with inks, and add textures, type and figures later.'

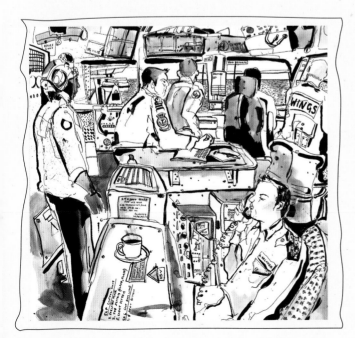

TURNING TO DETAILS

This drawing of the bridge of the HMS *Illustrious*, commissioned by the British Ministry of Defence, was completed by Anna-Louise Felstead using a dip pen and brush on paper. The scale (60cm × 42cm/24" × 16½") allowed her to focus on details, despite the fast-moving nature of the environment. 'The officers were moving around constantly so I had to work quickly, trying to capture the busyness of the ship and give a sense of the amount of technology and gadgets on board.' It took about ninety minutes to finish the drawing.

Opposite: Barry Jackson. Embankment, London, UK.
This page
Top: Josephine Birch. Fleet Street, London, UK.
Left: Anna-Louise Felstead. HMS *Illustrious*.

MAKING THE MOST OF EVERY MOMENT

How well you use your time to sketch largely depends upon whether you know exactly what you want to draw, and if you do, how well you know your subject. Finding the right viewpoint may take some time and this can seem at odds with making a quick drawing, but it prevents that nagging feeling that a better view or subject may be just around the corner when you are halfway through a sketch. However, sometimes the chance to draw can just fall into your lap.

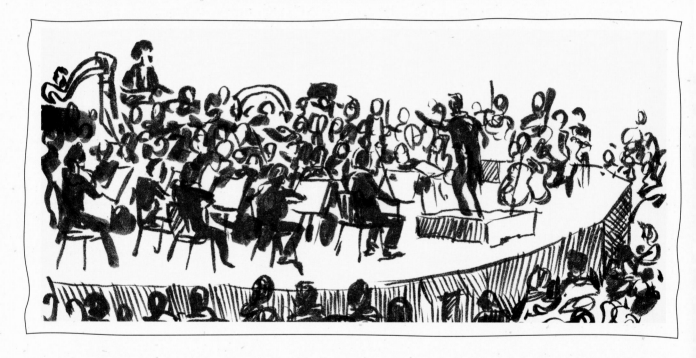

This page
Top: Adolfo Arranz. Hong Kong Philharmonic Orchestra, Hong Kong.
Bottom: Fernando Abadía. Family portrait.
Opposite: James Hobbs. Stationery and every day items.

Getting Started: Drawing Speed

MULTITASKING

One of the best ways of making the most of your time is to draw while you are doing something else. Adolfo Arranz was at the Hong Kong Cultural Center to hear Jun Märkl conduct the Hong Kong Philharmonic Orchestra. A small sketchbook, a brush pen and Indian ink are an unobtrusive combination unlikely to distract the orchestra or the other members of the audience. The music, like the drawing, took about twenty minutes.

THE ACCUMULATED IMAGE

The long family portrait by Fernando Abadía was drawn over the course of a week as he and his subjects found time to work on it. He used a concertina-style Japanese Moleskine sketchbook, a useful and creative format which allows images to be gradually added to when you have more time, and enlarged to embrace a panorama or, in this case, the artist's extended family. The book was given as a gift to his parents by Fernando, whose self-portrait appears at the right of the painting.

IN THE OFFICE

Keeping a sketchbook with you in the office can let creativity into the most uncompromising day. When I was office-bound, I kept a small sketchbook that gradually became filled with drawings of various stationery items made during lunchtimes and quiet moments during the day. Why not take a walk around the block during a lunch break to make even the quickest drawing – it will help you to work better in the afternoon.

43

CHAPTER 3
OBSERVATIONAL SKILLS

If you really want to know something well, draw it. That is what artists who head out with a sketchbook to draw from observation say over and over again. To draw a scene is to sit and commune with it, to learn its ways – and that doesn't happen in a few seconds. The relationship that develops with a drawn subject isn't like taking a quick photograph and then studying it closely later to see what has come out: drawing takes time and needs a connection to be made between the artist and the subject for it to really succeed.

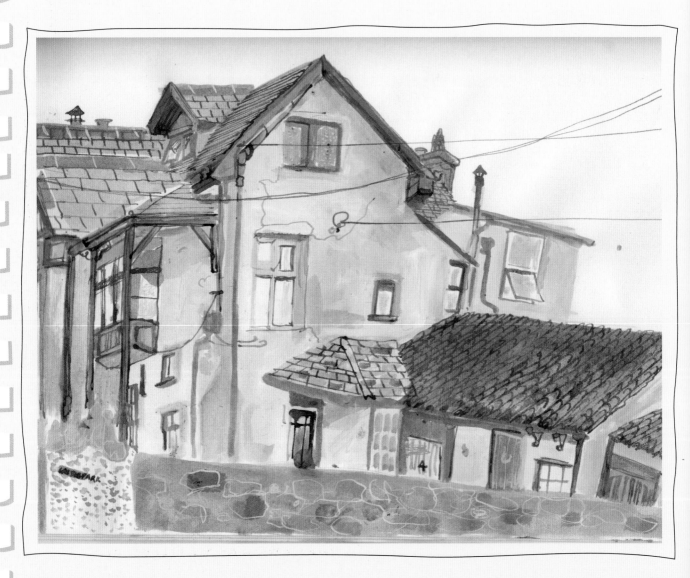

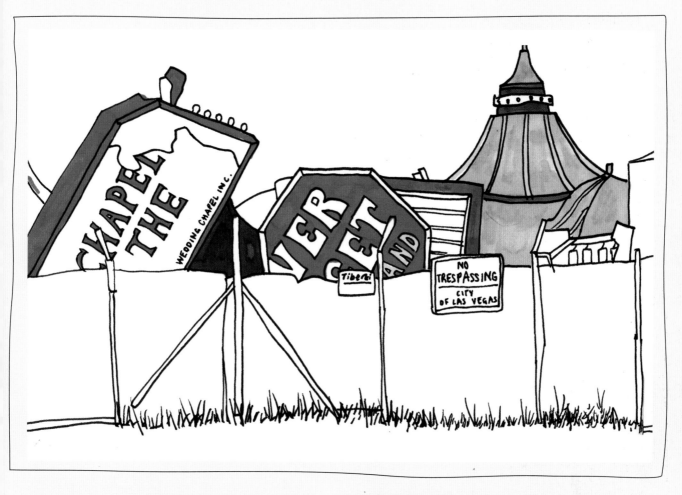

The most direct way to improve your observational skills is to look and to draw. The ability to depict what you see to your own satisfaction can seem elusive if you are new to drawing, but as your technical abilities improve, the way you see your subjects will change. The more you draw something, the better you draw it, and the closer you have looked at it, the more you will see it and be aware of it in your surroundings.

Looking at things as if encountering them for the first time, opens up a world of subjects that your eye might easily slide over otherwise: the view from your window, a tangle of wiring or traffic-swamped urban roads. But when you encounter something for the first time, such as when you travel to a new place, it is more a case of trying to draw this torrent of sensory information. That may be when your observational skills are keenest, when the colours ping, and everything calls out to be drawn or painted.

Sketchbooks inevitably come to reflect the life and character of their owners. We turn our attention towards the subjects that interest us, and portray them in a way as personal as handwriting. But in time, comparing the opening pages of your first sketchbook with your most recent work will show how the way you look at the world has changed.

Opposite: Josephine Birch. Boarden Barn, Exmouth, Devon, UK.
Above: Trudi Esberger. Neon boneyard, Las Vegas, USA.

STOP AND LOOK

Learning to see by drawing calls for time and close observation, and this means slowing down and opening up to everything that is around us.

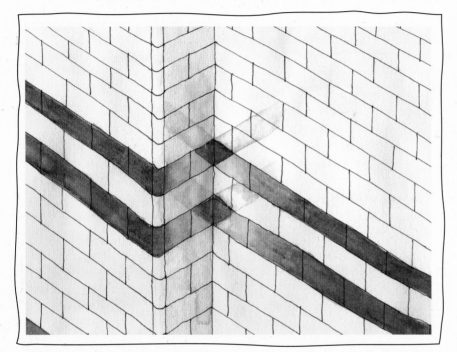

FOCUSING IN

The reflections in the glazed tiles that decorate Marylebone underground station in London caught the eye of Thomas Corrie as he headed home one evening. While waiting on the platform, he had time to make an ink drawing in his sketchbook and also some colour notes. Later when he was at home, he painted the subtle patterns of the overlapping reflections in watercolour.

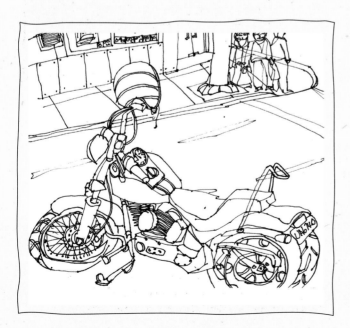

DRAWING WHAT YOU SEE

'I like coffee and drawing motorcycles', says Don McNulty, who was sitting in a café as he drew this motorcycle. This is a drawing made by someone who evidently understands his subject, and yet is still looking closely at it: this isn't how anyone would draw a motorcycle from his or her imagination. Rather than making marks that represent what we hazily remember or think we know, combining observation and a knowledge of our subject leads to the best observational drawings.

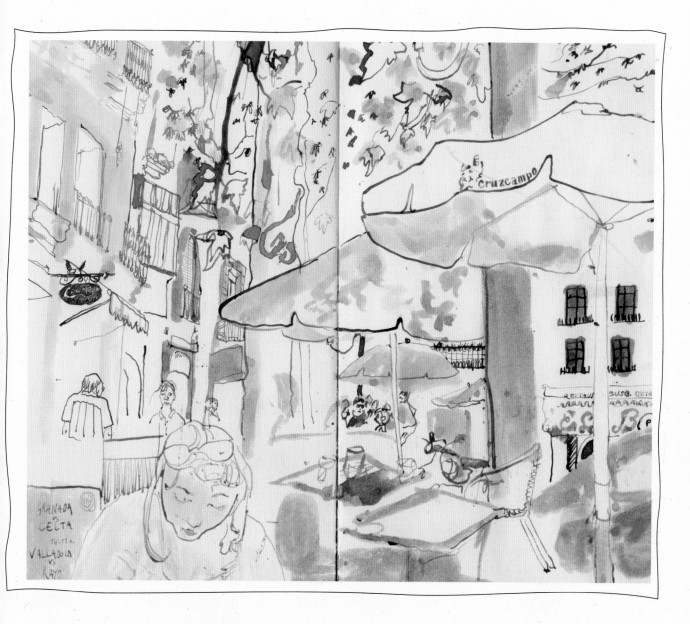

CAPTURING THE EXPERIENCE

Watching closely and drawing often become closely entwined with the experiences we have, so that just looking at a drawing can transport us back in time. Josephine Birch was in Seville, Spain, when she made this quick sketch on her first day exploring the city. 'This drawing takes me back to that moment and that square in a way that a photograph could never do', she says. 'Instead of a snapshot, a drawing represents a sustained amount of time looking and analysing, fixing a place in your mind. A drawing is like recording your peripheral vision: you can choose what goes in and what doesn't.'

Opposite
Top: Thomas Corrie. Marylebone underground station, London, UK.
Bottom: Don McNulty. Motorcycle, Vancouver, Canada.
This page top: Josephine Birch. Sally at lunchtime, Seville, Spain.

LEARNING TO LOOK

It can be surprising what catches the eye and demands to be drawn: it isn't necessarily the most historic building, or the best-known part of town, or even anywhere that will be recognised by most people, but don't let that put you off. Learning to look can take you to some interesting places.

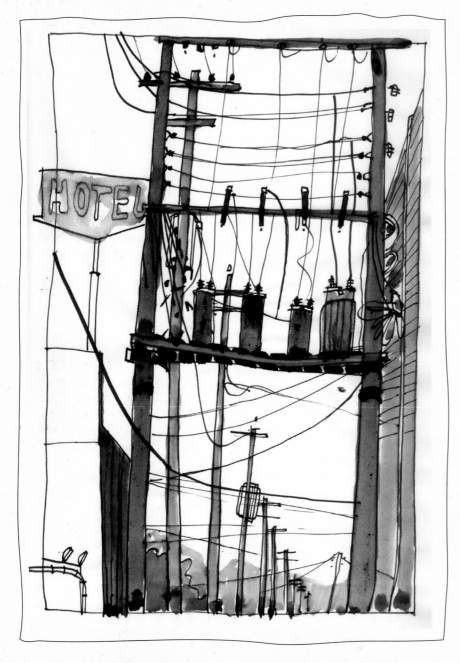

AWAY FROM THE GLITZ

Colin Moore's close observational eye focused on the spaces between all the razzmatazz of Las Vegas. 'Walking in the city's backstreets offers a welcome respite from the glitz and glamor of the Strip', he says. 'Here things are what they are: patched up, run down, bleached by the sun, rusting and fading beautifully. In formal terms, I liked the tangle of wires and poles, a nice subject for pen and ink.'

Left: Colin Moore. Power lines, Las Vegas, USA.

Opposite

Top: Rolf Schröter. Berlin junction, Germany.

Bottom: Naomi Strauss. Parthenon ruins, Athens, Greece.

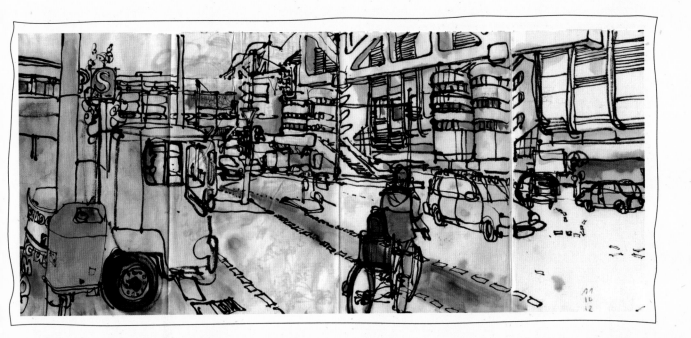

EXPLORE THROUGH DRAWING

The junction of a busy road and a motorway in Berlin may not seem a prime position for drawing, but it is a place Rolf Schröter knows well as it is on the route he and his children take to school. The spaceship-like design of the International Congress Center and proliferation of traffic make pedestrians and cyclists feel like 'aliens' there, Rolf says. 'The special roughness is an aesthetic part of Berlin's character. I'm interested in drawing such places, because the shapes are so expressive. Drawing them is exploring them, unfolding some meaning that isn't apparent when just passing by.'

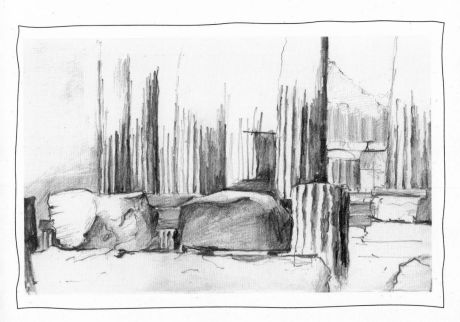

THE ALTERNATIVE VIEW

Naomi Strauss avoided drawing the familiar postcard view of the Parthenon in Athens, Greece, focusing instead on the abstract forms of the ruins. 'They could have been any ruins, but from the act of drawing them, my memory of the moment, place and atmosphere fifteen years later is still very strong', she says.

EXPLORING THEMES

The first drawing you make of a subject may not be the best one: repeatedly observing and drawing, perhaps from a different viewpoint or using a different medium, is a route to understanding a subject better. A series can throw new light on a subject and tell a story.

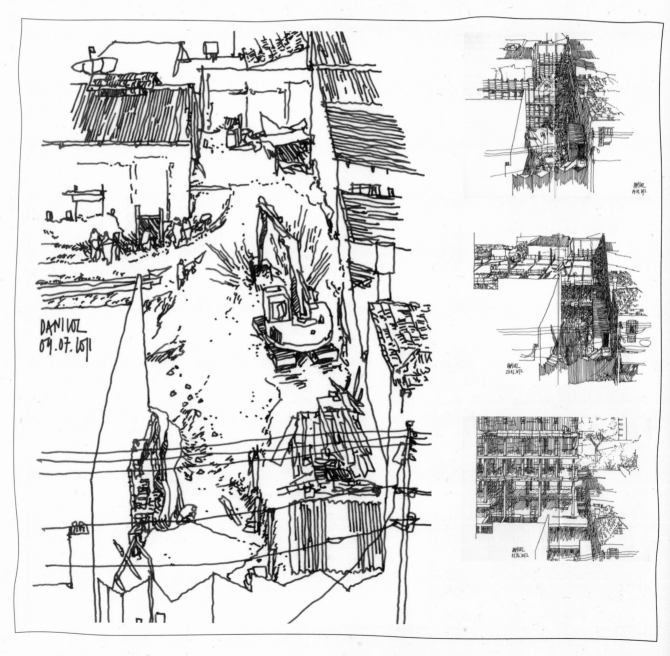

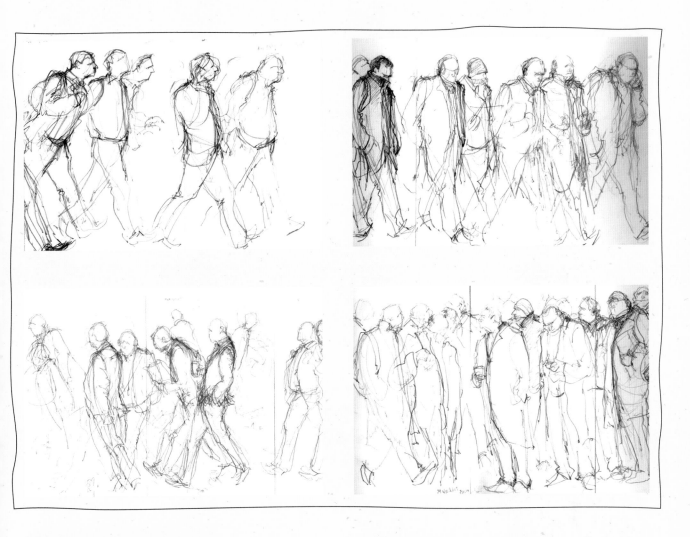

URBAN GROWTH

A building site in São Paulo, Brazil, across the road from the workplace of the artist Daniloz has become the subject of a continuing series of sketchbook works – twenty two, and counting – in which he is recording the gradual construction process of an eight-floor residential building. 'Looking at a building in the way we have to in order to draw it makes us comprehend it better', he says. 'The day I look at it finished, I'll look with the very eyes that accompanied the process of its building: it will be a kind of past component of the finished view.'

Opposite: Daniloz. Construction site series, São Paulo, Brazil.

Above: Rydal Hanbury. Morning commuters series, London, UK.

REPETITION AND ROUTINES

Over the past few years Rydal Hanbury has got underneath the skin of the morning routine of London's financial district. Taking her concertina-style Japanese Moleskine sketchbooks and stubby 6B pencils, she arrives ready to start drawing at 7am. 'I have the most incredible visual drawing feast imaginable, while thousands of commuters run through the narrow isthmus of the Mansion House stoplights', she says. 'By 9am it is all over.' She is familiar with the actions of the commuters as they cross the roads at different places, the directions in which they look, the view they offer, and how at some traffic islands they get enough time to check their mobile phones or read their newspapers until they can cross.

DRAWING THE FRESH AND NEW

Visiting somewhere new is always likely to open the sensory floodgates. If your time in a place is short, the pressure can be on to get some drawings in the sketchbook before it is time to leave: focus on the subjects that make the place special and different.

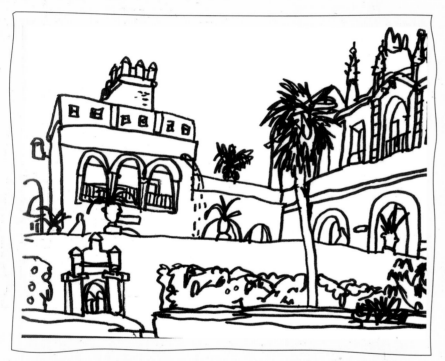

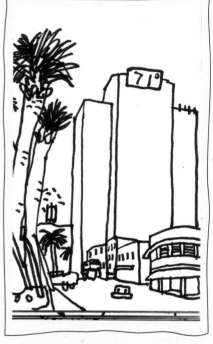

CULTURE AND HISTORY

The Alcázar in the centre of the Spanish city of Seville is a Moorish royal residence with a cooling, shady garden: a great combination of culture, history and nature in conditions that were perfect to work in. However popular it may be as a tourist attraction, it is still a subject that captures the heart of the city.

BEYOND ARCHITECTURE

This drawing, completed right next to architect Frank Gehry's gleaming New World Center, shows best, for me, the spirit of Miami Beach: palm trees, heat, as displayed on the screen at the top of the tower, and a spot of Art Deco architecture. The big, obvious subject in a place may not describe it best.

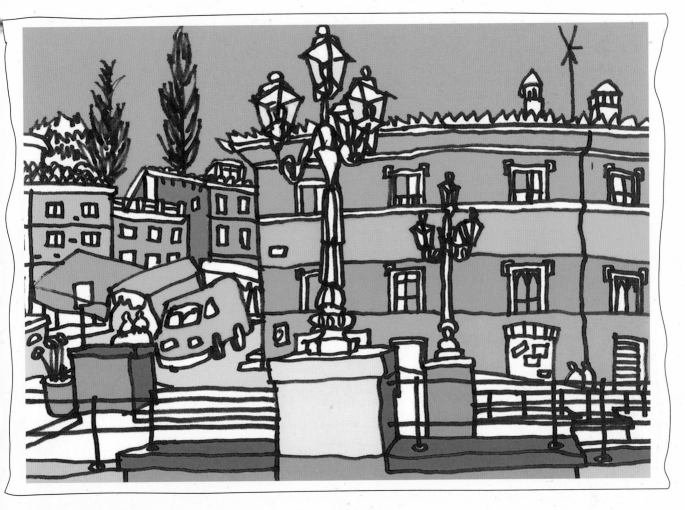

DAILY THEATRE

Often the best way to see a small town is to take a seat at a café, and watch its daily theatre unfold: above is Amandola, Italy.

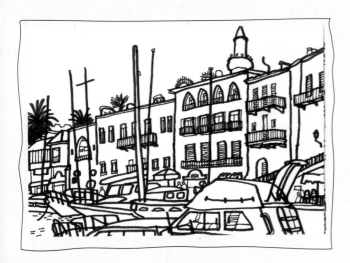

LOCAL FLAVOUR

Expensive boats often look the same (to non-mariners) floating in one harbour as they do in any another, but bringing a local flavour to your sketch can add a distinctive element, such as the minaret and waterside buildings in this drawing of Kyrenia, in the north of the Mediterranean island of Cyprus.

Opposite
Left: James Hobbs. Gardens at the Alcázar, Seville, Spain.
Right: James Hobbs. Street scene, Miami Beach, USA.
This page
Top: James Hobbs. Market, Amandola, Italy.
Left: James Hobbs. Kyrenia harbour, Cyprus.

THE OVERFAMILIAR: AROUND THE HOUSE

Your domestic surroundings can be a key element in developing the way you see, which you can then take with you when you're out and about with a sketchbook. To stop and draw what is part of your daily routine and domestic landscape is to halt the habitual slide of the eye over what you *think* you know best.

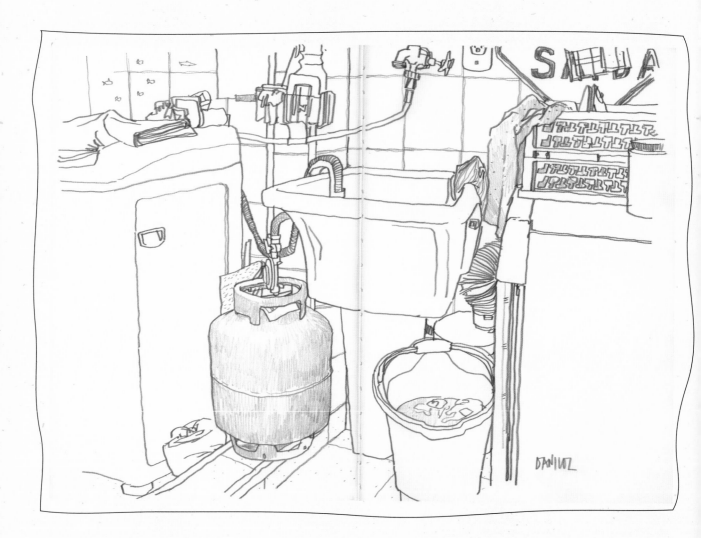

BEHIND THE SCENES

Domestic scenes don't have to be picturesque or beautiful to make good drawings. This closely observed 7B graphite drawing by Daniloz of his laundry room, with its network of pipes and washing equipment, and its subtle patterns and textures, hints at the architectural forms of a cityscape and the spaces around them. It is the domestic equivalent of the back alley, and all the more interesting for that.

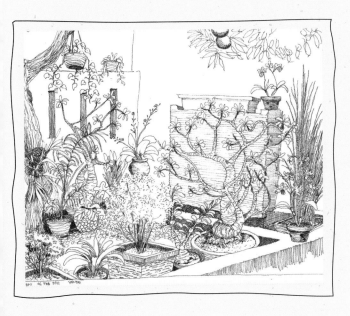

THE GARDEN
The diversity of plant life in Yanuar Ikhsan's Indonesian garden calls for attention to detail and a range of creative mark-making with his drawing pen.

FROM THE WINDOW
The view from your own window is something so familiar that it might be low on your list of things to draw. But drawing it will make you see it in a different light.

NEW ANGLES
Thomas Corrie took part in 28 Drawings Later, a project that encouraged people to find time to draw every day. 'Often I would get home late from work and cast around for a suitable subject to quickly draw', he says. 'On this particular day I sketched our apartment's hallway from the top of the stairs. I was attracted to the unusual perspective created from looking down a staircase.'

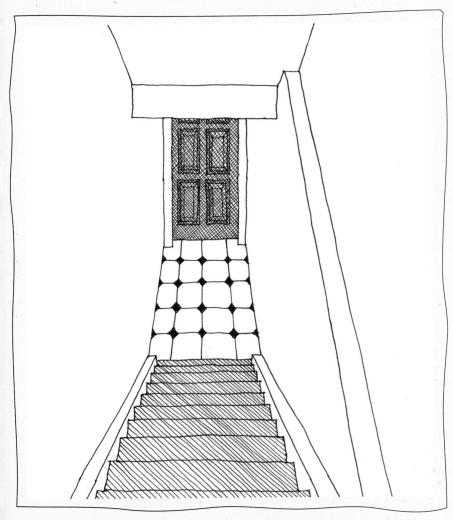

Opposite: Daniloz. Laundry room.

This page

Top: Yanuar Ikhsan. Garden.

Left: Thomas Corrie. Hallway.

CHAPTER 4
MAKING A DRAWING

Ask ten people to draw the same scene from observation, and you'll see ten very different works at the end. We all start off with the same drawing surface, media, tools and time to complete the work, but what we include and omit and the way we go about it – the marks we make, the way we compose the scene, our use of colour and tone, and the energy we bring to a drawing – is vast in scope. These all contribute towards a final, personal work.

Above: Max Naylor. Urban garden space, London, UK.

Opposite: Yanuar Ikhsan. Jalan Jendral Sudirman Buildings, Jakarta, Indonesia.

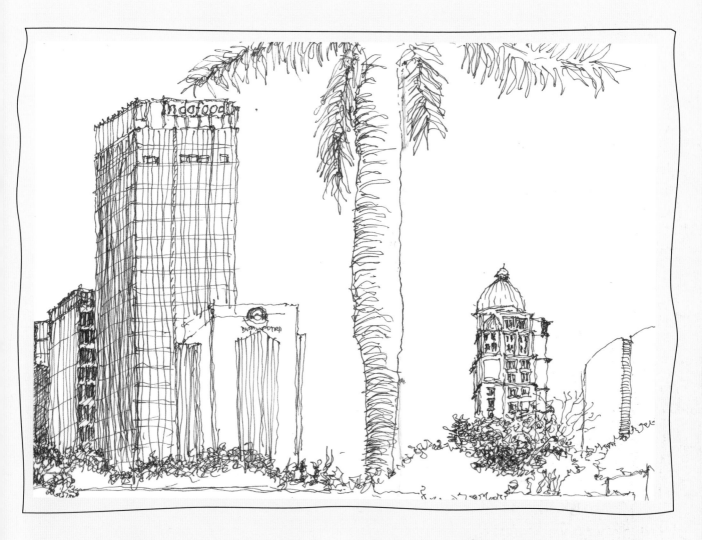

The journey from blank page to finished drawing has its ups and downs. Your ideas can go astray, hit dead ends and need remedial care. Decisions need to be made to cajole the marks into a work that you are happy with, and that can mean ditching your original intentions, accepting the accidental triumphs that you will later claim were intended and losing yourself in the journey to the drawing's completion. Embrace what stops your drawing being photographically accurate or too much like someone else's, however much you admire their work, because that is what makes it yours.

We are not always the best judges of our own work, especially in the heat of the moment of making it, so it can take a while to see what has worked best and what has not. Quite often it is in the context of what follows in a sketchbook that we recognise the strengths of what went before. Work can become too tight and need loosening up, and then too expressive and need reigning in; the goal of making drawings we are happy with can seem elusive. Experimenting and taking creative risks can take you forwards and stop you from making the same drawing over and over, but to do that you must dare to fail. With hindsight, we can often see that it is our failures that lead us on.

MAKING MARKS

Mark-making is the nuts and bolts of a drawing. The range of marks that each medium can provide is almost limitless, and restrained only, perhaps, by the repertoire to which we naturally resort. Developing this range of marks that you use, and finding the best marks to depict your subject, is a continual process.

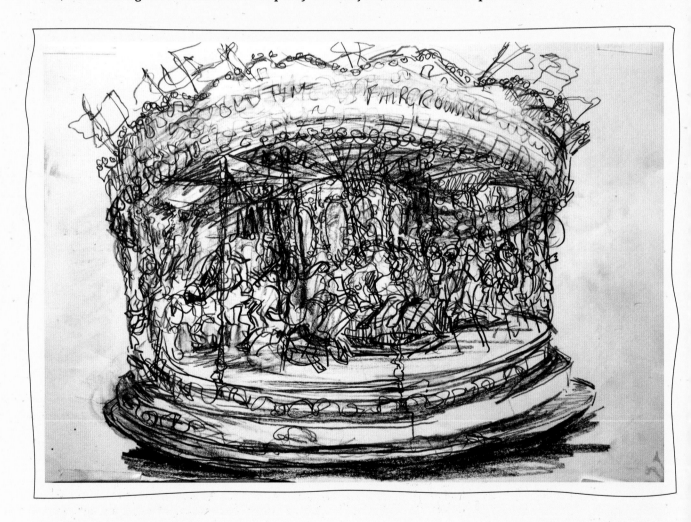

MARKS OF MOVEMENT

Drawing a moving image demands swift and spontaneously made marks. Pippa Ridley used graphite sticks, 6B and 3B pencils, and an eraser to capture this carousel. 'The marks become essential rather than descriptive as a desperate attempt to grasp what I am seeing', she says. 'I react to the "happening" with thin, fleeting lines, or thicker, denser ones for more solid forms or consistent areas of shadow. Through the layering of these, an image forms. I hope that the repeated movements come through in a pattern of marks that give the drawing a temporal quality.'

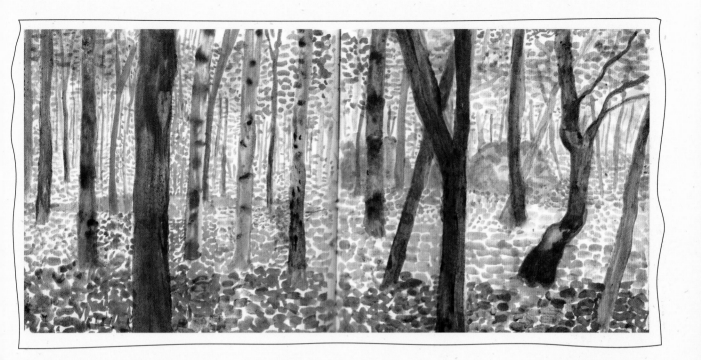

RESEARCH AND REFINE

'Translating nature visually can be an overwhelming experience', Craig Harper says. This ink drawing of a forest was done in a sketchbook back in his studio, working from various sketches and notations made whilst he was in the forest. 'I wanted the drawing to be more about the mark-making than trying to imitate what I was seeing. I find that once I have collected those details, I can translate them in the studio into a more refined representation.'

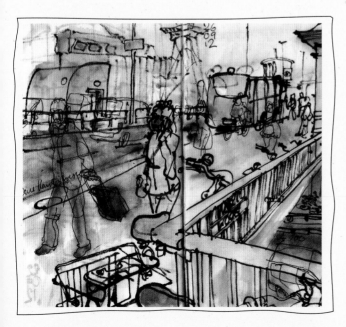

THE MARKS OF NOISE

The noise of Neue Kantstrasse, Berlin, busy with buses, motorbikes and commuters heading out in the morning, supplemented by the constant hiss of the A100 highway, is evident in the hierarchy of marks used in this drawing by Rolf Schröter. He used a brush pen for the static elements, superimposed by ballpoint pen for moving people and cars, and then finally, watercolour. A further level of interference is suggested by the other drawings leaking through the very light 40gsm (20lb) calligraphy paper that Rolf likes to use. 'No non-motorised noise shines through', he says.

Opposite: Pippa Ridley. Carousel.
This page
Top: Craig Harper. Forest.
Left: Rolf Schröter. Neue Kantstrasse, Berlin, Germany.

TONE

A tonal drawing requires decisions to be made about the relative lightness and darkness of a scene. Which are the subject's lightest elements, and which are its darkest? The quality of the light cast, its direction and strength, and the shadows it produces can create powerful forms even in a small sketchbook.

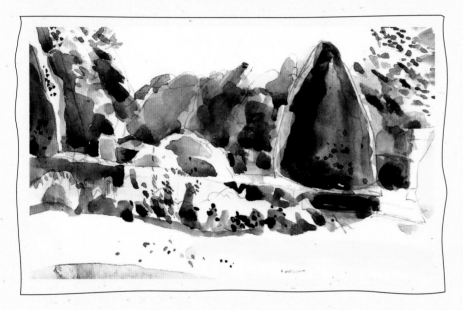

SCULPTURAL FORMS

Some subjects with strong forms or sculpted shapes suggest a tonal approach, as Caroline Johnson found when visiting the grounds of a country house. 'The weight and presence of the dark topiary trees behind a lighter hedge were ideal subject matter for a tonal study', she says. After drawing the main shapes in pencil, Caroline worked from light to dark with a black watercolour, looking for abstract forms. A few finer details were added at the end, to give the suggestion foliage and create a variety of marks.

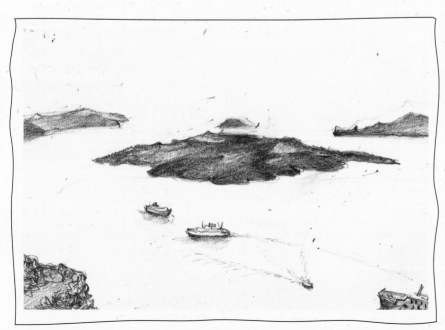

TONAL EXTREMES

'Before I start a drawing, I reflect on the special qualities of the scene before me and it helps me to make choices about the drawing and select what I want to focus on', Naomi Strauss says. 'The tonal extremes of the silhouetted islands and the sunlight reflected in the water made my job easier as they reduced the image to its starkest and simplest forms.'

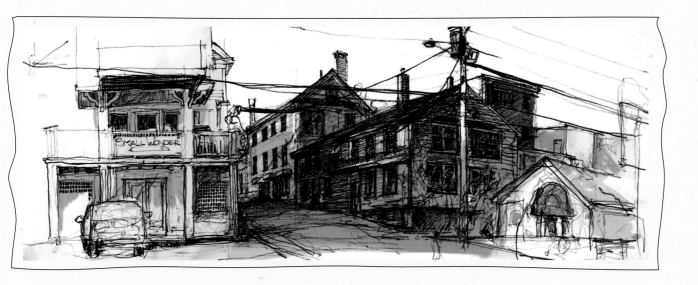

DIGITAL TONES

Ken Foster's drawing of a road in Camden, Maine, started out as a pencil work that explored the power lines and the way they intersected the buildings to which he intended to add watercolour washes. 'But I realized I had so much graphite on the page that I doubted the watercolour would work', he says.

'So I photographed it with my tablet and brought it into Photoshop Touch where I sketched in the grey tones in a new layer with a broad brush, adjusting the opacity of the layer and adding tone to different areas until I was pleased with the image.'

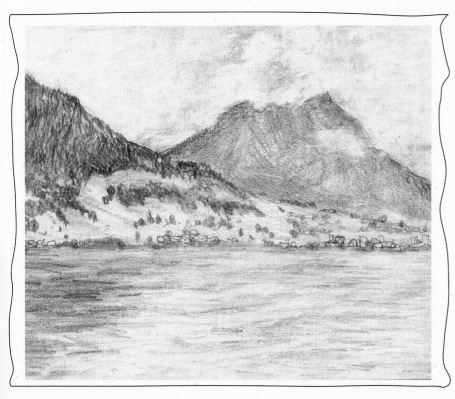

AVOIDING LINES

Focusing on tone in a drawing means resisting the urge to resort to using too many lines, as shown in this drawing by Naomi Strauss. 'I enjoyed trying to capture the foreground and background tonal variations and levels of definition with nothing but a 4B pencil and an eraser. There was nothing linear about it.'

Opposite

Top: Caroline Johnson. Topiary at Forde Abbey, Somerset, UK.

Bottom: Naomi Strauss. Santorini caldera, Greece.

This page

Top: Ken Foster. Cappy's Chowder House, Camden, Maine, USA.

Left: Naomi Strauss. Lake Lucerne, Switzerland.

LINES

Lines are the closest things in drawings to our handwriting. The lines we choose change over years of drawing and we have had to adapt them to best portray different subjects. A few lines, by breaking, by wavering, by thickening and thinning, can go a long way to expressing a scene.

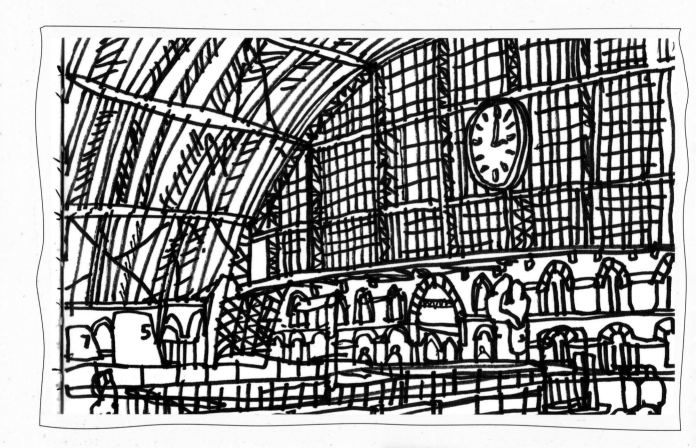

APPROXIMATE LINES
Lines can be used in a huge variety of ways to bring character to a drawing. Here a combination of quick, approximate lines come together to suggest the vast arching roof of St Pancras train station, London. Few of them could be described as 'right', and yet the overall effect is a generally realistic impression of the scene. The weight of line is the same across the image, the sense of depth being suggested by the receding perspectival angles.

Use different media to experiment with line; pencils, pens and charcoal offer a variety of expressive lines.

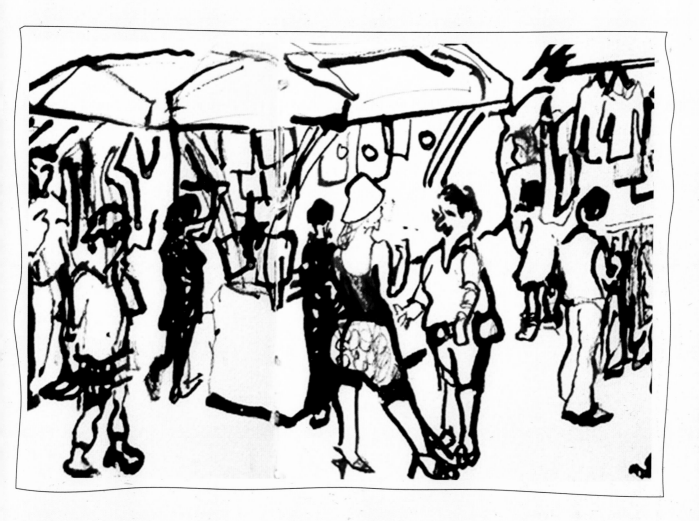

THE SOLID LINE

Marker pens have many advantages, but they are not always the most subtle of drawing instruments, the line of some having a continuous, even quality that is not very responsive to changing touch on the paper. But this solidity can also work to its advantage, and the boldness and constancy of their lines can inject energy and confidence when things work well.

VARIETY OF LINE

Using pens of differing tip size in a single drawing creates a variety of weights of line that allows detail in some areas and thicker, more expressive marks in others.

QUALITY OF LINES

Using a dip pen and ink can create a line with a variety of qualities, sometimes starting with a rush of ink and then flowing until the pen runs dry. In Pippa Ridley's market scene drawing, she used this variation, working on finer areas as the pen began to run dry. 'Although responding to what I observed, this medium took away an element of control and I had to allow the marks, blobs and scratches to stand independently from the subject as well as form it. I really enjoy the meditative quality that comes with manoeuvring ink and the character that comes out from its wobbly and awkward line.'

Opposite: James Hobbs. St Pancras station, London, UK.
Above: Pippa Ridley. Spitalfields Market, London, UK.

DRAWING WHAT YOU SEE

Standing before a scene you plan to draw can be a daunting prospect; what seemed like a relaxing pastime can suddenly seem less enticing. However, there are a few simple methods that will help you to build on the essential elements that go towards making a successful drawing, such as capturing the right perspective and working out the correct proportions. Stop, take time and look closely.

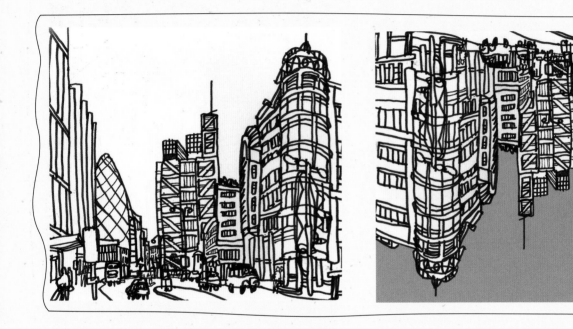

Try looking at your finished work in a mirror; the immediate effect of seeing the scene in a new way can highlight weaknesses in the composition.

NEGATIVE SPACE

Looking at the space between and around the objects in your subject can be an enlightening exercise in learning to build a composition accurately. This is apparent in drawings of buildings set against a sky, for instance, as in this example. Rather than just looking at the shape of the tops of the buildings, study the shape of the sky around them. The shape of the sky creates the shapes of the buildings: this can be more easily seen by turning a finished drawing upside down.

This page
Top left: James Hobbs. Bishopsgate, London, UK.
Top right: James Hobbs. Bishopsgate, London, UK (inverted).
Opposite: James Hobbs. Great Eastern Street, London, UK.

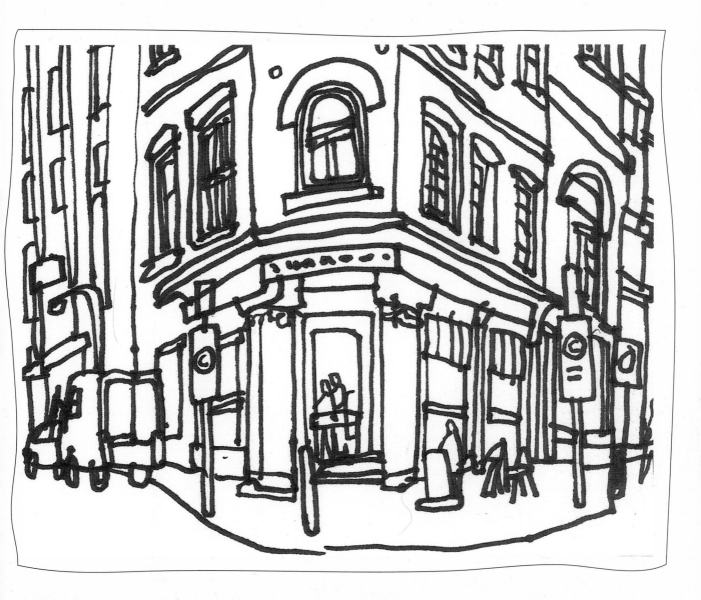

PERSPECTIVE

Especially important when drawing architecture, the lines of a scene can either give a drawing dynamism or make it look unbelievable. Some sketchers hold up a horizontal pencil at arm's length to judge the relative angle of lines, but judging this becomes second nature without props. In this drawing, look to see how much steeper the line of the building is at the top compared with the bottom, and which lines are at eye level and therefore closer to horizontal. Remember that when you are standing on flat ground, people of similar height will have eyes on the same line across your drawing, no matter how far away they are.

PROPORTIONS

Drawing is a constant state of measuring and comparing, both of which are essential in order to make a drawing fit onto the page in the way you want, and for it to be faithful to the scene before you. In a similar way to measuring perspective, this can be aided by holding out a pencil at arm's length and using a finger along it to measure and compare widths. While some sketchers find this technique useful, others may find it can tighten up and slow down the creative process, especially when trying to capture a scene quickly on location.

COMPOSITION

What is the best way to bring the scene before you into the pages of a sketchbook in a way that creates a balanced whole? Should the image be landscape or portrait, or even across two pages? Where should you stand to get the best angle? How is the eye going to be led around the finished work?

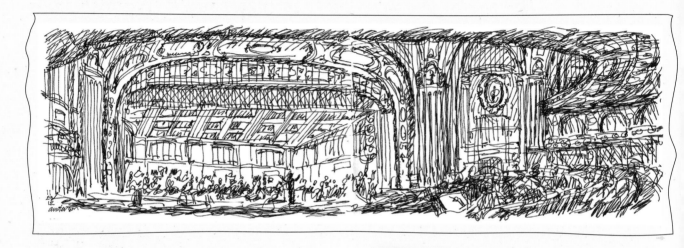

WIDE ANGLES

Michael Anderson was limited to taking a small sketchbook and a ballpoint pen when he and a group of artists were invited to attend a rehearsal of the St Louis Symphony Orchestra at the city's Powell Hall. The idea was to make drawings to develop into later paintings. Even working across two pages of the sketchbook, measuring 13cm × 41cm (5" × 16"), capturing the grandeur and scale of the auditorium required a creative use of perspective that included foreshortening the height of the proscenium arch. The panoramic format allowed a wide, almost 180-degree angle of vision to be drawn.

You may want to draw the main components of your scene lightly in pencil before following on with other media, but don't let this hold you back. Learn to trust your eye, and be bold. Make mistakes. You are learning to look and draw rather than to trace.

Above: Michael Anderson. St Louis Symphony Orchestra, Powell Hall, St Louis, USA.

Opposite
Top: Colin Moore. Street scene, Cholula, Mexico.
Bottom left: Daniel Zalkus. Rockefeller Center, New York, USA.
Bottom right: James Hobbs. Boats on Shaldon beach, Devon, UK.

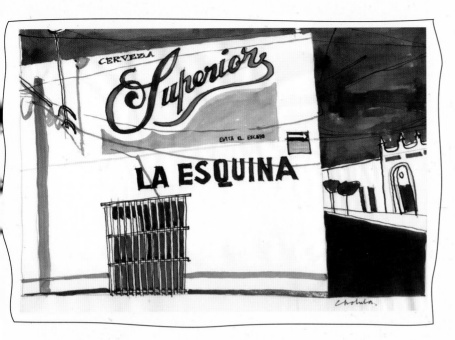

BALANCE AND DEPTH

The composition of Colin Moore's fountain pen drawing of Cholula, Mexico, is sophisticated in its apparent simplicity. No lines are quite horizontal, adding a subtle tension. The lines of the shadows on the side of the building lead our eye around the surface, and the glimpse of the road on the right-hand side creates balance and depth and suggests the character and atmosphere of the town.

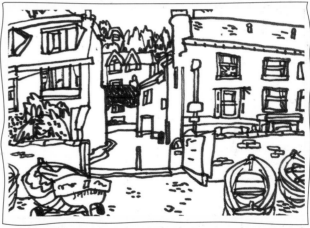

MULTIPLE FOCUS

A drawing may have an obvious, single, central focus or, as in this charcoal drawing of the Lower Plaza of the Rockefeller Center, New York, by Daniel Zalkus, have a series of areas that lead the eye around. As well as the diners in the plaza below, the line of flags at ground level, and the lower floors of rising buildings create areas of busyness and calm.

RULES OF COMPOSITION

Compositional guidelines, such as the 'rule of thirds', in which areas of interest are placed on or near horizontal and vertical lines dividing the image in three, are used by some artists. Finding a natural sense of balance in a work may show you have followed such a rule even if you weren't aware of it at the time, as happened to me with this coastal scene. Trust your instincts, and don't be bound by such compositional aids, which can restrict creativity.

COLOUR

Some scenes can only be expressed using the language of colour, while sometimes adding just a hint of colour to a drawing can bring it to life. Using colour doesn't mean that a drawing has to take a long time: watercolours and coloured pencils are convenient and portable.

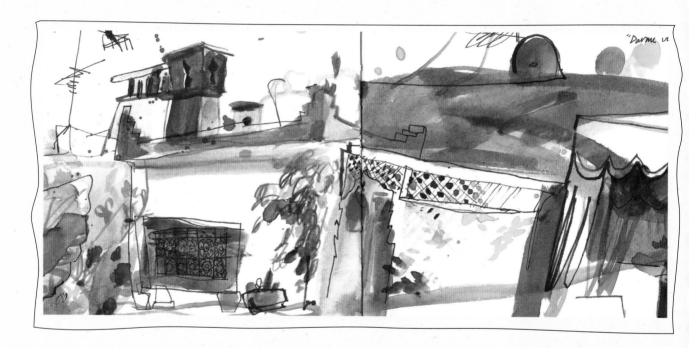

Using watercolour? A waterbrush, with its leakproof, refillable reservoir, does away with the need to include a jar of water in your kit.

EXPRESSIVE COLOUR

This painting by Inma Serrano reflects the blue that can be found everywhere in Morocco, from facades to the sky. She started by applying broad strokes of diluted watercolour and ink in a waterbrush, then added watercolour pencil marks on the damp paper, then finally drew lines with a fine black pen. 'For me, the colour is essential in this kind of sketch, when I know I have little time and the landscape and the environment is changing colour every minute', Inma says.

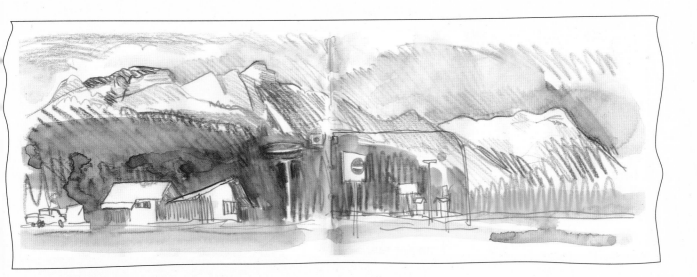

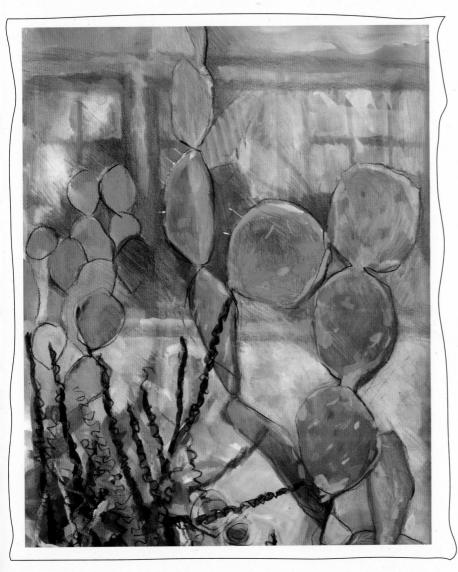

SENSE OF ATMOSPHERE

Lachlan Goudie uses information about colour that he records in his sketchbooks while travelling to make larger works when he returns. 'Back in the studio, it is hard to recapture that moment, that sense of atmosphere, that movement that animated me outdoors. I find it crucial to have the summaries of the light and the moment and the sense of atmosphere that radiates from a sketchbook.'

CONTRASTING COLOURS

The grey-green forms of drought-loving plants in a botanical garden have been contrasted with deep burgundy colours by Juliet Docherty, using gouache, pencils, and pastels.

Opposite: Inma Serrano. Street scene, Asilah, Morocco.

This page

Top: Lachlan Goudie. Route 93, Canada.

Left: Juliet Docherty. Cactus, Cambridge University Botanic Gardens, Cambridge, UK.

TAKE A CREATIVE RISK

Sketchbooks don't have to be filled with 'perfect' drawings from cover to cover: experiment with new kinds of marks, play, and draw unselfconsciously without worrying about the finished product.

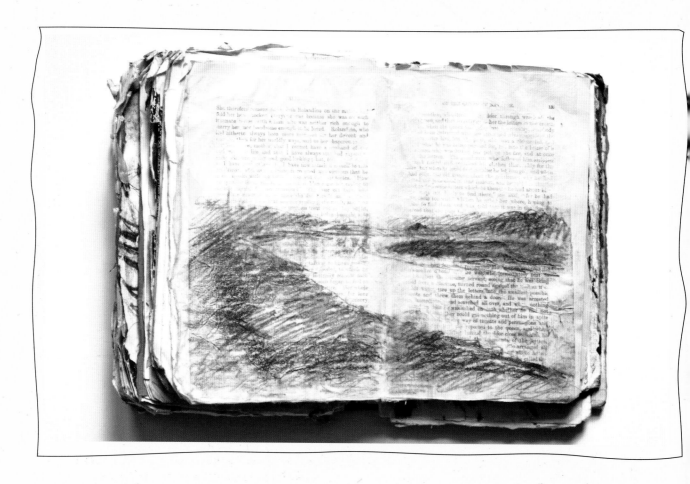

A NOVEL APPROACH TO SKETCHBOOKS

Anthony Banks turns old books into sketchbooks by sticking a variety of paper into their pages. 'I find shop-bought sketchbooks sterile and impersonal, and I end up drawing in them in exactly that way. Old books have an amazing nostalgic quality, a history of the hands they have passed through', he says. The text in the pages can sometimes show through his paper, so he chooses a page with a texture and colour that will work best with the drawing. 'My sketchbooks are only for my own use in my studio, but I think they have a quality as pieces of art in their own right.'

Above: Anthony Banks. River scene in sketchbook.
Opposite
Top: Toni Zhao. Experimental drawings.
Bottom: Naomi Strauss. Drawing without looking at the paper.

PLAYING WITH MARKS AND LINE

Toni Zhao makes works that spring from the subconscious, triggered at times by accidental marks. Although these drawings are not done from observation, they are an example of a liberated approach. 'The key is to just let go', she says. 'The lines belong to where they want to go.' As an exercise, this can help you to loosen up, become less inhibited, and make your observational drawings more expressive.

The drawing on the right began as Toni tried out a new blue pen. She then continued to shape new forms and new marks, creating moments of discovery that surprised even her.

LOOSEN UP

Try these loosening-up exercises to break out of drawing in a repetitive and predictable way and develop a range of marks and observational skills.

- Draw without looking down at your drawing: to develop the co-ordination of hand and eye.
- Keep your pen on the paper as you draw: to keep the line moving and flowing around the paper.
- Cover a page with charcoal or pencil and draw into it with an eraser: to evaluate a scene in terms of tone.
- Work with two pencils or pens taped together: to break away from an emphasis on outlines.

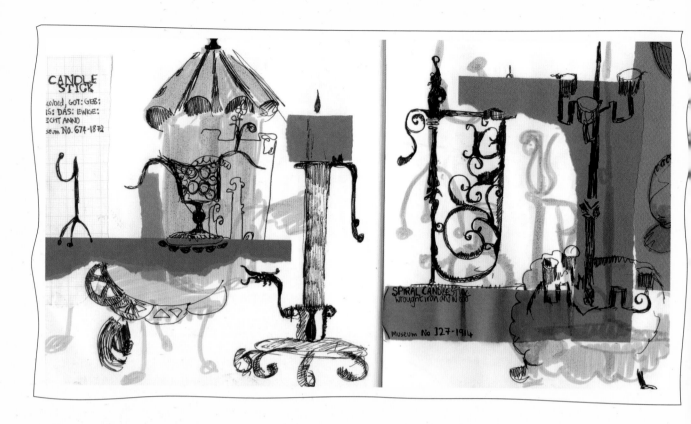

TRY COLLAGE

The intimidating whiteness of a new page in a sketchbook can be overcome by pasting paper to break the surface and add colour and pattern. In this drawing of exhibits in the Victoria and Albert Museum, London, Julie Bolus has used torn paper to divide the space, a warm grey brush pen for light tonal areas, and black fineliner to show the details of the candlesticks.

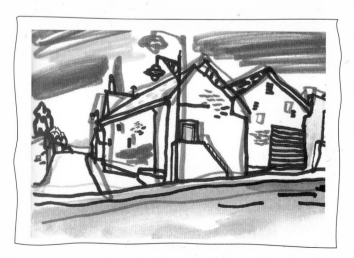

WHEN THINGS GO WRONG

Don't rip drawings out of a sketchbook if they don't work well. They are an opportunity to rework, experiment, obliterate, rebuild, without the fear of losing something you value. Embrace failure and build on it. Here, a lacklustre black pen drawing was reworked and superimposed with coloured pens and diluted ink to liven it up.

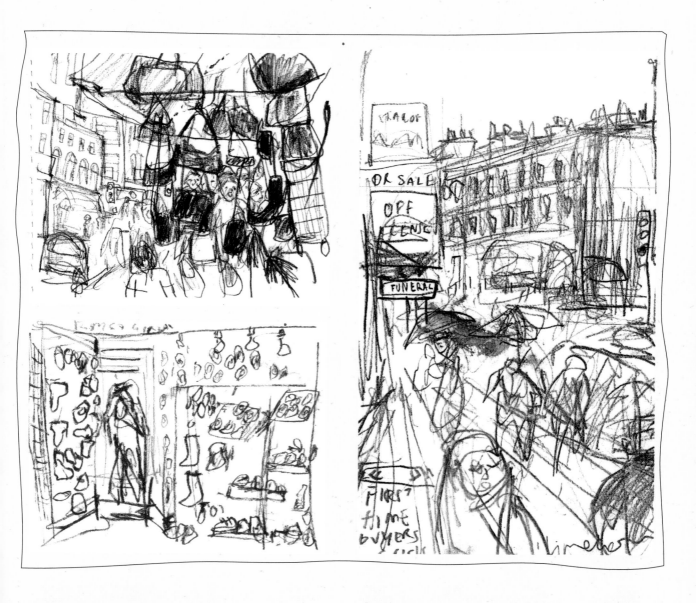

BEYOND THE VISUAL

Drawing in the city doesn't have to be about capturing architectural details or the colours of the park. The drawings of Liza Dimbleby, a tutor at the Prince's Drawing School, London, capture her experiences and all the sensory stimulation she encounters. 'They are an attempt to enter into the city that I am in, to catch its rhythm and to see into its life more fully', she says.

Something takes place that you are not aware of at the time, Liza says. 'While you are drawing, it seems that you are merely stabbing into the chaos, or increasing it, or getting lost in it. It seems that you will never be able to make sense of the amount of visual information that is hurtling at you from all sides. You feel that you have captured nothing but a vibrant memory. Afterwards, however, chancing on an old sketchbook, you can be surprised by how much has been held in these marks.'

Opposite
Top: Julie Bolus. Victoria and Albert Museum, London, UK.
Bottom: James Hobbs. Warehouses, Bristol, UK.
This page top: Liza Dimbleby. Bethnal Green, Roman Road, and Limehouse, in the East End of London, UK.

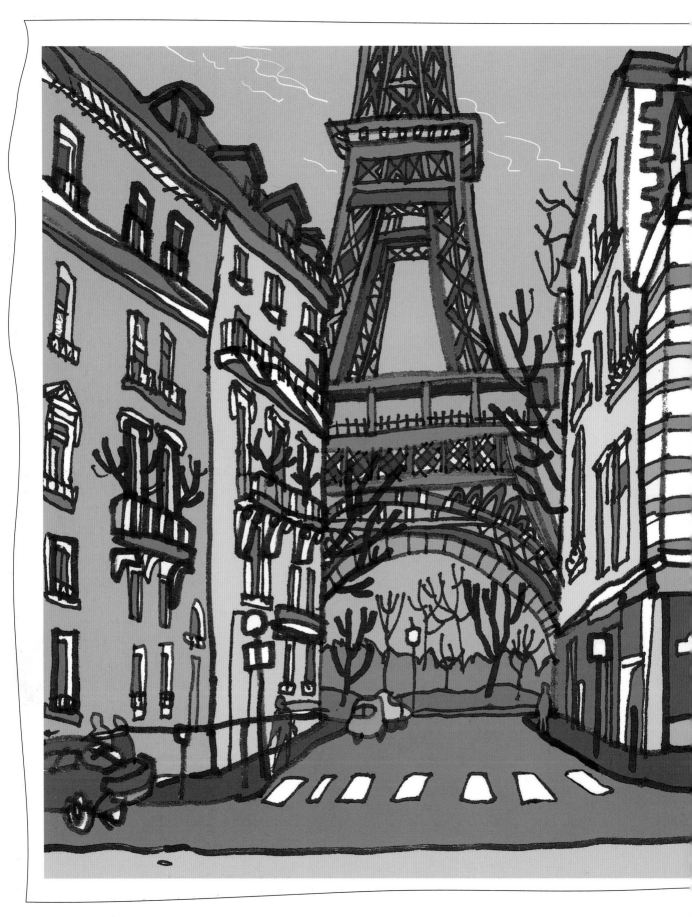

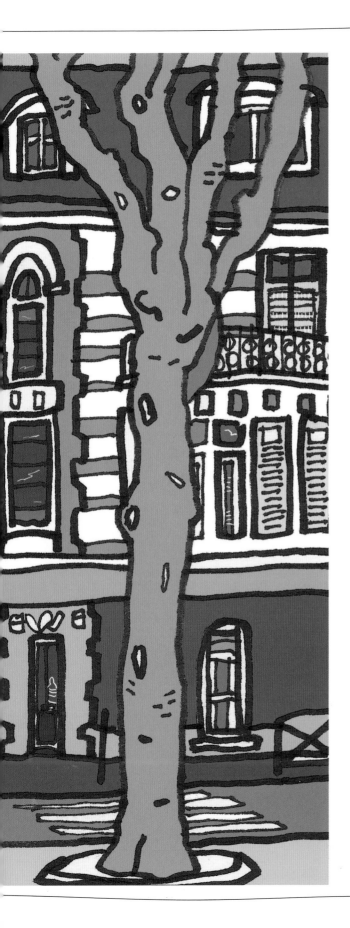

SKETCHING
TECHNIQUES

James Hobbs. Eiffel Tower, Paris, France.

CHAPTER 5
ARCHITECTURE

Whether you are drawing in the city or out in the countryside, it is difficult to avoid architecture. And why would you want to? It is what encapsulates the urban experience, and what epitomises the beating heart of the crowded and colourful places millions of us choose to live and work. Away from the city, architecture is still a regular focus or backdrop to our rural explorations.

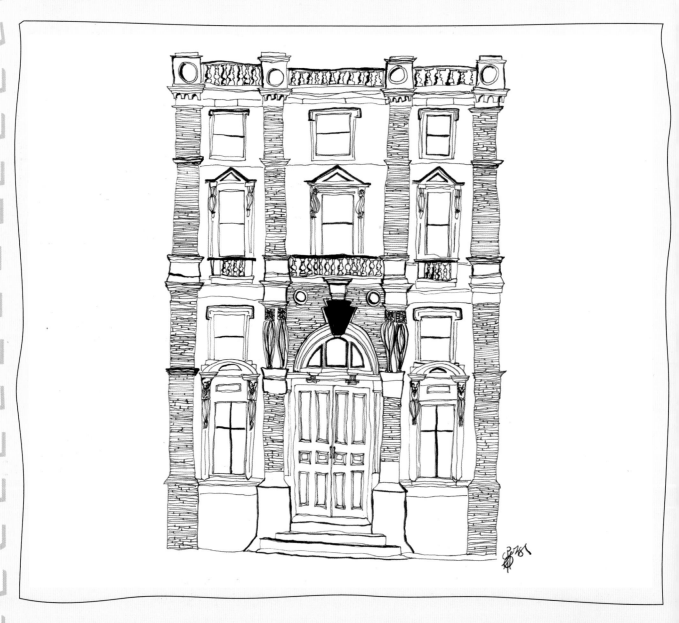

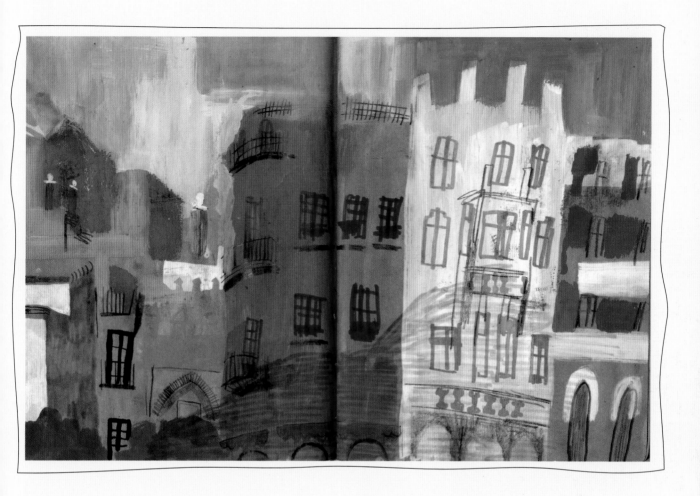

Often it is that showpiece building, the one that has attracted the travellers through the centuries, or become a modern classic in recent years, that gets us reaching for the sketchbook. It may have been drawn many times before, and a drawing may run the risk of becoming another cliché, but it is also a chance to make it your own and record it in a fresh, new way. The best-known buildings are so easily recognised that each drawing is a portrait and will be judged accordingly. It is up to you to find your own angles, your own vision, and your own ways of representing it: you are working to nobody's brief but your own.

But it is just as likely that it is the nondescript, overlooked building that catches the attention, speaks most clearly about the locality or tells a story. Turning your attention to the commonplace and easily overlooked is one of the best things about keeping a sketchbook. The character and essence of our towns and cities are found in the backstreets, housing developments, shopping centres and bus stations as much as anywhere else. Drawings of these can tell more about a place than the latest star architect-designed masterpiece rising from the ground.

What is the appeal of drawing architecture? Cities are continually changing – parts demolished, parts developed, neighbourhoods gentrified, others abandoned. This can be a trigger for your imagination, a stimulus to express something in your subconscious. Architecture has colour, rhythm, contrasts, sculptural forms and mathematical beauty, and it is just outside your door.

Opposite: Chichi Parish. House, Olympia, London, UK.
Above: Poppy Skelley. Skyline, Seville, Spain.

ARCHITECTURAL SPLENDOURS

It is easy to be lured by great architecture. There is the implication that you are somehow obliged to draw it, especially if you are in a location for a short time. But if you do – and you don't have to – make your drawings and paintings as if with fresh eyes, looking for something that makes it distinctly your own.

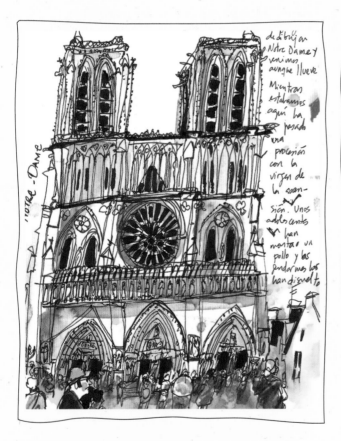

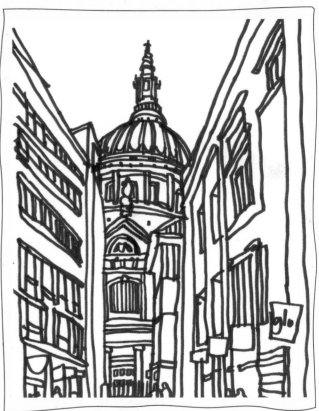

MAKE IT YOUR OWN
Notre Dame Cathedral in Paris is one of the great icons of Gothic architecture. Inma Serrano's drawing of it has an exuberance and vitality that shows it as the great piece of architecture that it is, through her own distinctive and personal marks. It is easy to get bogged down in the fine details of such a building, but she has kept her drawing fresh, lively and colourful by focusing on the essentials and working quickly.

FINDING NEW VIEWPOINTS
Well-known buildings often have the set-piece standard view – you only have to spend time studying a postcard rack to see what these may be. A new network of alleyways, squares and shopping centres has been built around St Paul's Cathedral in London, and it was the way that the Cathedral emerged from the modern architectural developments that caught my eye.

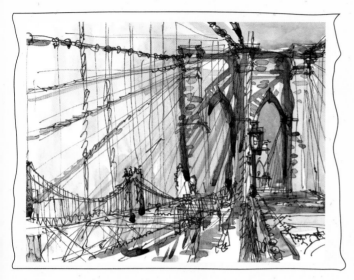

GETTING UP CLOSE

This sketch of Brooklyn Bridge presented an unusual challenge to Suhita Shirodkar: 'I usually get to stand back and observe something I draw. But I was on the bridge, walking across it when I stopped to make this sketch. I tried to capture the drama of being right up against a large structure and its scale as I stood right on it.'

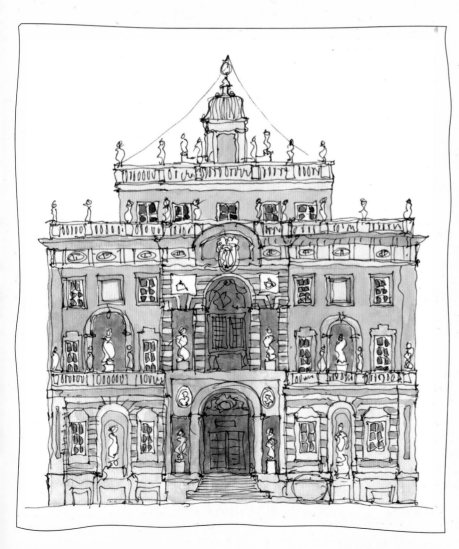

SCALE AND BALANCE

A focus on the scale, balance and rhythm of a building is often best achieved by treating it in isolation. Villa Torrigiani, in Italy, is set in magnificent gardens. Thomas Corrie, an architect, has brought together the symmetry, balance, and variety of coloured stonework of its façade by restraining any interest he may have had in its setting or perspective: we see the villa face on and can appreciate its grandeur and rhythm clearly.

Opposite

Left: Inma Serrano. Notre Dame Cathedral, Paris, France.

Right: James Hobbs. St Paul's Cathedral, London, UK.

This page

Top: Suhita Shirodkar. Brooklyn Bridge, New York, USA.

Left: Thomas Corrie. Villa Torrigiani, Camigliano, Italy.

EVERYDAY ARCHITECTURE

For every great example of world-renowned architecture there are millions more undistinguished buildings that are the sustaining daily fare of the artist with a sketchbook. The high-rises, the shanty towns, the suburban sprawl and the ubiquitous, overlooked structures that make up much of our environment are also worth drawing because they are the character and lifeblood of our communities, and you will never see them quite the same way again after you have brought them into your sketchbook.

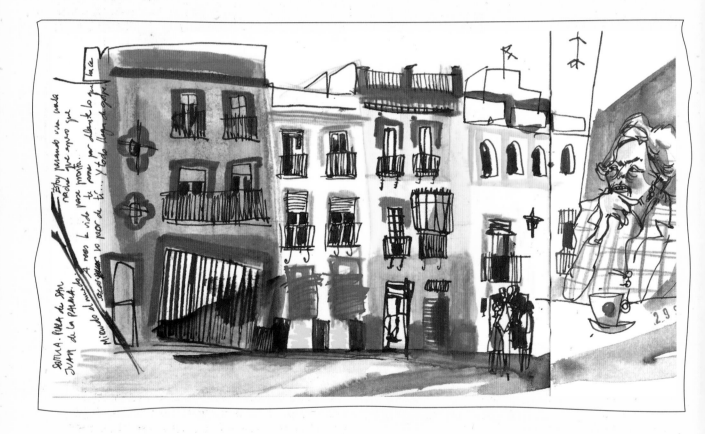

CHARACTER AND METAPHOR

Looking closely at architecture can draw out fresh aspects to add character and life to a drawing. Inma Serrano says she has never been good at drawing architecture because: 'I hate straight lines and I don't control the perspective'. But she recognised shapes in these buildings that suggested to her the forms of human figures with eyes, legs, hands and mouths. 'The houses surrounding this square in Seville have the same appearance as the gossipy ladies who sit at the terraces for coffee', she says, adding one such lady to her drawing.

BECAUSE IT'S THERE

Seaside towns are wonderful places to draw. 'Dinard in northern France has every subject the artist could wish for', says Caroline Johnson. 'Seascapes, crowds, gardens, striped changing tents and fine architecture.' Her sketch of a crêpe and waffle stand, painted as she sat at a promenade café, picks up on the cheerful character of the architecture.

ACCENTUATE THE POSITIVE

This shopping centre was looking tired and past its best, with some closed shops and very few shoppers. Drawing such a scene, however, can often highlight any architectural charms, and let you see the scene in a more sympathetic light.

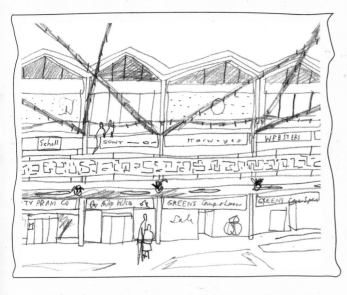

Opposite: Inma Serrano. Street and café in Seville, Spain.
This page
Top: Caroline Johnson. Promenade, Dinard, France.
Bottom: James Hobbs. Shopping centre in Coventry, UK.

HOW TO MAKE DEPTH WORK

Architecture has an extraordinary facility for guiding the eye around a drawing and creating a sense of depth, depending upon the viewpoint you have taken. Perspective can seem like an intimidating concept, as it seems to bring with it a mathematical syllabus that must be learnt and practised. However, in reality, you don't have to follow these principles, and drawings can be all the better for breaking them.

① FIND THE BEST VIEWPOINT

Think carefully about exactly where you are going to stand before you start work: a few steps one way or another can add a new perspective to your drawing. Junctions in particular can offer a variety of avenues and receding views that can add interest. By taking a viewpoint opposite a junction on a hill, this drawing presents two views: one along the flat to the left, and the other up a hill to the right (fig. 1a). This creates two different perspectival challenges, but also two visual journeys for the viewer to consider.

A few steps in any direction can radically change the view. Here the same scene is shown from viewpoints just a few yards away in different directions (fig. 1b).

② VANISHING POINTS

Where are the vanishing points in your scene? Railway stations such as the one shown in fig. 2a – a huge structure with descending and disappearing lines from the metalwork of the roof – can make excellent subjects for experimenting with depth if you take an interesting position to draw from.

The main arch of the roof, if it was infinitely long, would disappear somewhere midway down the right side of the drawing (fig. 2b). Look for points like these, but without tightening up and slowing down your marks – perspectival perfection can sometimes come at the expense of more energising qualities.

③ BE CREATIVE WITH PERSPECTIVE

Be prepared to break the boundaries of convention to create a specific focus in a drawing. Although this drawing of a 1950s inner city high-rise is not a faithful depiction of how it looks – its sides rise vertically as you may reasonably expect (fig. 3c) – the artist Dave Black has, in part at least, remained true to the spirit of perspective (fig. 3a).

The distinctive, curved concrete canopy has been brought closer by the tower being drawn tapering out towards its summit, and yet we still know we are looking up (fig. 3b).

Perspective ideas

Include more details in the foreground, and fewer farther back to enhance the sense of depth.

Look for the basic structural lines of a building when you are preparing to draw, and study its receding lines. Don't overcomplicate.

Experiment with a variety of thickness of mark on the same drawing to bring some things forward, and make others recede.

Opposite
Top: James Hobbs. Street scene, Owengate, Durham, UK.
Centre: James Hobbs. Paddington station, London, UK.
Bottom: Dave Black. Great Arthur House, London, UK.

1

a.

b.

2

a.

b.

3

a.

b.

c.

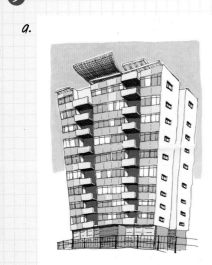

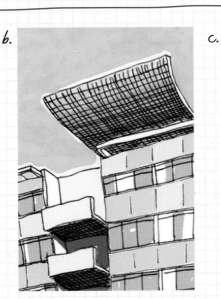

THE ARCHITECTURAL PORTRAIT

Tackling an unknown building is all very well – nobody is going to know if it is a true likeness and it will be judged purely on the quality of the drawing. But if you draw a recognisable landmark, even if you bring to it your own handwriting and personal approach, you are essentially making a portrait and it will be judged as such.

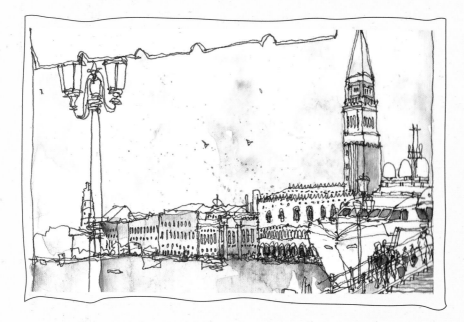

ATTENTION TO DETAIL
In Venice, maybe more than any other place, it is important to tread carefully as its past acts as a magnet for artists working to a formula. Architect Simone Ridyard's drawing is lifted by the touches of watercolour. 'I was sitting at a café and the umbrella awning was visible at the top of the sketch. It is this attention to detail that I find so thrilling about urban sketching: the "reportage" involved in capturing everything we can see.'

CAPTURE THE CHARACTER
Some structures are about so much more than architecture that they come to represent a country, a continent, an attitude to life even – and that can be a daunting prospect. An unusual composition can help you to forget a structure's iconic status – what you leave out is as important as what you include. By showing only a partial view of the Eiffel Tower and setting it in a typically Parisian tree-lined street adds a context without distracting from the character of the tower.

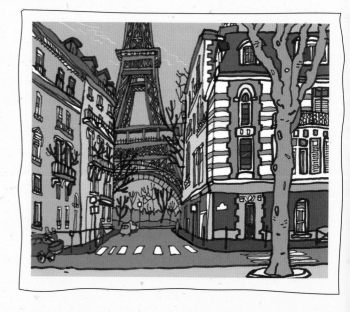

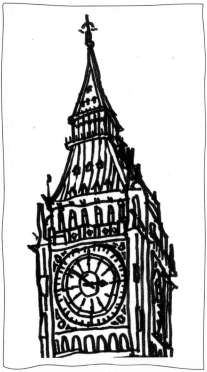

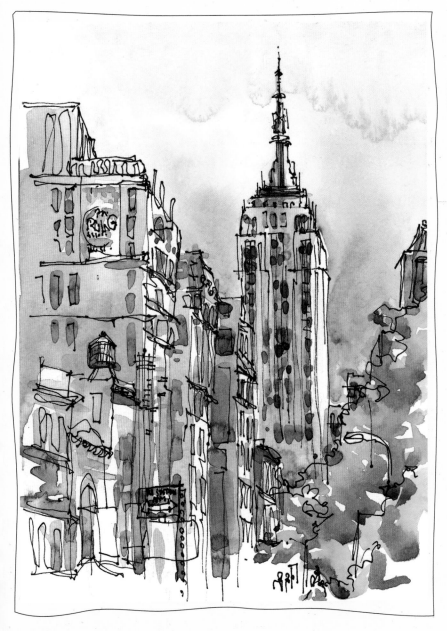

SEEING AFRESH

The outline of the Houses of Parliament in London has one of the most distinctive architectural profiles. But the better we know a building, the more disciplined we need to be to represent it faithfully. Elizabeth Tower, better known as Big Ben, proves this point: as you draw, you have to forget the familiar image that clamours in your head and trust in what you see before you.

THE BEST VANTAGE POINT

Travel light, work standing up and be prepared to work from traffic islands to get the best vantage point, suggests Suhita Shirodkar, who works with her watercolour set in one hand. To sketch tall buildings in congested cities you need to get some distance away from them.

Opposite

Top: Simone Ridyard. Towards San Giorgio, Venice, Italy.

Bottom: James Hobbs. Eiffel Tower, Paris, France.

This page

Left: Suhita Shirodkar. Empire State Building, New York, USA.

Right: James Hobbs. Big Ben, London, UK.

ROOFTOPS

In the middle of a congested city it is all too easy to keep your artistic attention at ground level as you are drawn in by the bustle of activity on the street. But stopping to look towards the skies offers rich pickings for the sketchbook artist, the upper levels and rooftops of buildings often taking on a much more interesting appearance than the commercial activity beneath would at first suggest. And just as the view from below can be inspirational, so can the view from above looking down.

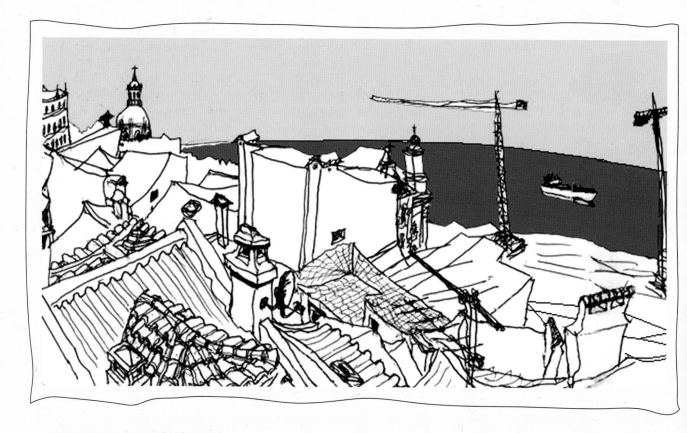

CREATING CONTRASTS

An advantage of a high viewpoint is the opportunity to look across a scene to something beyond. The this drawing by Maria Lopes, the contrast lies between the tangled confusion of a variety of rooftops and construction cranes in the foreground and the calm flatness of the sea.

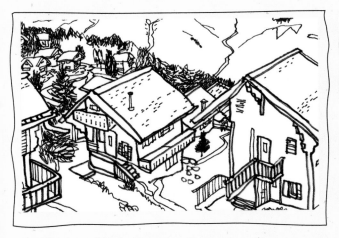

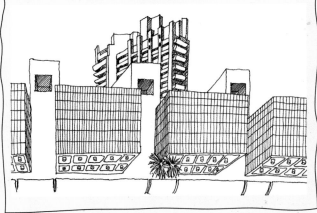

LEADING THE EYE

This view of rooftops in mountainous Switzerland leads the eye down and then away towards the top of the page and the distant foothills, with snatches of footpaths visible between the buildings. The terraced layout of the village presents an interesting challenge in terms of perspective: the main vanishing point is towards the top right-hand side of the drawing.

MODERN ROOFLINES

The structure and clean lines of rooftops of modern architecture can be just as enticing to a sketchbook artist as older, more organic developments. Thomas Corrie made this small drawing of a London high-rise cutting through the regimented lines of the foreground as he waited to meet his friends.

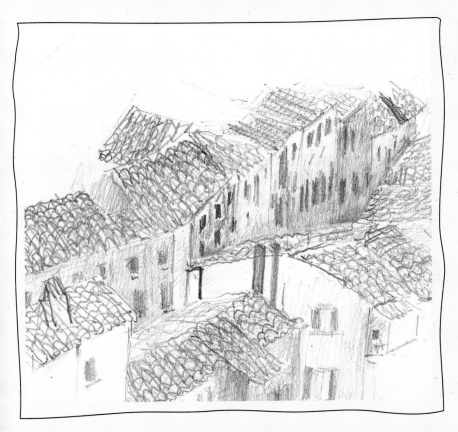

TOWNS INTO MODELS

Seen from above – as with Naomi Strauss's drawing of the streets of the Italian city of Perugia – the architecture of a place can take on the appearance of a model, the streets becoming channels running between the buildings with their distinctive, textured roof tiles.

Opposite: Maria Lopes. Rooftops, Miradouro de Santa Luzia, Lisbon, Portugal.

This page
Top left: James Hobbs. Bettmeralp rooftops, Switzerland.

Top right: Thomas Corrie. Barbican and Cromwell Tower, London, UK.

Left: Naomi Strauss. Rooftops, Perugia, Italy.

BUILDING SITES

One of the invigorating things about living in a city is seeing it changing and growing as buildings come and go. Construction sites are centres of activity and energy and offer a fleeting chance to document a vital moment in a city's history and development.

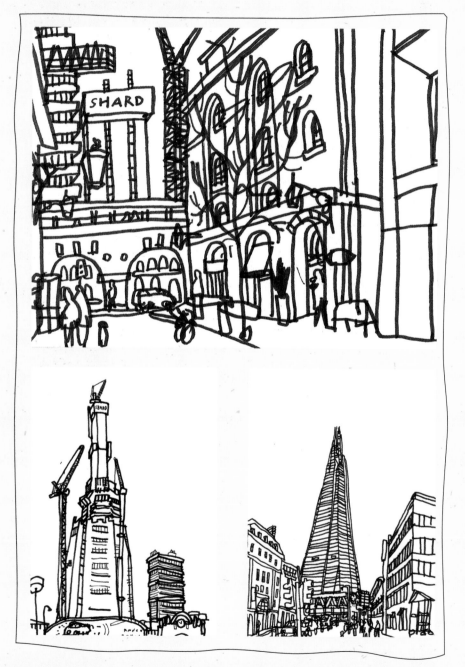

RECORDING THE RISE

The Shard, now London's tallest building, is a new addition to the city's relatively short list of skyscrapers. This series shows its rise from a small stump only visible from the streets that are immediately around it, to an incomplete tower surrounded by construction cranes still in action, to the finished 87-floor Shard. The early stages are the easiest to miss out on; if you want to chart the rise of a building, make sure you keep up to date with the local news and any planning applications.

Left: James Hobbs. Shard construction series, London, UK.

Opposite

Top: James Hobbs. Potsdamer Platz, Berlin, Germany.

Bottom: James Hobbs. Dalston building site, London, UK.

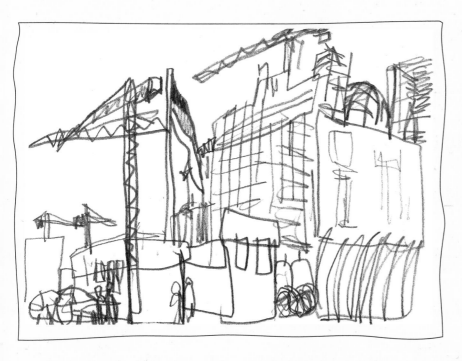

BERLIN

The reunification of Germany brought about vast redevelopment in Berlin in the 1990s, with some neighbourhoods seeming to be almost entirely at the mercy of the construction workers. The drawing on the left was completed quickly from the top of an open top tour bus. The speed at which the pencil drawing was completed reflects the energy and rapid change of the city at that time.

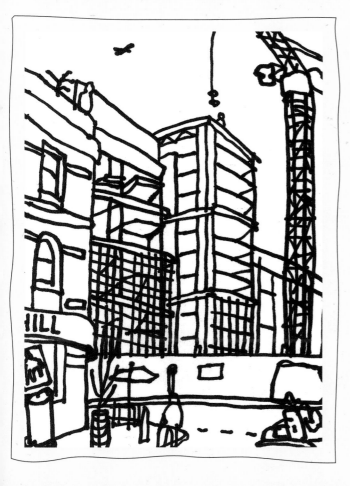

SKELETAL BUILDINGS

A half-finished high-rise building, laid out like a skeleton, can present some challenges in perspective that can actually be enlightening by allowing you to see through the building to its receding lines on the other side. Making drawings like the one on the left of a high-rise being built in east London, can help inform a better understanding of later drawings of finished buildings. The simplified structure of a half-finished building laid bare can make an enjoyable play of lines and rhythms.

PROFILE: MIGUEL HERRANZ

Barcelona's architecture is a regular backdrop to the work of freelance illustrator Miguel Herranz. 'I love drawing buildings, but I see them as the environment where human life goes on. I love those places where there is maybe not so much architectural interest, but of which you can make a very good drawing.'

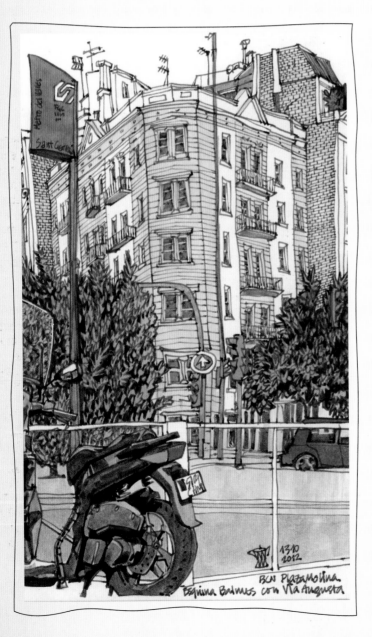

Miguel's interest in drawing in sketchbooks is fuelled by the time he spends working digitally on a computer, mainly making storyboards for commercials. 'Missing the feeling of the paper encourages me to go out and draw', he says.

He uses two sizes of sketchbook, one A6, for portraits and quick sketches – 'it goes everywhere with me, even if I'm just going to buy some bread' – and a larger A5 one for longer, 'quieter' works when he goes out specifically to draw. He always uses line and watercolour, but the materials he employs vary from fountain pens to fibre pens, brush pens and ballpoint pens.

Miguel has always been an enthusiastic advocate of sketchbooks. 'I love the idea of sketchbooks, of fixing a drawing in a timeline, because I also like to write about my experiences, about the drawing itself, and about the things I see around me. Over the past six years, I have been learning and researching my style, but I don't feel I have arrived at that point. I continually change my tools and approaches, and am trying to find my way and every day I'm closer to arriving. Maybe it is better never to arrive.'

'I also like to write about my experiences, about the drawing itself and about the things I see around me.'

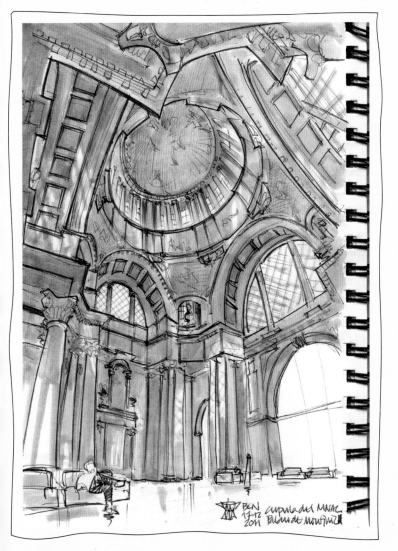

BEAUTY IN THE OVERLOOKED

Opposite: It is not just the great works of architecture that can catch the urban artist's eye, as shown in this drawing of Plaza Molina, Barcelona. 'I like it when somewhere like this, without any obvious appeal, catches me for some reason. One of the great things about urban sketching is extracting this kind of beauty from points in the city where you *must* stop and draw it. Maybe it's the kind of beauty that you only see if you draw', says Miguel.

FINDING A RHYTHM

Top: Miguel was concerned that his drawings were becoming too rushed and wanted them to flow more naturally. He returned to this view from his apartment in Barcelona, for an hour at the same time on three consecutive afternoons to complete the work.

NEW IDEAS AND APPROACHES

Left: This drawing of the Museu Nacional d'Art de Catalunya, Barcelona, started as an experiment in embracing a wide viewpoint; from the floor to the heights of the museum's cupola. The experiment extended to Miguel's drawing position; he lay on a sofa to ensure he could capture the extremes of perspective.

PROFILE: MATTHEW CENCICH

Matthew Cencich has a career in architectural technology, but about twelve years ago, while on a visit to Rome, he went into an art materials shop to buy a sketchbook and some pencils. 'I started drawing the Roman Forum; the first sketch turned out great, and I've been sketching ever since', he says.

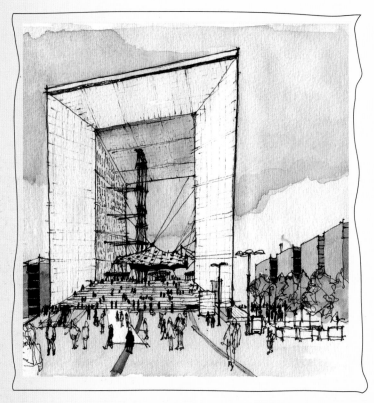

In keeping with his occupation, Matthew often focuses on drawing architecture, and through his travels in South America and Europe he has developed an interest in urban design. 'I carry a sketchbook with me when I'm out and about, but I have to be interested in something to draw it. I keep my eyes peeled for a streetscape or building that attracts me, and when I see that, I'll remember it and come back and sketch it. I'm always scanning the horizon and urban streetscapes to try to find something that I want to draw.'

His equipment, stored in a small shaving kit bag, includes five or six pencils ranging from hard to soft, a sharpener, pocket knife, erasers, a portable watercolour kit and fine-point markers. 'I have a bit of a fetish for sketchbooks', he admits. 'I have about fifteen; some of them are half full, and some have just one or two drawings in them. I'm always experimenting.'

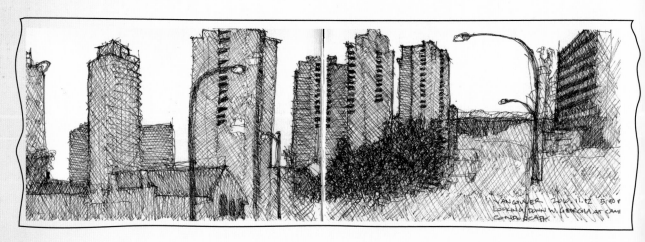

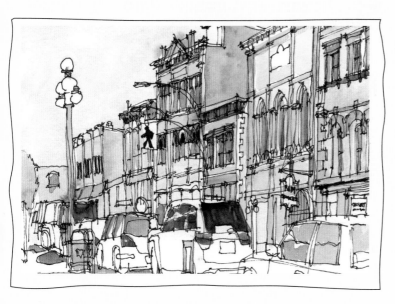

'I'm always scanning the horizon and urban streetscapes to try to find something that I want to draw.'

PURE GEOMETRY AND PEOPLE

Opposite top: Matthew was drawn to the pure geometry of La Grande Arche de la Défense, in Paris. The people in the scene are simply drawn, but create the sense of scale and lead the eye up the steps to the centre of the arch.

HIGH-RISES

Opposite bottom: There is a brooding quality to this drawing of Vancouver. Matthew drew it with crosshatched marks as the sun set. The sky creates powerful negative space that seems to be pushing against the condominiums that rise up into it.

SPRING COLOURS

Above: When Matthew set out to sketch these colourful buildings in Lower Johnson, Victoria, Canada, the sunshine brought out their vivid hues as if they, too, were in flower. 'It was one of those drawings that came quickly and worked well from the beginning to the end', he says.

BOOM BUILDINGS

Right: Matthew's watercolour sketch of the unfinished Bow Building in Calgary captures the atmosphere of the city's oil boom and, through the intense blue of the sky, a hint of the nearby mountain range. The inclusion of the older building creates a contrast with the modern.

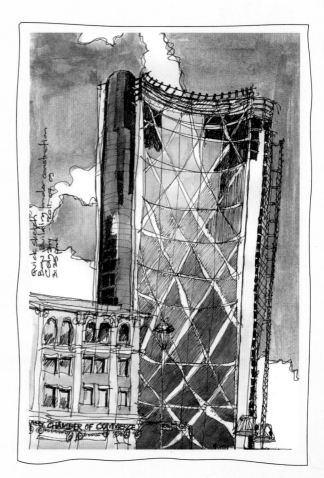

CHAPTER 6
PARKS

An urban park or green space can be, for an artist with a sketchbook, the perfect antidote to life in the city. Nature rarely disappoints. The lines are generally softer than those of a built-up environment and the colours are more relaxing and calming. And nature is always changing with the seasons: some artists set themselves the task of drawing a scene or perhaps just a single tree as it is transformed through the year. It is impossible to imagine architecture being traced by an artist in such a seasonal way.

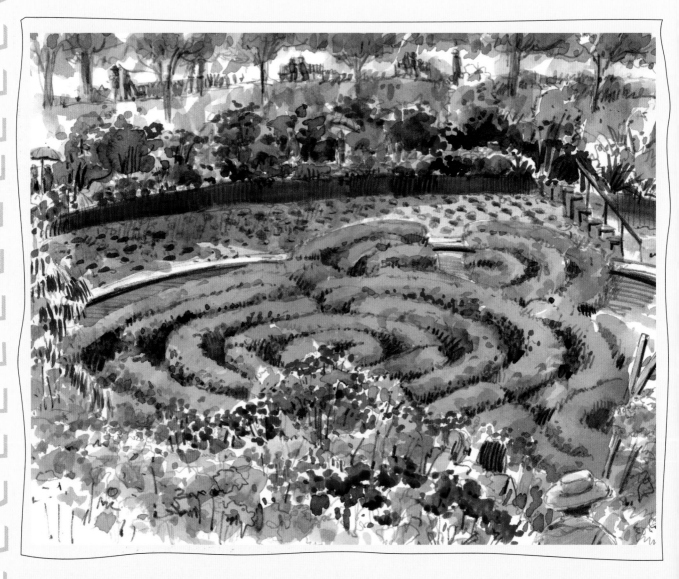

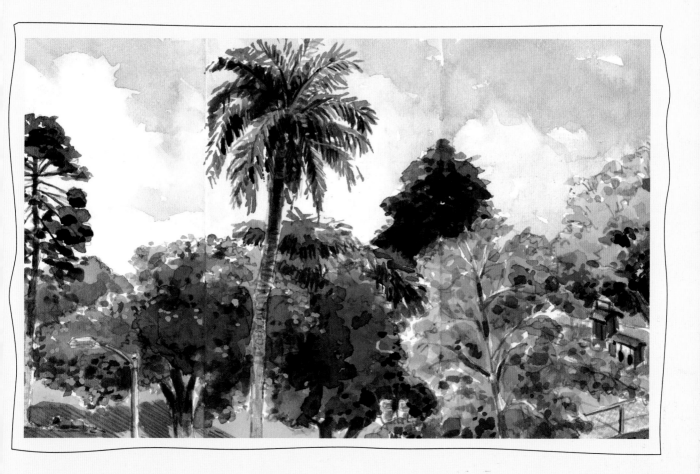

The variety of views these spaces offer is remarkably diverse. There is the hidden square in the depths of a city, with high-rise buildings and police sirens all around; the lush, verdant acres of equatorial parkland teeming with exotic wildlife; and then the precise, nurtured, formal gardens of the historic mansion. The horticultural characters of such spaces around the world can be poles apart, just as the approaches and responses of sketchbook artists can be.

Spending time exploring and observing closely the abundance of textures, colours and forms can help to release a host of mark-making. While the order and rhythms of architecture have their own distinctive pleasures, nature can open up liberating, expressive opportunities: bring the two together and there are endless compositional routes to take that can say much about the places where we live and our attitude to our natural environment.

Drawing trees and plants doesn't have to take you into the world of botanical illustration unless you want it to. But native species go a long way in defining the place where you are working, and to portray a tree in a Swedish forest in the same way as one on the boardwalk of Miami Beach is to miss a trick. If you treat them all the same way, you may as well stay at home and draw from your imagination.

And then, of course, there is colour. Green spaces are so much more than green, as the artists on these pages prove. With colour, as with everything else, nature has a way of surpassing our imagination.

Opposite: Virginia Hein. Garden at the Getty Center, Los Angeles, USA.
Above: Virginia Hein. Central Park, Pasadena, USA.

THE MARKS OF NATURE

Parks offer the sketchbook artist a little space from the bustle of city streets, quiet corners to draw in peace without being hassled by onlookers, wide vistas or formal settings to suit your taste and mood. But it doesn't have to start with colour and it doesn't have to be about botanical exactitude. Nature offers an abundance of rhythms and textures for us to find and express in our own way in the pages of our sketchbooks.

LINES AND CONTOURS

This simple drawing by Alexandre Esgaio has a sensitivity of line that captures the semi-seclusion of a square in Lisbon, the outlined shapes of the trees pushing out the tall, surrounding houses. However noisy the square may be in reality, Alexandre has focused on it as a people-free place of reflection, creating forms with inquiring lines that focus on the intricate fountain, the top of which came a little too soon for the sketchbook's edge.

FOCUS AND CONTRAST

The hot climate of Kelantan, Malaysia, means that palm trees are a familiar sight: a defining, signature tree can go a long way to stamping a sense of place on a drawing. Architect Amer Ismail's drawing of his uncle's house uses the lushness and tangled confusion of the foliage to create a contrast with the background. He admits finding plants hard to draw, 'but when I do, I get stuck into it and really enjoy it', he says.

MOVEMENT AND MEMORY

Carol Hsiung was attracted by the layered composition of this evocative scene at her neighbourhood park, which she would visit regularly with her son when he was small. The ducks in the foreground suggest movement, and the trees in the background frame the receding layers of the composition. 'The scene reminds me of the many hours sitting by the pond with my son, who could spend hours throwing rocks into the water', she says.

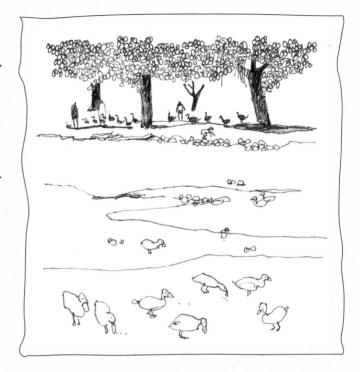

LETTING GO WITH MARKS

Find a varied plot of foliage and your drawing implement of choice, look closely, and make the marks that define that particular tree or plant. Each one may suggest a kind of mark you want to make, but ask yourself, are these marks about that plant and its foliage, or have you resorted to a shorthand filler? It's a question that is as continually relevant for nature as it is for everything else you draw.

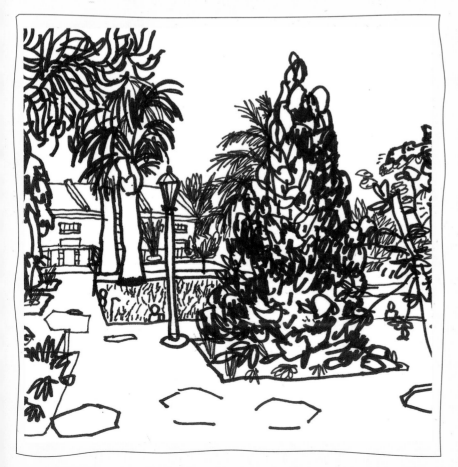

Opposite

Left: Alexandre Esgaio. Largo do Mastro, Lisbon, Portugal.
Right: Amer Ismail. Garden at Kelantan, Malaysia.

This page
Top: Carol Hsiung. Taylor Park, New Jersey, USA.
Left: James Hobbs. Almond Holiday Village, Cyprus.

THE COLOURS OF NATURE

Although there is no reason why you shouldn't work in black and white, nature's colours can have a calming and seductive quality that make reaching for the watercolours or coloured pencils an appealing option. But which green to use? The temptation may be to select the ready-made ones in your palette, but you can also find a remarkable range of greens and earthy hues by mixing other colours.

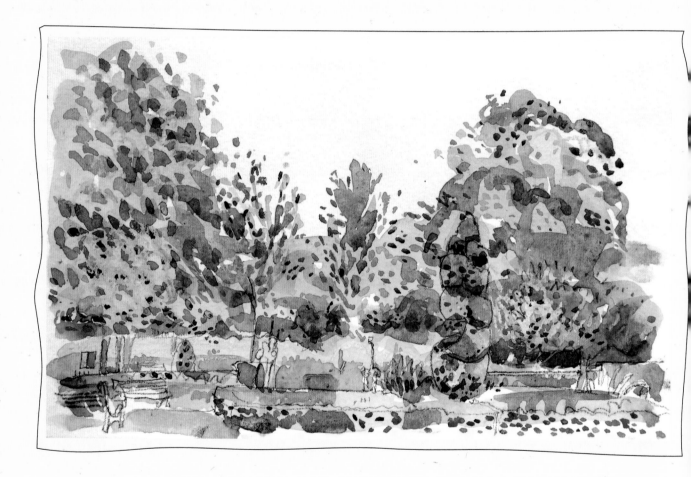

MASS AND WEIGHT OF TREES

In this painting of Worden Park, UK, Caroline Johnson has conveyed the mass and weight of the trees using light and shade, and combined this with the delicate pattern of the leaves. 'I avoid using any colour, including green, straight from the tube, which can be unsubtle and crude', she says. 'I usually add blue or yellow, and a lovely green can be achieved by mixing Prussian blue with yellow ochre.'

CONTRASTING COLOURS

Juliet Docherty spent time sketching in the Mediterranean Garden at Cambridge University Botanic Garden. The drought-loving plants, often silvery-grey in colour, contrast with the deep burgundy colours of other plants.

'The flashes of turquoise are an exaggerated reference to the blue-greens found within plants such as lavender', she says. 'I was particularly struck with how abstracted and pattern-like many of the plants were when sketched from a distance.'

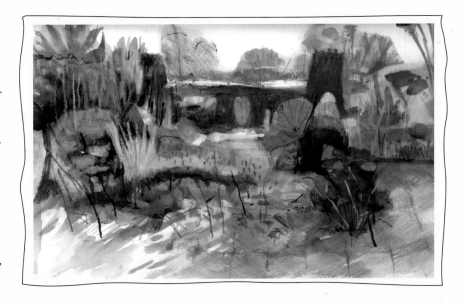

WORKING WITHOUT GREENS

A limited palette can be used to create a variety of greens, even without including green. Virginia Hein wanted to see the variety of warm and cool greens that could be made using just quinacridone gold, ultramarine, Payne's grey and a little burnt sienna in this view of the Japanese Garden at Huntington Botanical Gardens, San Marino, California.

Opposite: Caroline Johnson. Worden Park, Lancashire, UK.

This page

Top: Juliet Docherty. Cambridge University Botanic Garden, UK.

Left: Virginia Hein. Huntington Botanical Gardens, San Marino, USA.

COMPOSITION

Parks and green spaces often flourish in the most uncompromising urban environments. Many have survived as green lungs and as recreational areas inspired by the pressures of the intensely populated neighbourhoods in which they are situated. The balance of nature and civilisation presents a host of compositional opportunities for the sketchbook artist.

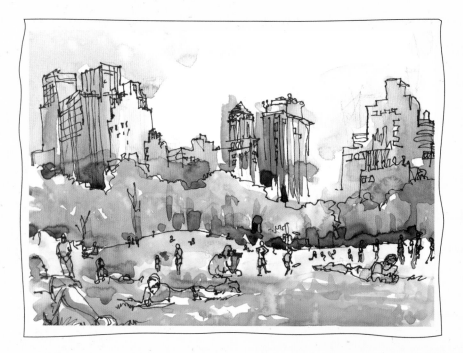

MIXING NATURAL AND URBAN

Central Park in New York, USA, is one of those unmistakable locations where a green space has doggedly held fast despite the constantly encroaching urban development. 'Sheep Meadow is where every New Yorker can quickly access a little bit of the openness and space that is so alien to the city', says Suhita Shirodkar. 'Yet there is never a time when you can't see the tops of the skyscrapers that line the horizon beyond the treetops.'

CREATING PATHWAYS

Trees have an excellent way of inviting visual journeys. This scene of a holiday village on the island of Cyprus uses them to frame pathways that lead around the picture, along to the right past the pool, and up the steps to the left. The buildings showing between the plants and shrubs are distant, and a mental journey between the trees to reach them draws the viewer in. Look for the elements in your composition that can offer this journey.

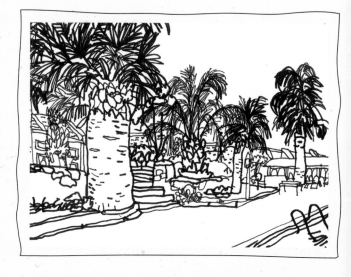

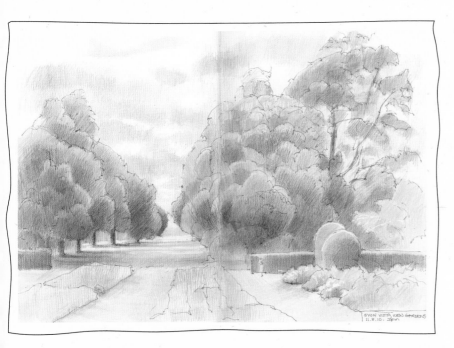

THE RULE OF THIRDS

Katherine Tyrrell used the 'rule of thirds' for this coloured pencil composition of the view from the Palm House at Kew Gardens, London, through an avenue of trees towards the River Thames. This essentially divides the image into thirds horizontally and vertically, with major elements of the view placed on or near to those lines, or where they meet, to create a composition that is both pleasing and balanced.

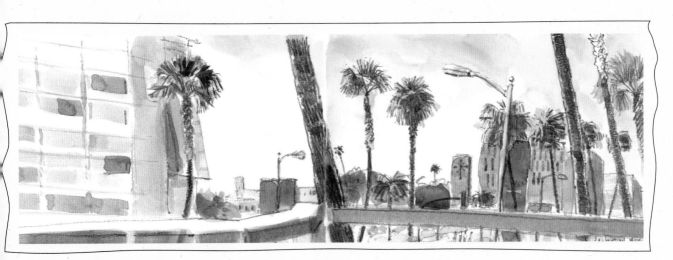

VERTICALS AND HORIZONTALS

When you are opening up your sketchbook, consider the option of working right across both of the pages, especially if it has a landscape format. The strong horizontal lines of this view of Sunset Boulevard, Los Angeles, USA, drawn from the cafeteria of a hospital by Virginia Hein, is interspersed with a succession of vertical elements – trees, lampposts and buildings – some of them cropped at the top. The balance of greenery and concrete suggests that nature always finds a way through, and captures a particular sense of place.

Opposite

Top: Suhita Shirodkar. Central Park, New York, USA.

Bottom: James Hobbs. Poolside, Cyprus.

This page

Top: Katherine Tyrrell. Kew Gardens, London, UK.

Bottom: Virginia Hein. Sunset Boulevard, Los Angeles, USA.

DRAWING GREEN SPACES

Whether you are using colour or not, the natural elements that find their way into a sketchbook can help to build the mood and character of a drawing and the place it depicts. This is particularly true in the parks and green spaces of the inner-city, where a burst of lively vegetation, balanced with more rigid architectural lines can bring a softness and contrast that can sometimes belie a subject's urban location.

1 WORK IN PROGRESS

These four sketches in fig. 1 and fig. 2 show how I set about recreating a favourite local scene; two churches set next to an inner-city park, a shady, relaxing place to draw. The heart of the financial district is only a few miles away, but the effect is almost rural. Including some figures under the umbrellas helps to add a sense of scale and depth (fig. 2a).

2 SETTING PARAMETERS

There was a tall church tower on the right that hasn't completely made it into this drawing. This would have involved a bigger sketch and including more white space, and is the kind of decision to make before starting. What should you include and what should you leave out? Aim to tell the drawing that, rather than letting the drawing dictate as it progresses (fig. 2).

3 TACKLING FOLIAGE

There can be a lazy temptation when there is a lot of foliage in a scene to treat it all with the same leafy marks. It is not important to know the names of all the trees you are drawing, but if they look different, try to draw them in a distinct way.

To familiarise yourself with different techniques and to broaden your skills in this area, why not take some time to practise sketching different types of foliage in your local park? This will help you to feel more confident about attempting different styles when sketching on location (fig. 3).

Ideas for Drawing Foliage

Be expressive: foliage is a great outlet for experimenting with new marks without having to worry about aiming for a specific likeness.

Try using pens or pencils with different tones to accentuate the element of depth in dense areas of parkland trees and shrubs.

Explore your local park through the changing seasons with a series of drawings or paintings from the same spot.

Opposite
Top: James Hobbs. Clissold Park, Stoke Newington, London, UK.
Bottom: Lis Watkins. Horniman Gardens, London, UK.

1

2

a.

b.

c.

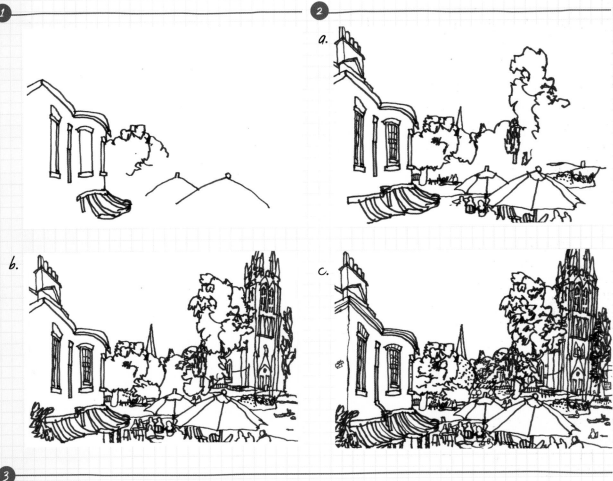

3

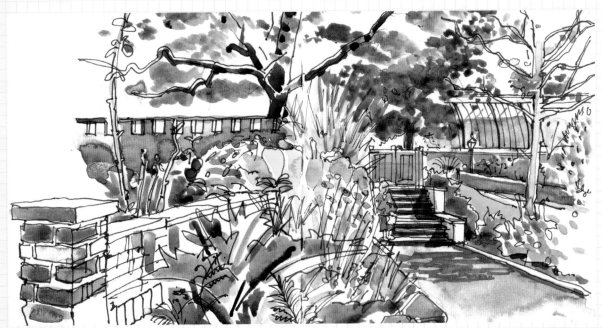

PROFILE: KATHERINE TYRRELL

Katherine Tyrrell started to sketch when she was on holiday more than twenty years ago, but it was while working for the British government, which took her travelling across the UK, that she started to take a sketchbook wherever she went. 'Keeping up with life drawing classes became difficult, but sketching can be done anywhere, and I found it a complete contrast to long, intensive days of interviewing and information gathering', she says. It was an enjoyable way to spend time when she was dining alone in the evenings: 'I'm rarely able to sit down for a cup of tea without whipping out my sketchbook, pen and beloved coloured pencils', she says.

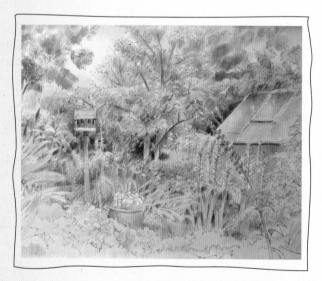 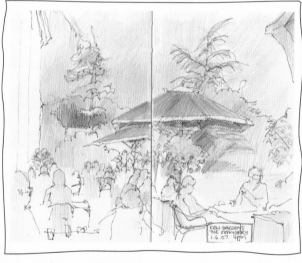

When she retired, she launched her *Travels with a Sketchbook* blog to record two US road trips and subsequent journeys, and to offer advice to sketchers. It is also evidence of her passion for plants, trees and landscape gardens around the world.

Katherine loves the morphology of plants and exhibits her interior landscapes of them regularly with the Society of Botanical Artists. However, in her travel sketching, she prefers to tackle big views and simpler shapes rather than individual plants and flowers, and often seeks out vegetation and trees with interesting shapes and colours.

She works in a Moleskine sketchbook, usually A5 or A4, but sometimes A3, and finds its robust surface works well with pen and ink, and coloured pencils. She starts her works with a pen-and-ink drawing, then adds loosely hatched colour with sharp, coloured pencils, mixing the colours by laying them next to each other on the paper so they give the effect of vibrating. She uses a battery-powered eraser to lift out colour and create highlights or further optical mixes.

'Keeping up with life drawing classes became difficult, but sketching can be done anywhere.'

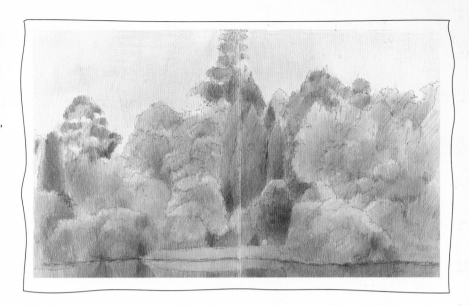

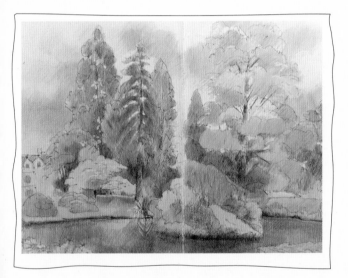

QUICK SKETCHES

Opposite right: In challenging herself to see how much she can get done in a short break Katherine has drawn many sketches while having afternoon tea, such as this one from Kew Gardens Orangery, London, UK. 'Some work and some don't, but that's fine as I regard this type of sketching as like practising piano scales. The more you do, the better you get, and the faster you can sketch, the more you will be able to do in the future.' This is excellent preparation for when you are out and about with your sketchbook.

SUBTLE AUTUMN SHADES

This page: Not all trees are the same shape, not all greens are the same green, and not all autumn colours are the same. In these sketches from Sheffield Park (top) Wakehurst Place (left), Sussex, UK, Katherine focused on picking out the different shapes and growth patterns of trees and shrubs within a large mass of vegetation, and the contrasts and subtlety of the autumn colours. After drawing the shapes and growth patterns in pen and ink, she used coloured pencils to mix and produce the subtle shades within the yellows, oranges, reds, crimsons and purples, as well as the many different greens.

VIEWS OF A GARDEN

Opposite left: This sketch is one of a series that Katherine made at different times of the year while sitting in an armchair next to the windows at her mother's home in Cheshire, UK. 'The great benefit of a static location that you visit a lot is that you can "do a Monet" by sketching forms and colours for a short time at the same time each day in the same light – and in different seasons', she says.

CHAPTER 7
PEOPLE

People bring life to a drawing in a way nothing else can. They add narrative, humour and energy to a composition. By including the human figure, urban scenes can change from some nightmarish vision of the world after an apocalypse to one that explores the rich culture and environment of a community going about its daily activities.

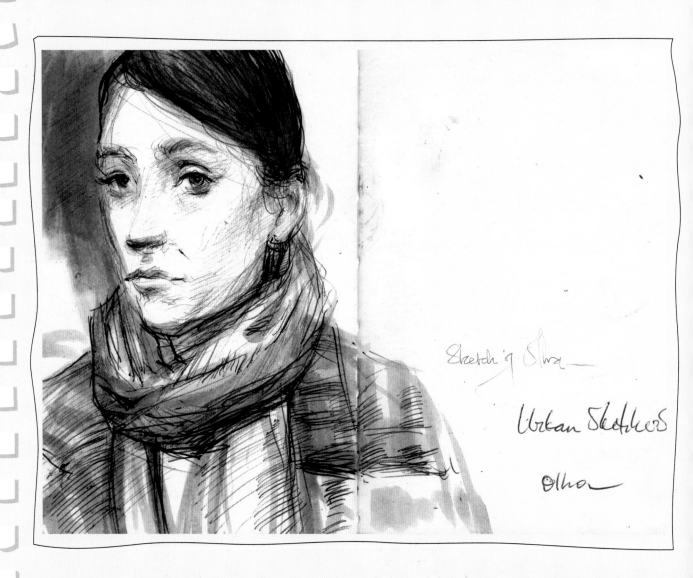

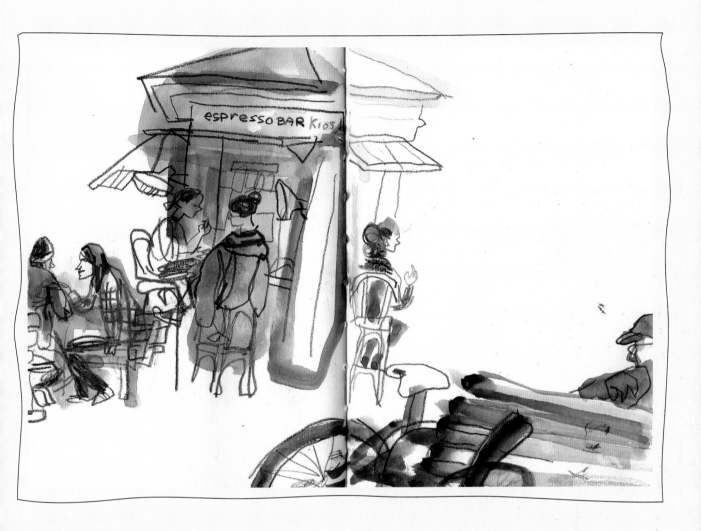

The urban artist has the opportunity to draw a rapidly changing and diverse range of models. By keeping a small sketchbook and something to draw with in your pocket or bag, you can make the most of this supply of sitters, in waiting rooms, in cafés or on trains. The more you draw people, the better you will get at it.

What's the main difficulty to deal with when drawing people? The biggest fears for the sketchbook artist to overcome are self-consciousness and the scrutiny of onlookers. These are things that every artist in these pages has had to get past, and some seasoned sketchers still find it difficult. But this is a hurdle that can be eased or overcome through experience, by finding settings to draw where you feel comfortable and by knowing how to deal with unwanted attention. The time may come when someone approaching you can actually be an enjoyable chance to talk to a person who is interested in your work.

Whatever you are interested in drawing, human figures often make an appearance, and for that reason it is a subject worth tackling rather than editing them out from your composition. They may just make it on to the peripheries of your drawings of architecture to give a sense of scale, they may be part of a crowded blur passing through the main focus of your work, or they may be the full-on close-up portrait of a sleeping train passenger. Whichever it is, it is worth letting people in to your sketchbook.

Opposite: Adebanji Alade. Portrait of a sketcher.
Above: Marina Grechanik. Rothschild Boulevard, Tel Aviv, Israel.

FINDING SUBJECTS

There is no shortage of people to draw. In the summer, go to parks and beaches, and in the winter, head to cafés, bars and restaurants. People do move or walk away, or come over to see what you are doing, but these are just a few aspects of what, in time, makes drawing them so enjoyable. You are drawing life, and taking people-watching to a new level.

CAST OF CHARACTERS
Public transport offers a constantly changing cast of characters. Rolf Schröter was drawing people on an underground train; he had finished the man on the left by the time he got off the train to be replaced by a woman. Drawing in this environment encourages fast work and makes you focus on the essentials of a figure.

BARBERS AND HAIR SALONS
Hair salons are good places to draw for many reasons: the cutters will not leave suddenly, and their moves are repetitive, so that if you miss a posture it is likely to be repeated again. Marina Grechanik's drawing captures the stooped intensity of the cutters' postures.

RETINAL IMAGES

Joan Mas's watercolour silhouettes are drawn from the imagination, but spring from a background of close observation and an understanding of posture and movement. Being able to capture such poses quickly becomes possible with practice and a keen eye, supplemented here with humour and a surrealist streak.

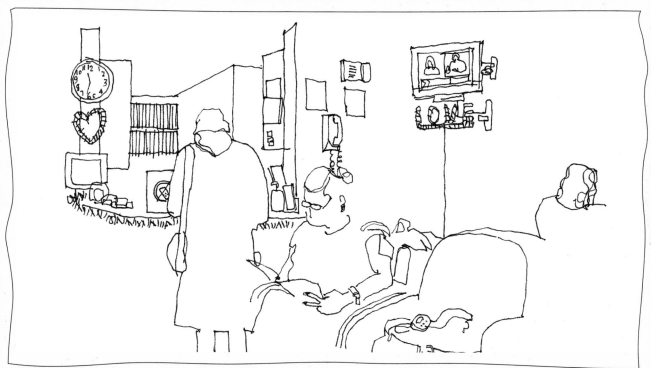

WAITING ROOMS

The simple, apparently continuous, ink line of this drawing by Carol Hsiung shows her fellow patients waiting at the allergist during one of her regular visits. 'I am required to wait twenty minutes after my shot, so instead of reading magazines, I draw. I find sketching is a great way to kill time', she says. The hard edges of the office environment are softened by the Valentine's Day decorations.

Opposite

Top: Rolf Schröter. Berlin underground train, Germany.

Bottom: Marina Grechanik. Hair salon.

This page

Top: Joan Mas. Silhouettes.

Bottom: Carol Hsiung. Waiting room.

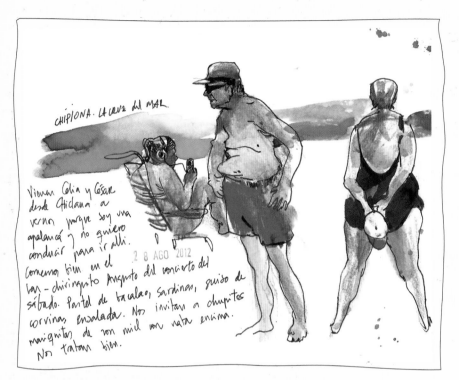

BEACHES

You don't need to go to a life drawing class or hire a model if you are interested in drawing the human body. It is likely to be a succession of short poses with at least partly dressed models, but the aims are the same: the posture, balance and weight of these beachgoers by Inma Serrano are believable and real, and suggest a narrative that is usually absent in drawings from a life studio.

AT THE TOWN HALL

Caroline Johnson's wait in line at her local municipal office started to stretch out, and although she had forgotten her sketchbook and favourite fountain pen, she had a black Biro and a leaflet with a blank reverse to make this drawing. 'Sometimes a sketch works out better when it is on a piece of scrap paper. There's none of the fear of "spoiling the sketchbook" by drawing it wrong', she says.

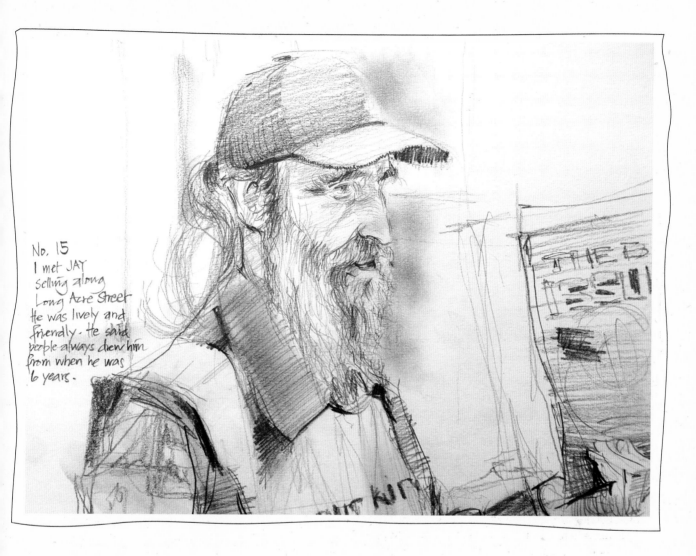

No. 15
I met JAY
selling along
Long Acre Street
He was lively and
friendly. He said
people always drew him
from when he was
6 years.

STREET PEOPLE

You can find willing models on the streets. Adebanji Alade looks for sellers
of the *Big Issue* (a magazine sold by homeless people in the UK and other
countries), drawing them in graphite or oil-based pencils. He buys a copy
or two of the magazine, and pays them a bit more if the drawing works out
well. 'They don't pose, I just tell them that they should stand in their usual
way when they're selling. It's the passion I have for people and faces that
keeps me in the hunt for them in ordinary settings.'

Opposite
Top: Inma Serrano. Beachgoers, Chipiona beach, Cadiz, Spain.
Bottom: Caroline Johnson. Waiting in line, Leyland Council Offices, Lancashire, UK.
This page
Top: Adebanji Alade. *Big Issue* seller, Long Acre, London, UK.

PEOPLE IN CAFÉS

Cafés and restaurants are good places to draw because they generally offer a relaxed atmosphere where you can spend time with a good supply of food, drink and willing friends for subjects. Sketchbooks merge well with crockery and cutlery to aid your undercover status if you are drawing the unwitting people sitting around you, and a table provides a barrier and an area of defined personal space to deter people who may approach.

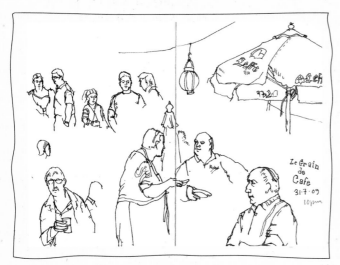

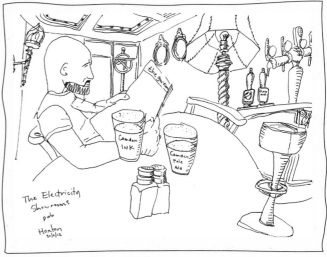

LOOSEN UP IN A RELAXED ATMOSPHERE

Caroline Johnson took to a corner of a local bar with her A5 sketchbook and fountain pen to draw the evening as it unfolded to the sounds of folk tunes. Noise, low lighting, and flowing wine can relax your subjects and make drawing an easier task. 'I thought I was doing this discreetly', she says, 'but by the end of the evening I'd attracted a crowd who took great pleasure in recognising friends and family in my pictures'.

This page
Left: Caroline Johnson. Bar opening, France.
Right: Dave Black. Bar scene, Hoxton, London, UK.
Opposite
Top: James Hobbs. Café, Tottenham Court Road, London, UK.
Bottom: Marina Grechanik. Coffee shop in Tel Aviv, Israel.

FIND A VIEWPOINT

Dave Black admits the position he takes is usually the one in which he feels most comfortable, even if it involves an element of hiding, rather than the one that gives him the best view of what he wants to draw. Often these decisions are dictated by which seats are free: sitting where you can and making the best of it can sometimes produce the best results. But be ready to shift to a recently vacated table if it suits your needs better. In the drawing above, Dave focused on the area immediately around him, ignoring the other tables and people in the bar.

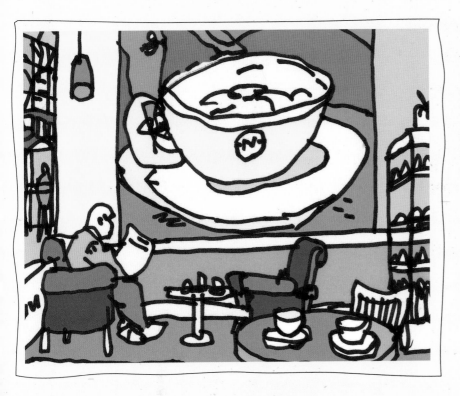

PUTTING PEOPLE IN A PLACE

While your focus may be on the facial characteristics or postures of people around you in a café, the inclusion of the colour and details of your environment adds a new dimension to the mix. The context of this figure reading a newspaper in an armchair is created by including the furniture, the coffee cup design on the wall and a glimpse of the view out of the window. We can recognise this sort of café, and can imagine ourselves being in it.

CAPTURE MOOD

As soon as you draw two or more people together, they have some kind of relationship, and this suggests a narrative. However the attitude and demeanour of a single character can conjure a mood in a drawing, whether it is tiredness from traipsing the streets, or absorption in a mobile phone or laptop, as in the painting on the right by Marina Grechanik of a Tel Aviv coffee shop.

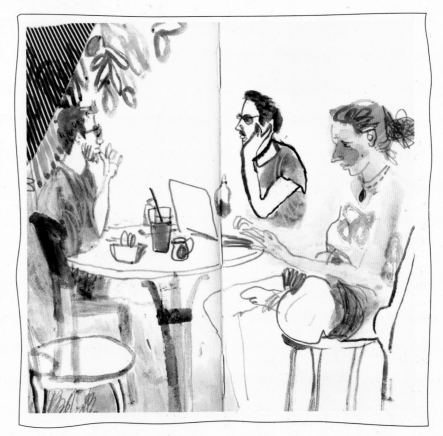

PEOPLE AND SCALE

Including people in your drawings in even the smallest way gives the landscape an immediate sense of scale and a humanising perspective, their movement and energy having an animating effect. These figures don't have to be in much detail – they will probably be some distance from your viewpoint, and more than likely on the move – but they enliven the image.

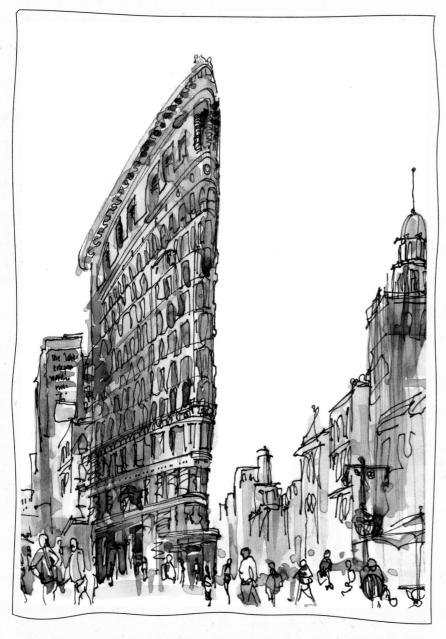

BRINGING SCENES ALIVE

'While I often draw buildings and structures', Suhita Shirodkar says, 'it is the presence of people on the scene that brings them alive for me. They are integral to the scene, just like the doors and windows on a building are integral to it.' The angles of the distinctive Flatiron Building in New York ensure that it has an exaggerated monumentality whenever it is viewed from road level; this effect is enhanced by the quickly drawn but effective figures in the foreground. The people you include to provide a sense of scale may seem small in relation to the whole drawing, and on the move, so you have to work fast, but don't lapse into shorthand when you draw them. Try to get the scale and placement right, and say something about the kind of people they are: people in a financial district might be very different to those visiting a zoo, for example.

Left: Suhita Shirodkar. Flatiron Building, New York, USA.

Opposite

Top: Inma Serrano. Cadiz Cathedral, Cadiz, Spain.

Bottom: James Hobbs. British Museum, London, UK.

OUTDOOR CULTURE

The atmosphere of sunny southern Spain permeates this watercolour, fountain pen and watercolour pencil sketch of Cadiz Cathedral by Inma Serrano. Just by their presence, the handful of figures she has included on its steps suggest the hugeness of the baroque building. This scale is further accentuated by the way the tower veers off the top of the page.

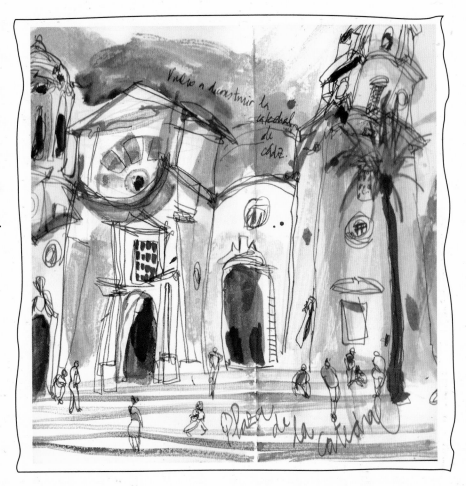

LINKS AND THEMES

The British Museum in London attracts nearly six million visitors a year, so it is a good place to draw crowds. In this scene, its visitors are drawn with little more detail than the shape of their heads, shoulders, and legs, which is enough to suggest their posture and movement. They also link, via the strong vertical lines of the columns, to the figures in the frieze above. Keep an eye open for such links and themes in a scene.

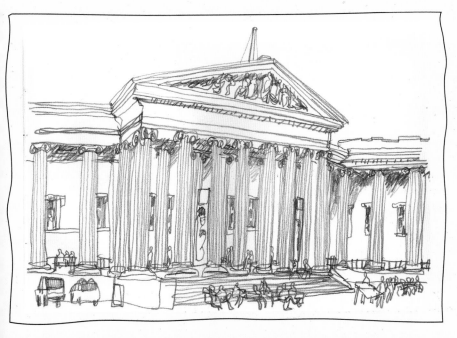

115

PEOPLE AND MOVEMENT

The advantage of drawing people who are out and about may be that they are plentiful and you don't have to pay for a model, but the downside is that they are on the move and doing unexpected things. But these problems, if embraced, can be to the advantage of a drawing. Showing people as a swirling mass can ignite a scene. You won't be drawing portraits – there won't be enough time for that – but you will be defining the character and energy of a place through the movement of the people who inhabit it. That is the power of people.

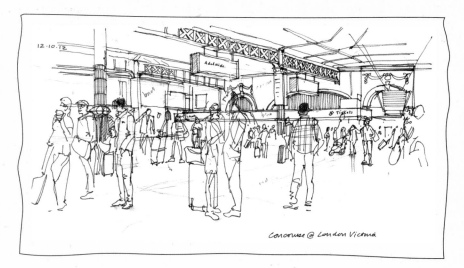

Concourse @ London Victoria

BUSY CONCOURSES

If you are worried about drawing people when you go out, then an hour or two with a sketchbook at a train station will help get you accustomed to it. Everyone is in too much of a rush to realise what you are doing, and you can easily blend into the background. Lis Watkins's drawing of London's Victoria station shows the solid architectural detail at the top and the ebb and flow of travellers in the lower part.

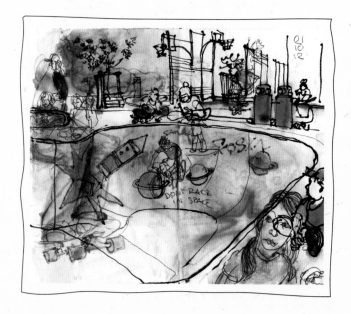

COMPRESSING TIME

Drawing at a skate park is always going to involve working quickly and building an image from the changing participants. 'This sketch is a selective compression of about forty-five minutes', Rolf Schröter says. 'After sketching the pool, I tried to capture folk with a Biro and highlighter pens as another transparent layer above.' The light calligraphy paper absorbs the colour to heighten the sense of movement and energy.

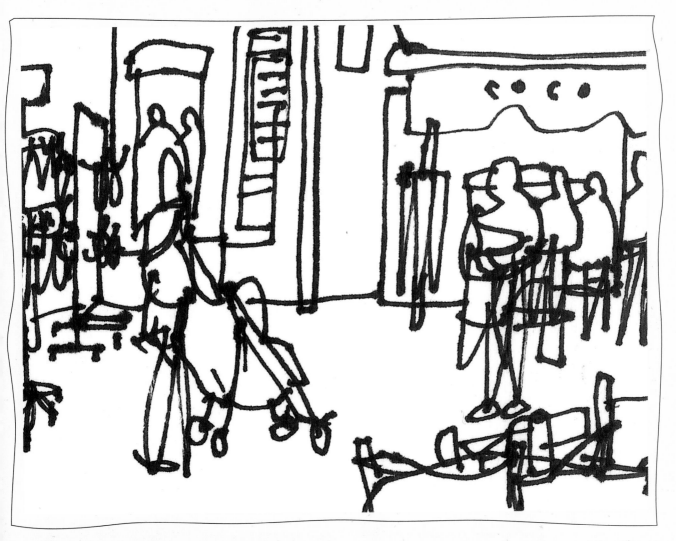

SHOPPING STREETS

People on the move are the decisive factor in depicting a shopping street during opening hours. Rather than focusing too closely on individual characteristics, here each person is treated in a similar way to create an overall feeling of movement and busyness. Blurring and overlapping are inevitable, and can enhance the sense of movement.

Opposite

Top: Lis Watkins. Victoria station, London, UK.

Bottom: Rolf Schröter. Skate park, Gleisdreieck, Germany.

This page

Top: James Hobbs. Ciutadella, Menorca, Spain.

SKETCHING PEOPLE ON THE GO

Drawing people is one of the most challenging and yet fulfilling opportunities for an artist on the move. While a life model in a studio may offer a professional stillness, and self-portraiture is an ever-ready subject, there are numerous places to find models at large in the world. Capturing the position of the figure, its attitude, and the fall of its weight in a believable and proportioned way comes with close observation and regular practice.

1 MAKE YOUR MARK

Because speed is important, it is vital to be selective in the marks you make. Look for the most important lines that make up the shape of the head and face: it is the character of the subject that you are aiming to capture, rather than a perfect likeness (fig. 1).

2 WORKING BLIND

The drawings in fig. 2 of people by a lake were completed in the middle distance with an emphasis on pose and posture rather than facial characteristics. When sketching people on the move, it is best to draw quickly without looking at the paper.

3 TELL STORIES

Start by drawing the surroundings of a view, adding people when you see something interesting that will add to the image: good observation skills will help you to memorise subjects in movement (fig. 3a).

Try to get to 'know' the people you are drawing and tell stories about them in order to help you capture their expressions and postures better, as Marina Grechanik has done here (fig. 3b).

Tips for drawing people on the go

If people spot you drawing them, show it to them when you have finished – they are usually flattered. Offer to email them a scan of it if they are interested.

Draw people who are absorbed in reading a book, working on a laptop or text messaging on their mobile phones, as these activities involve less movement.

If you are drawing somebody in a café or train and they change their pose, abandon the drawing for a while and start a new one. People often have a repertoire of positions, and it is likely they will return to it shortly.

Ask permission? It's best not to. If you do, your drawing becomes a portrait, your subject will pose in an unnatural way, and there is the pressure to capture a likeness.

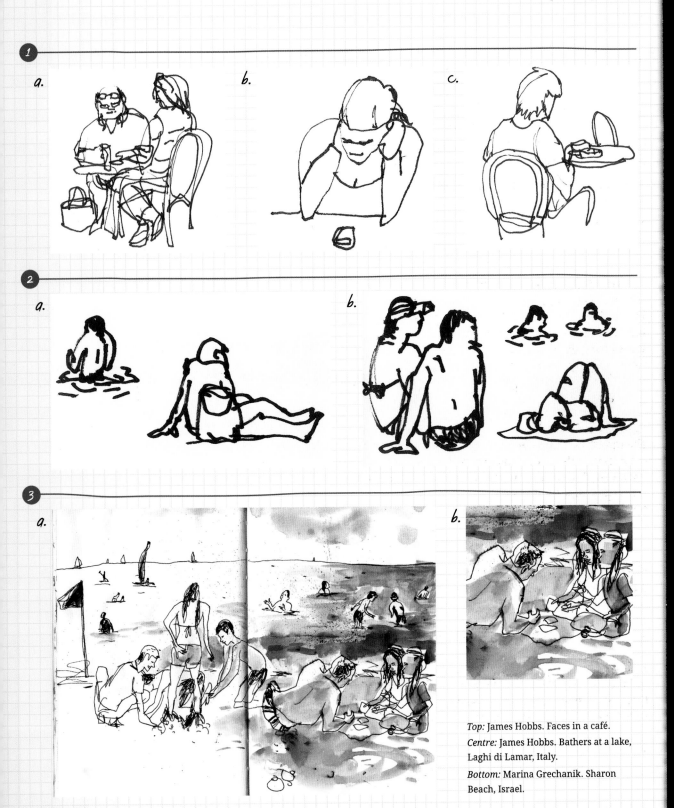

Top: James Hobbs. Faces in a café.

Centre: James Hobbs. Bathers at a lake, Laghi di Lamar, Italy.

Bottom: Marina Grechanik. Sharon Beach, Israel.

119

PROFILE: MARINA GRECHANIK

Marina Grechanik is a freelance graphic designer and illustrator who lives in Ra'anana, Israel. About seven years ago she started carrying a sketchbook around with her with the idea of drawing when she could find time in her busy schedule. 'Now I am addicted to it; I draw nearly every day', she says.

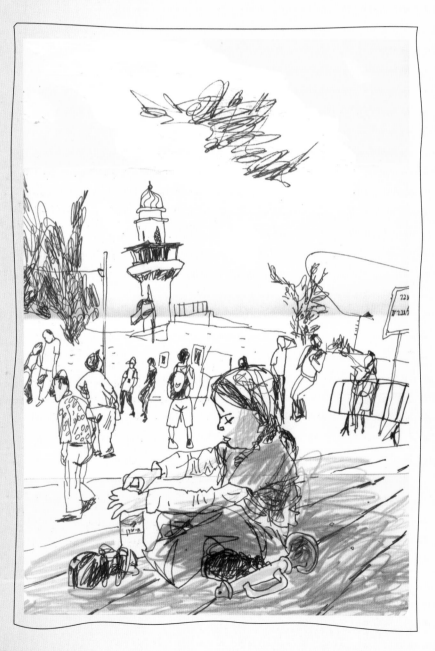

Although people are generally at the centre of her sketches, they are not portraits in the traditional sense of the word. 'I'm more interested in what people are doing, and making up stories about them – it makes my sketches more personal and helps me to draw their expressions and postures better. A likeness doesn't have to be like a photograph. I'm trying to capture the essence of the character as I think it is.'

Her painting equipment consists of a small watercolour box with ten colours, watercolour pencils, graphite pencils, a fountain pen, and black pens, occasionally adding something different, such as oil pastels or gouache. She likes to use colour in an imaginative way to pick out elements of the scene that are important to her: 'Maybe the colour I use isn't realistic; sometimes I make it up. But this allows me to be freer with it.'

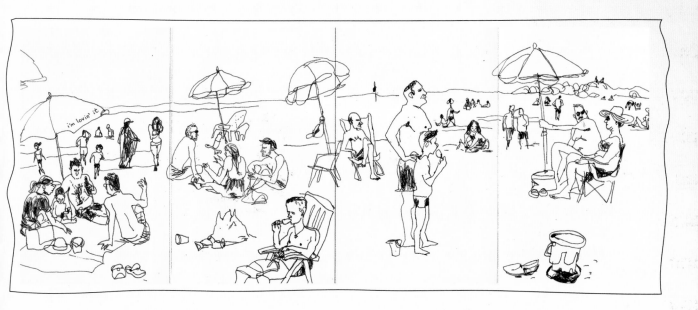

'A likeness doesn't have to be like a photograph. I'm trying to capture the essence of the character as I think it is.'

LOOKING FOR THE STATIC

Opposite: This drawing shows Marina's daughter waiting for the rest of the family in Jerusalem. Only the girl and the buildings in the background were static: everything else was moving very fast, so Marina had to draw quickly using a pen for the main scene and then coloured pencils for the foreground. Static points can be anchors for the movement around them.

PANORAMIC BEACH SCENES

Above: By using the accordion pages of a Japanese Moleskine sketchbook, Marina was able to create a full range of sunbathing characters using a fountain pen and ink, part of which is shown here. The complete drawing was done over several visits to a beach close to her home.

SLEEPING BABIES

Left: There is something very personal about drawing babies with whom you have a close relationship, as the finished work preserves an all too brief moment in time. Drawings such as this one of Marina's twin nieces become more and more precious over the years.

PROFILE: STEVE WILKIN

Steve Wilkin remembers having a conversation with his head of department at the University of Central Lancashire illustration department where he lectures, about how he found it difficult to find time to make his own work. 'He said to me, "You are sitting on the train for two hours every day – you should use that time." So I did. I started to keep a sketchbook and to draw the passengers around me.'

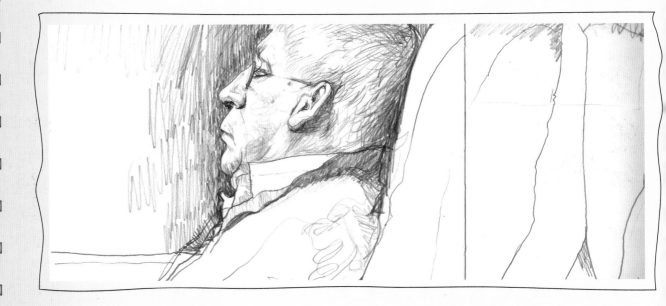

His equipment is minimal – just an A5 sketchbook and a propelling pencil – so he can work quickly and unobtrusively. He starts with the profile if he's drawing somebody across the aisle of the train, or perhaps their posture: 'I may have five minutes to draw them, twenty minutes, or the full journey, but I never know when I may have to finish the drawing if a passenger gets up and leaves'. The ghostly outlines of people who have disembarked occasionally appear in his drawings.

The biggest hurdle to overcome with such drawings is self-consciousness. 'You occasionally get people noticing what you are doing, but I've got much thicker skin now. I'll happily engage somebody in conversation about it. In all the years that I've been doing it, nobody has ever come over and asked me to stop.'

His close observation means his subjects seem very recognisable, but capturing a likeness isn't his main aim. 'I don't want to do portraits. I'm trying to catch the everyday experience of people on the train as naturally as possible. If people notice I'm doing it and then start holding their double chins in, or whatever, it would become a different thing all together. There is suddenly an expectation to create a work that is acceptable to the sitter rather than to me.'

'I don't want to do portraits. I'm trying to catch the everyday experience of people on the train as naturally as possible.'

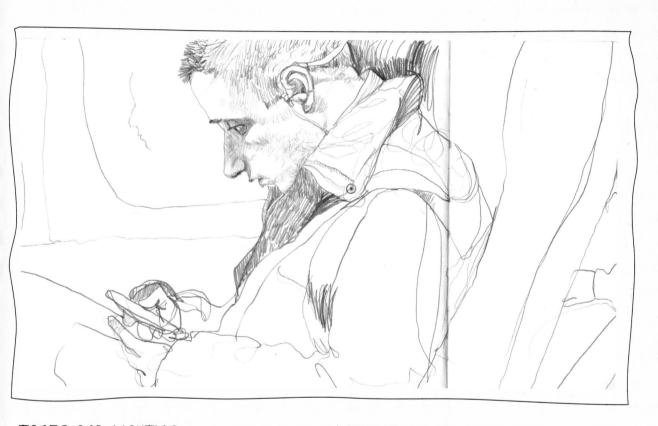

TONES AND LIGHTING

Opposite: This early morning drawing of a sleeping passenger on the 7:38am train from Hebden Bridge shows the winter darkness visible through the window, framing the subject's face. The darker tonal values accentuate his profile and the back of his head where it leans against the seat. 'There's a very particular light on the trains, a kind of strip lighting that throws heavy shadows', Steve says.

KEEPING A LOW PROFILE

Above: Commuters absorbed in activity are usually oblivious to being drawn. 'I sometimes put my earphones in to listen to music, and I find people are less likely to notice that you are drawing them if you have earphones in, as they think you're doing something else. One piece of advice: stick at it. If you feel you're not very good at drawing people, the only way you're going to get better is by doing it. Draw them over and over again.' This drawing includes in the background the ghostly profile of a passenger who disembarked before he could be fully drawn.

CHAPTER 8
TRAVEL JOURNALS

Sketchbooks are made for travelling, not just in our normal daily lives, but, if
we are lucky, on more far-flung journeys overseas. New sights can cry out to
be in a sketchbook, perhaps because we know that if they aren't drawn at that
moment, then the chance may be lost forever. You could make drawings and
paintings later from photographs, but there is nothing like capturing the energy,
life and noise of a place at the very moment you are experiencing it.

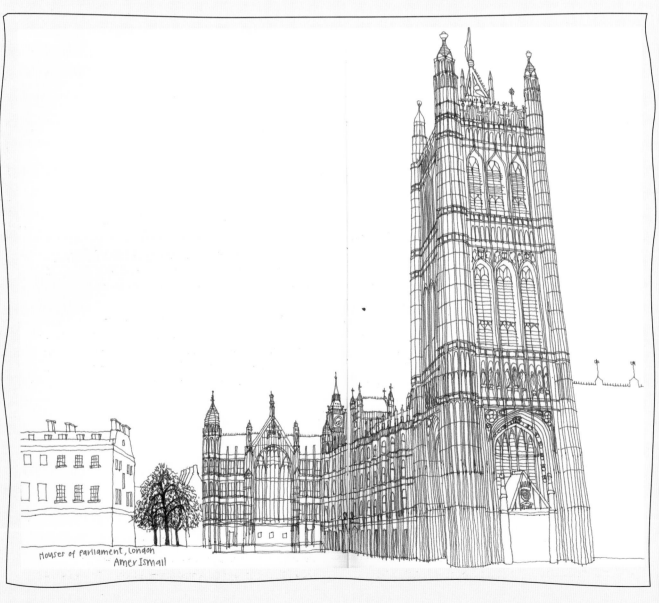

Houses of Parliament, London
Amer Ismail

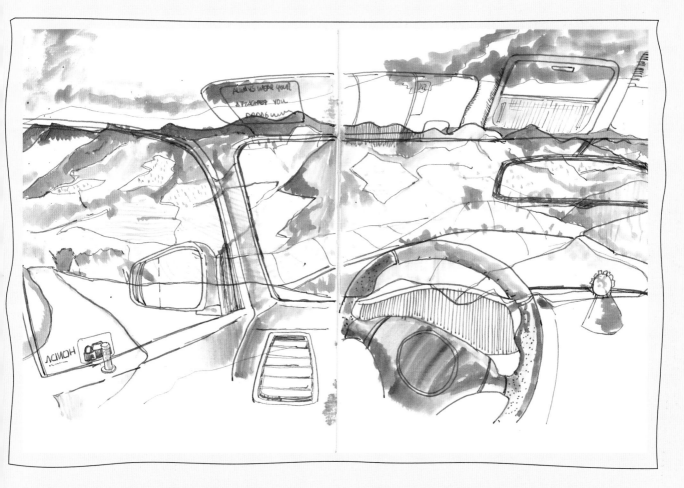

Packing sketchbooks and sketching materials becomes a vital step to enjoying and making the most of such journeys, and as essential as a passport and travel insurance. Drawing makes us stop and look at our surroundings in a questioning way that we wouldn't otherwise. We are all familiar with the sight of tourists making their way around the world with a video camera clamped to their faces. While they may have many happy hours viewing once they are home, the moment of actual experience has been lost. Travel journals let you seize the here and now, capture the artist's handwriting in both words and drawings, and don't depend on technology to enjoy once home.

A travel journal doesn't have to be so different from an everyday sketchbook, but as it is probably worked on during a holiday when there is more time to immerse yourself in the sensory experiences and events of a journey, it can take on the form of a visual diary. It can include notes, tickets, maps, phone numbers and records of conversations as well as drawings, and because it is in chronological order, it tells a story in the most personal way. Keeping a visual diary, rather than a written one, can be a liberating act.

Whatever else you may bring back from a holiday or journey, it is unlikely to be anything as enduring and memory-jogging as a travel journal. You will almost certainly spend less on souvenirs, because you will be taking home the best one of all.

Opposite: Amer Ismail. Houses of Parliament, London, UK.
Above: Fernando Abadía. Behind the wheel, Olves, Zaragoza, Spain.

LIVING THE MOMENT

Travel heightens our awareness of the things around us by bringing us into contact with refreshing and unfamiliar sights and situations, and recording these in a sketchbook allows us to experience them fully without having to look continuously through a camera viewfinder.

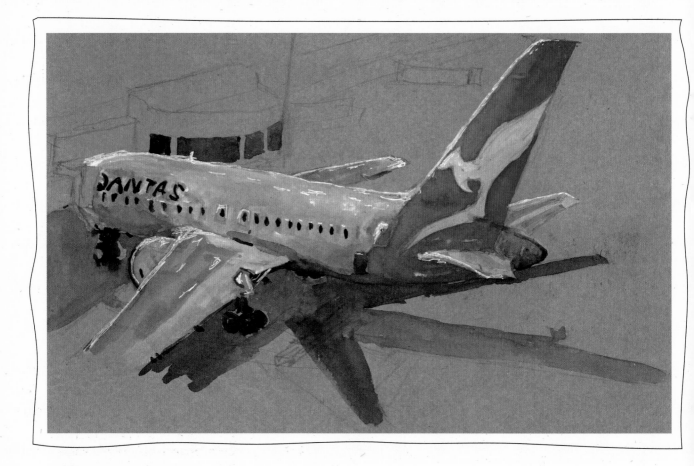

AIRPORTS

Travel journals may depict as many drawings and paintings of the journey as of the destination. The dead time spent waiting around in airports can be put to good use. Asuka Kagawa used watercolours, white gouache and a white gel pen on the beige paper of her sketchbook to draw her view of the airport.

Above: Asuka Kagawa. Melbourne Airport, Australia.

Opposite

Top: Inma Serrano. Market, Asilah, Morocco.

Bottom: Paul Sutliff. Map of South Korea.

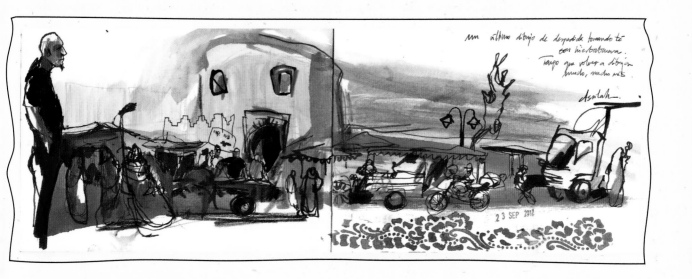

EXPLORING CULTURES

Markets capture the colour, character and energy of a community. They are busy and distinctive, and if, like Inma Serrano did in Asilah, Morocco, you find a place to sit and drink tea as you draw, you are in a perfect position to embrace it in your sketchbook. She included on the right-hand page a stencil of a henna tattoo design worn by Arab women she saw in the market. 'It was a magical moment with the smell of spices and lamb and the continuous movement of people', she says. 'The place was constantly changing its appearance and colour.'

PLANNING YOUR ROUTE

Travel journals can tell the story of a journey through more than just drawings and paintings. Packed itineraries and rapid transfers mean it can be difficult to remember where you were and what you were doing just a couple of days before. Paul Sutliff includes maps in his sketchbooks. 'All my notebooks have a country plan and city plan inked out and labelled on the flight in and at the end of the day when I'm having a beer somewhere', he says, as with this one of South Korea.

MAKING IT PERSONAL

Travel journals are a space to fill with those personal experiences that can easily slip by in the whirlwind that journeys and holidays can often be. Seize the moment before it has gone.

① LABEL YOUR DRAWINGS

Dates, places, names: memories being what they are, the best time to record where you have been and what you have seen on a journey is straight away. The water damage on this drawing of a French lake is a reminder of the dangers of using non-waterproof ink on a holiday spent close to the water's edge (fig. 1a).

Try adding a few short scribbled notes or annotated drawings, which can put your movements into context and add interest to a travel journal. This can lead to working in a more relaxed way that is less about the drawing and more about the recording (fig. 1b).

② MAKE A MEMORY

Alexandre Esgaio includes a variety of tickets, publicity, literature and other odd pieces in his drawings as a record of places he has visited. 'It's all about memory', he says. 'One day these things will change or even disappear.' Here he has included a ticket from his journey on the ferry that links the islands of the Ria Formosa lagoon, Portugal. There are times when the vitality and noise of a place with which you are unfamiliar overtakes you, and the usual routine of looking for a suitable viewpoint and looking closely at your environment goes out of the window – you just have to stop and draw. If the atmosphere of a scene excites you, let it show in your sketches.

③ INCLUDE TICKETS IN COLLAGES

Why stick to drawing? Pages of your sketchbook can be turned over to collages that capture the experiences you have in a new place. Tickets, stubs and receipts can be considered as trash or can be used to add a new element to your sketchbook's pages. Some sketchbooks come with pockets inside their back cover for the storage of such items.

Using new sketchbooks

New sketchbook for a new trip? Why not try…

- Taking new sketchbooks with you that focus solely on that journey
- Buying sketchbooks at your destination so they have a local flavour
- Continuing your everyday sketchbook so that the journey and the drawings you make on it are part of its chronology and narrative
- Using unfinished sketchbooks from your previous travels to the same city, country, or continent so you can trace your experiences there in a single book
- Making your own customised sketchbook

1

2

3

Top left and right: James Hobbs. Panorama, Lake Annecy, France.
Centre left: Alexandre Esgaio. Ferry, Portugal.
Centre right: Naomi Strauss. Ticket collage.

PROFILE: AMER ISMAIL

Amer Ismail travels a lot, but he hasn't always taken a sketchbook with him. 'I didn't believe in drawing before', he says. 'In Malaysia, where I grew up, we were taught to draw a little, but I always believed in using a computer – it was all about technology for me.'

That changed when he saw the work of his colleague Narinder Sagoo at the office of architect Sir Norman Foster, where Amer works. 'Narinder's drawing inspired me', he says. 'There's something special about the way he communicates architecture through his sketches.'

His interest was reinforced by finding journals he had written as a child. 'It was amazing to read them all that time later. So I thought, why not do the same thing while travelling? It adds value to the experience and makes a great souvenir from my travels. So I started to write journals and take my sketchbook everywhere I went.' He carries an A6-sized Moleskine sketchbook, 0.1, 0.3 and 0.5 Pentel pigment ink pens, and a small set of coloured pencils. His drawings and words aim to capture his experiences, rather than being solely about the visual aspect of the places he visits.

Adventurous anecdotes about his journeys enrich his books, such as the airport taxi driver who unexpectedly took him to wash his car and have a coffee en route to Amer's hotel in Tirana, or the ride in an Albanian train that even the locals warned him against, and which turned out to be an unforgettable experience.

He finds he attracts most attention at places where there are fewer artists out drawing. At the Great Wall of China, he found a quiet place to draw away from the crowds. 'Suddenly a group of six people came to watch me – and then it became ten. They were as intrigued about how I captured the place as I was intrigued by the scenery. It was a great conversation starter. This experience helped boost my confidence and became one of my inspirations to continue sketching.'

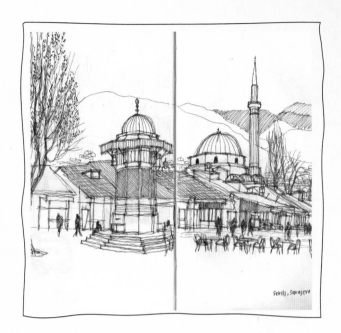

'[Drawing] adds value to the experience and makes a great souvenir from my travels.'

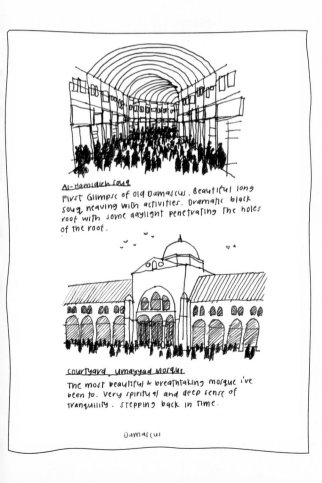

Al-Hamidieh souq
First glimpse of old Damascus. Beautiful long souq heaving with activities. Dramatic black roof with some daylight penetrating the holes of the roof.

Courtyard, Umayyad Mosque.
The most beautiful & breathtaking mosque I've been to. Very spiritual and deep sense of tranquillity. Stepping back in time.

Damascus

USING WORDS AND DRAWINGS
Opposite: A travel journal is about clinging on to the unusual experiences you may have in a different place or culture. This page from a visit to Amman Beach, Jordan, consists of a series of diagrams that speak of the unreal experience of floating in the salty lake rather than showing just the view.

INTERACTING WITH LOCALS
Above: 'I had just finished sketching this view of the old town of Sarajevo when a waiter approached me and pointed out what was missing in my sketch,' says Amer. 'As he didn't speak English, he drew the missing background details on a receipt so that I could understand what he was talking about. Drawing transcends language, and this is more evident during my travels.'

MONUMENTAL SCALE
Left: These small, fast drawings of the Al-Hamidiyah souk and Umayyad Mosque in Damascus, Syria, are little more than thumbnails, but capture the monumental scale of the historic buildings.

CHAPTER 9
REPORTAGE

Just occasionally, whether you are out looking for it or not, you will stumble across a newsworthy event, and feel the urge to draw it. When this happens, your role goes beyond that of a casual traveller or observer, to become instead that of an eyewitness with a tale to tell. It could be as simple as a new museum opening or as devastating as an earthquake destroying homes and livelihoods. The drawing is as much about the story behind it as the finished work.

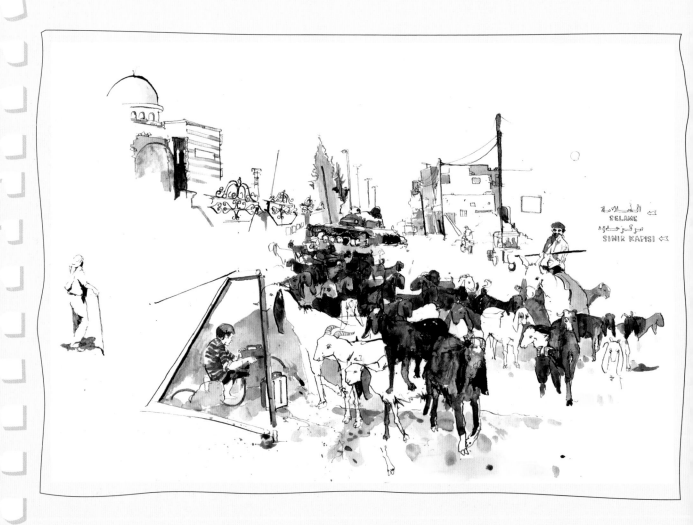

Above: George Butler. Goat herder, Azaz, Syria.
Opposite: Mario Minichiello. Burning gum trees, Australia.

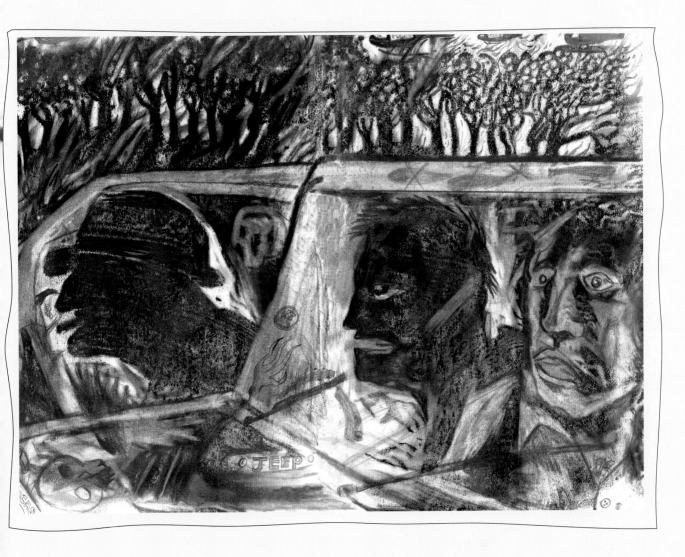

The number of people who are employed as staff artists by news organisations or work freelance are very few, but they do exist. Gabriel Campanario, whose work appears regularly in the *Seattle Times*, and George Butler, a young British reportage artist who has reported from Syria and Afghanistan, are proof that there is a place for the journalistic qualities that reportage artists are able to bring to the published page or website.

But it doesn't suit everyone to draw in a war zone. If you are happier in a more protected and predictable environment, you could seek out a residency in one of the companies and organisations that allow artists to explore behind the scenes to create a visual record of their employees at work and daily routines.

While it may seem that photography is the natural way to cover news events, someone armed with a sketchbook and pen can see and record events with a depth beyond that captured by the click of a digital shutter. Drawings take time, can be selective in what they include, and can also allow the artist's feelings to shine through. Reportage artists on the street are even viewed differently to photographers, as Mario Minichiello once said after drawing among riot police: 'Drawing on the streets with a pack of felt pens and a box of graphite lumps possibly made me look rather harmless, even silly, and quite at odds with the paparazzi. No one ever ran away from a pencil.'

ARTISTS IN RESIDENCE

Some companies and organisations allow artists into their midst to explore and record their activities behind the scenes. For the artist, it is a chance to be a fly on the wall, and to become immersed in another world.

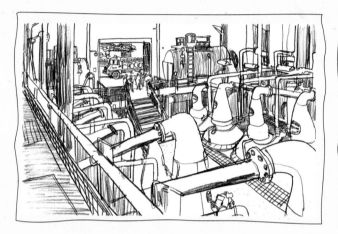

AT THE DISTILLERY

Every year the Glenfiddich whisky distillery in Scotland invites eight artists from around the world to take part in its artists-in-residency programme. American illustrator Daniel Zalkus spent several months living at the distillery in 2012 making a series of charcoal drawings later published in a limited-edition book, *Charcoal and Whisky*. His subjects included the coopers, the skilled craftspeople who repair barrels (above right). 'The challenge with this drawing was to capture the workers, their tools and overall environment. I quickly realized that the coopers moved fast and the best way to capture that was to let go and react. At times, it helped if I stopped to study them before I put pencil to paper, as that way I could better understand what it was they were doing. The more I drew in the cooperage, the easier it was for me to find patterns in the way they moved and the way they worked.'

AT SEA WITH THE NAVY

Anna-Louise Felstead's twenty-minute journey in a Sea King helicopter on her way to spend three days on board the aircraft carrier HMS *Illustrious* didn't leave her much space or time to draw. Commissioned by the British Ministry of Defence to draw on the theme of 'Life at Sea' for the Royal Navy, she abandoned her usual dip pen for this drawing because of her concern that the ink would be spilled on the bumpy ride, so she used a ballpoint pen instead. The Ministry of Defence used her images on promotional and recruitment exhibition stands.

This page
Left and right: Daniel Zalkus. Glenfiddich distillery, Scotland.
Opposite: Anna-Louise Felstead. Sea King helicopter ride.

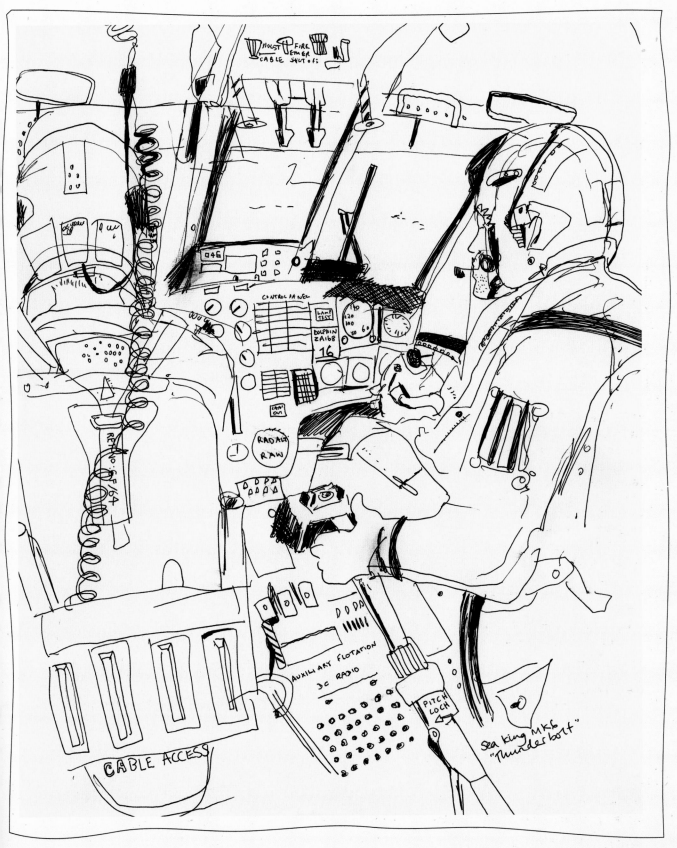

REFLECT AND REPORT

Reportage gets under the skin of a situation, whether it is on the streets with a demonstration, revealing social injustice or tracking someone in their working role. Spending time and reflecting on the subject you are exploring lets your drawings go beyond a snatched image of a single moment, to become part of an unfolding narrative.

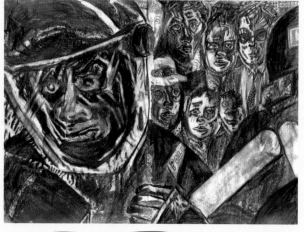

DRAWING DEMONSTRATIONS

In 2007, Mario Minichiello made a series of drawings over two months for the *Sydney Morning Herald* during his time as a visiting fellow of Sydney College of the Arts. This coincided with the arrival of world leaders in the city for the Asia Pacific Economic Cooperation forum in 2007, with the huge security measures and demonstrations that it attracted. Mario used a small sketchbook for line drawings done on the spot, which he developed into larger graphite works and linocuts based on the drawings and from memory. His work was closely scrutinised by the security forces, and brought him into close contact with riot police. 'There was a ban on photography, but the police seemed to think what I was doing was childish – even foolish', he says. Mario has also drawn conflicts in Afghanistan, Northern Ireland and Bosnia, and has worked for the BBC and the *Guardian* newspaper.

Above: Mario Minichiello. Demonstration at Asia Pacific Economic Cooperation forum, Sydney, Australia.
Opposite
Top: Adebanji Alade. Homeless people in London, UK.
Bottom: George Butler. Surgeon at Cromwell Hospital, London, UK.

ON THE STREETS OF LONDON

Recurring themes we are attracted to can take on a journalistic angle through an insistent line of enquiry. For Adebanji Alade this includes drawings of people living rough on London's streets. Because Adebanji uses his drawings as supporting studies for his paintings that he makes back in the studio, it suits him to work in detail using oil-based pencils, focusing on the individual characters of his subjects.

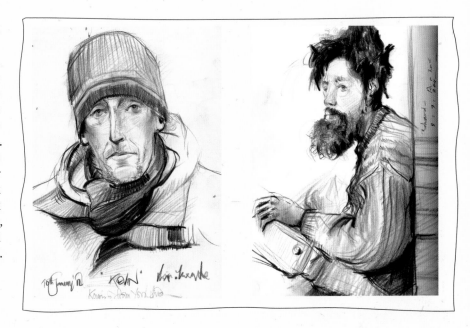

IN THE OPERATING ROOM

This drawing by George Butler is one of a series on the theme of surgeons working at Cromwell Hospital in London, arranged as part of his college course work. Working in this environment can call for chameleon-like qualities to ensure the artist doesn't encroach on the team at work.

TELLING A STORY

Exploring a theme through a series of drawings or paintings allows you to get under the skin of a subject or situation and make works that can carry a powerful message.

① BUILD TRUST WITH YOUR SUBJECTS

Some situations call for sensitivity in the search for drawings that tell a story. Caroline Johnson spent a week documenting the day-to-day life at a care home for the elderly in the south of England. She spent the first day drawing the gardens and the interiors of the residents' rooms as she earned their trust, and gradually the people who lived and worked there became the focus of the work. At the end of the week, Caroline's sketchbook was left with the home as a record for residents, staff and visitors.

Choosing to explore a theme allows you to look for the oblique viewpoint: this drawing of a resident's windowsill represents a poignant image of life in the care home without directly showing the owner of the photographs (fig. 1b).

② EXPLORE LOCAL NEWS STORIES

Be aware of local issues and campaigns. Struggles faced by people during the economic crisis have been highlighted in a series of drawings by Inma Serrano of an empty building in Seville that was taken over by thirty-six homeless families. With the story featured on the national news, Inma was invited into the block, known as Corrala Utopía, to interview and draw its inhabitants, including seven-year-old Ainhoa, a young girl who lives with her grandmother, father and uncle, without running water or electricity. Inma brings the complexities of the economic situation to a very human level through the figure of the young girl as she sits in an apartment with her father.

Ways to spread the news

Thinking of reportage?

- You don't have to travel to a war zone to be a reportage artist
- Find a subject that fires you up, and explore it
- Look for places that take artists in residence
- Use social media to get your drawings seen
- Keep an eye on local issues that are newsworthy

Opposite

Top: Caroline Johnson. Care home, Sussex, UK.
Bottom: Inma Serrano. Occupation of Corrala Utopía building, Seville, Spain.

1

a.

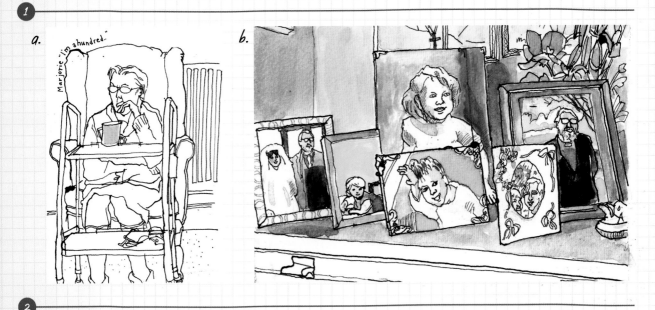

2

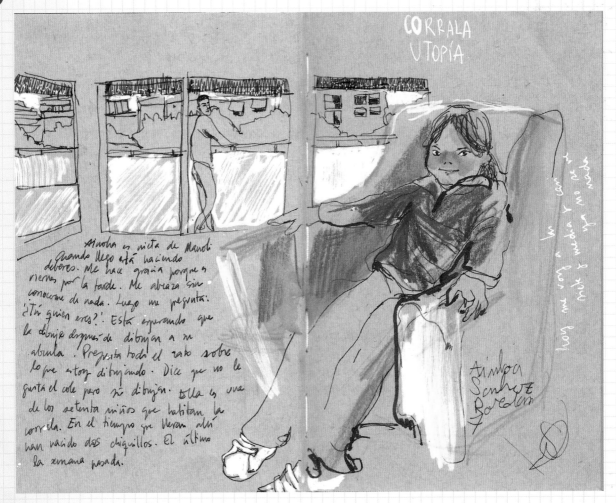

PROFILE: GABRIEL CAMPANARIO

Reportage artist Gabriel Campanario trained as a journalist rather than as an artist. After moving from his native Spain to Seattle in 2006, he started the *Seattle Sketcher* blog in his spare time, and then approached his editor at the *Seattle Times* with the idea of a regular illustration in the paper, telling a story of local interest through drawings and words. His work appears in the paper every Saturday, and online, reaching an audience of hundreds of thousands each week.

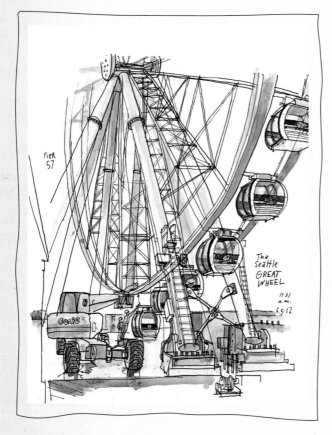

Each of Gabriel's assignments takes about a day for him to complete. He works in an 28cm × 5.5cm (11" × 14") sketchbook, making several drawings in pen, sometimes with a few guiding pencil marks. The human element of the story is usually at the centre of the drawing, with the names, date and points of interest labelled. Gabriel adds colour on location, using watercolour, sometimes developing this later on. The finished works are supplied to his editor at the end of the day.

Carrying and using a sketchbook everywhere he goes is natural for Gabriel, and drawing so frequently has changed his work. 'People worry about developing a personal style, but that comes with time and experience', he says. Should there be an explosion in Seattle, would he reach for his sketchbook or rush to people's help? 'I'd reach for the sketchbook. I'm not a medical person and I'm afraid I'd get in the way of the paramedics.'

Gabriel, who founded Urban Sketchers, believes that the best first step for aspiring reportage artists is to simply go ahead and do it. 'Don't wait. Find the stories that interest you, post the drawings online, and use social media to get them seen.' His interest is not in creating works to be framed and hung in galleries, he says: 'My aim is to be good at just one thing: telling a story well through drawings and 200 words.'

'Don't wait. Find the stories that interest you, post the drawings online, and use social media to get them seen.'

LOCAL NEWS ANGLES

Opposite: Gabriel's role as reportage artist enabled him to visit Seattle's Great Wheel, overlooking Elliott Bay, during its construction. His subsequent online posting created a wave of debate about the wheel; reportage can have a political angle that invites wide-ranging opinions.

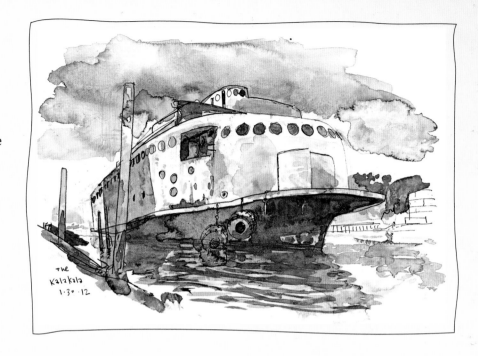

TAKING RISKS

Above: Gabriel's journey to Tacoma, Washington, USA, to see this stylish but decaying former ferry that served Seattle in the 1930s involved a two-hour kayak passage and an unfortunate dip into the bay that caused some water damage to some of his drawings. Always try to be prepared to travel and take risks to tell the story you are after.

QUICK WORK

Left: For this story about real estate development threatening the identity of Brier, a Seattle suburb, the rider kept his horse steady while Gabriel drew as quickly as possible.

PROFILE: GEORGE BUTLER

The British artist George Butler was still studying illustration at college when he realised that he wanted to focus on reportage after visits to Morocco, Afghanistan and Jordan in his final year. Now he works as a freelance artist, and has had his drawings published in the *New York Times*, the *Guardian* and *New Statesman*, among others.

His two-week stay in Afghanistan with the British Army was unofficial, arranged through a personal contact, but it helped him to realise that there was value in documenting the things he saw there through illustration. Capturing the human element, such as ordinary people trapped in a war zone, and telling their personal stories are just as important as the quality of the finished drawing, he says.

George's work is a combination of commissions and sales of images to newspapers and magazines he makes after visits to places he has arranged for himself. His work has inevitably led him into dangerous situations, particularly when he tried, with the help of Tuareg guides, to cross the border from Algeria to Mali and was lucky to escape kidnappers who trade in Westerners. 'Although that is the thing that people often ask me about', he says, 'there were hundreds of times that local people gave me a place to sleep or food to eat. Although I shouldn't be, I am consistently amazed by the locals' generosity to strangers, especially when they appear to have relatively little to give away.'

The equipment he takes with him is minimal: dip pens, ink, watercolours, four or five sable/synthetic mix brushes in a variety of sizes and 'as much paper as I can strap to my back'. Mobility and adaptability are important, so he blends in and doesn't get in people's way as he works.

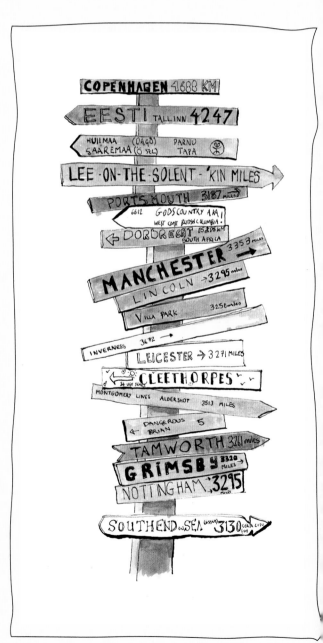

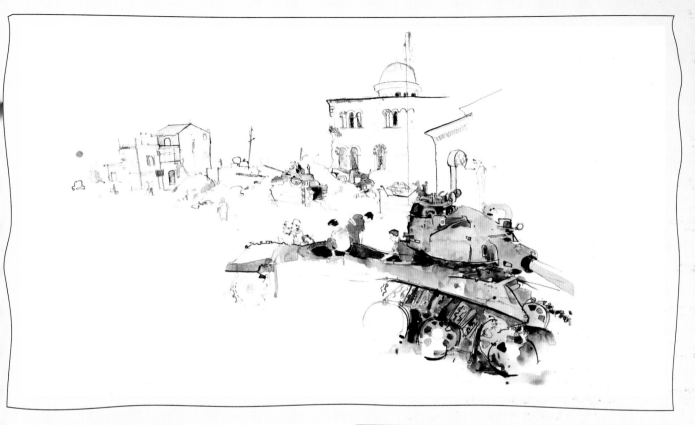

HELMAND PROVINCE

Opposite: This sign erected by NATO Allied forces in Lashkar Gah, Afghanistan, which shows how far away they were from home, is a poignant image that tells a story about the soldiers fighting there.

THE HUMAN FACTOR

Above: George spent several days drawing in Azaz, a small Syrian town that had been the scene of a battle ten days before between the Syrian government forces and the Free Syrian Army. The focus is on the people coming back to see if their shops or houses had been destroyed, and finding collapsed buildings and abandoned tanks.

WORKING FAST

Right: During a lull in the fighting, George heard that between 500 and 700 refugees were passing over the border between Syria and Turkey each day, having packed everything they could into their cars. It was important to work fast; using a limited palette and focusing solely on what was visible through the car windows both saved time and emphasised the personal dramas unfolding as families fled.

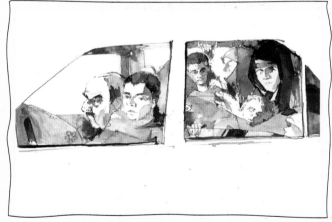

'Drawings are open for people to see what you are doing, so they can trust your work in a way that perhaps they can't if you are taking photographs.'

143

CHAPTER 10
NIGHT-TIME

Why stop drawing when it gets dark? It is true, some works with a focus on colour and light can be dependent upon a fairly constant level of illumination, but often, especially when we are making quick works in a sketchbook, the end of the day can open up new subjects or let familiar ones be viewed in a new way.

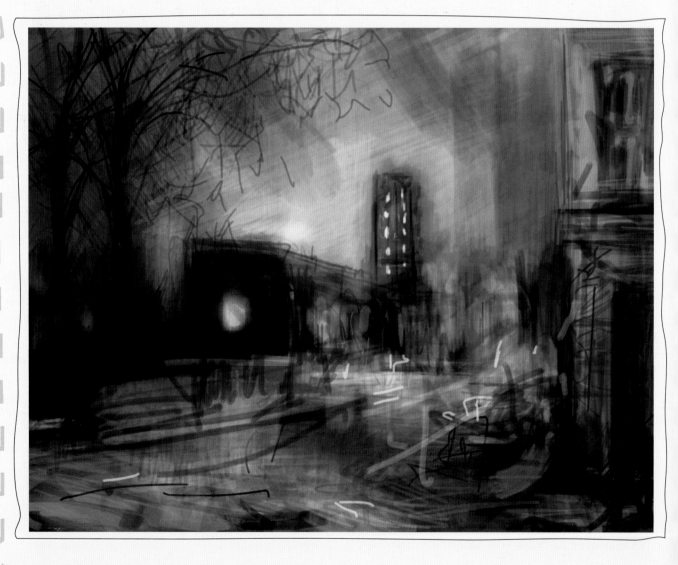

Above: Fraser Scarfe. iPad sketch of Commercial Street in London, UK.
Opposite: Max Naylor. Drawing of South Bank, London, UK.

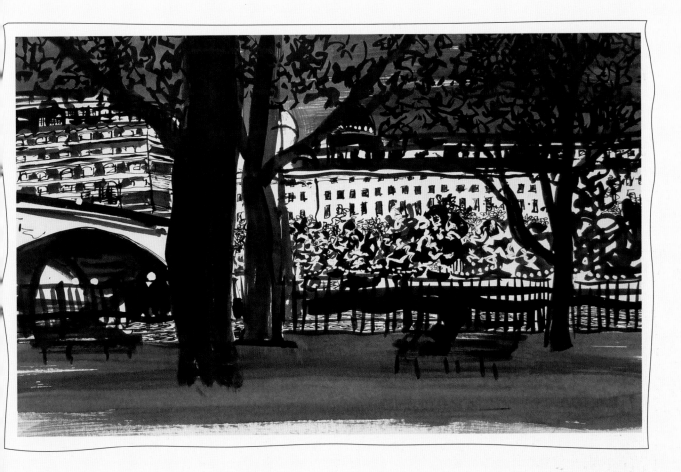

Drawing at night can, of course, mean vastly different things in different locations. Long, balmy summer evenings on the promenade, sitting with a sketchbook at a café overlooking the water, is a world away from icy or wet conditions in an intimidating part of town. But the urge to draw doesn't fade with the light. You can head indoors to find subjects, to bars, restaurants, concerts and performances, but the great outdoors shows another side of itself under darkness, and there is no need to stop sketching if the conditions are right.

Stark shadows cast across a scene by artificial lighting can add a sense of drama. Intense darkness can lead us to deal with monumental forms rather than details. And spotlights can sometimes help us to see elements of a scene that are harder to pick out during the day. Drawings can become looser and more instinctive when the information laid out is sparse and ambiguous, where edges and decoration are hard to perceive.

The tools for drawing at night may change: charcoal and inks that can cover areas with an array of shades of black to leave the white of the paper showing through can seem a natural choice, but night drawings are about more than making the sky dark and may not immediately appear to have been done at night when they are complete. Packing a head flashlight can be useful if a lit doorway or café table isn't suitably positioned, and fingerless gloves are a good idea. The dark hours are also a perfect time to draw using the glowing screen of a tablet or smartphone.

EXPLORING TONAL VALUES

A monochrome drawing can range from its lightest areas, perhaps created by leaving areas of white paper exposed, to the darkest areas that can be created by the medium that is being used. Between these extremes there is a range of tones that can be employed to create forms and reveal the fall of light across your subject. A black and white image can strip a scene back to its most pure and dramatic form.

1 FINDING MID TONES
Charcoal is a great medium for working at night, one that can be smudged around the surface, erased and built up to create a range of tonal values, as in this drawing of a late night scene by Seoungjun Baek (fig. 1 a). 'Night reveals the dramatic face of things', he says. 'In daylight, it is easier to miss massiveness or the relationship between objects, and it's hard to spot the darkest part of an object. It is much easier to recognise in night drawings.' Seoungjun started this drawing by covering the paper with charcoal, creating lighter areas with an eraser, and then the lightest and darkest areas with black and white conté – a drawing medium made from compressed graphite (fig. 1b).

2 PRESERVE WHITE
The intensity of this bonfire to celebrate the festival of St John in Spain was accentuated by Adolfo Arranz by forcing the darkness to the peripheries of the image, showing the people warming themselves in bright light and the warm glow of the fire (fig. 2a). With ink, the whiteness of the paper has to be preserved to create contrast. Shadows and flames licking up into the night sky suggest light and heat, even in black and white. Try using a brush pen in a small sketchbook so areas can be filled quickly. Paint light in negative: leave the white of the paper for the brightest areas. Here, Adolfo has depicted the flames and most intense light by drawing them in negative (fig. 2b).

3 USE THE MEDIUM'S STRENGTHS
Because tablets glow and the colour palettes found in applications are more discernible in poor light than, say, in a watercolour set, they can be useful for working at night. 'Life painting at night can be incredibly difficult to do with natural media', says Oscar-winning animator Patrick Osborne. 'You have to bring your own light sources, find power, and the light from your painting setup pollutes your perception of how light plays in the subject.' He used an iPad with the Brushes app for this view from the rooftop of a building in downtown Los Angeles (fig. 3a). The temptation looking at night-time scenes is to think that everything is black, but once your eyes adjust you will be able to see a variety of subtle colours among the darks: in this drawing, greens, greys, browns, oranges and pinks have been combined by Patrick to create the darkness of downtown Los Angeles (fig. 3b).

Tonal ideas
Working at night may mean you have fewer people around you as you work, but the attention you do get may be unwanted. Drawing with friends or the view from a window adds a sense of security.

1

a. 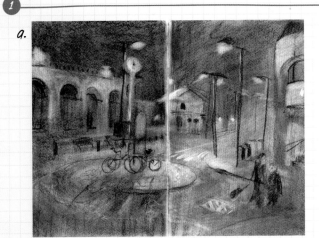 b.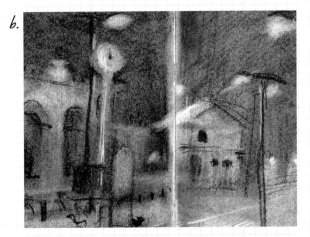

2

a. 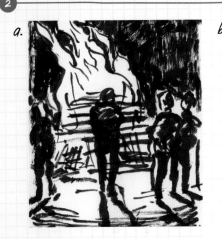 b.

3

a. 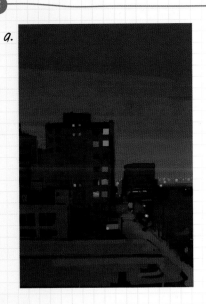 b.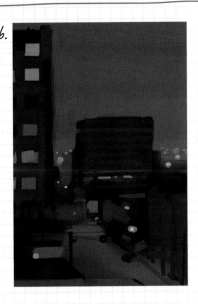

Above: Seoungjun Baek. Cambridge railway station at night, UK.

Centre: Adolfo Arranz. St John's Eve festival, Velilla del Río Carrión, Spain.

Bottom: Patrick Osborne. 8th Street East, Los Angeles, USA.

LIGHT IN DARKNESS

The character of any place changes through the day, whether it is a tourist destination freed from human activity early in the morning or the changing light effects falling across a mountain range. Darkness not only reveals a new face of a subject, but forces us to present it in a new way.

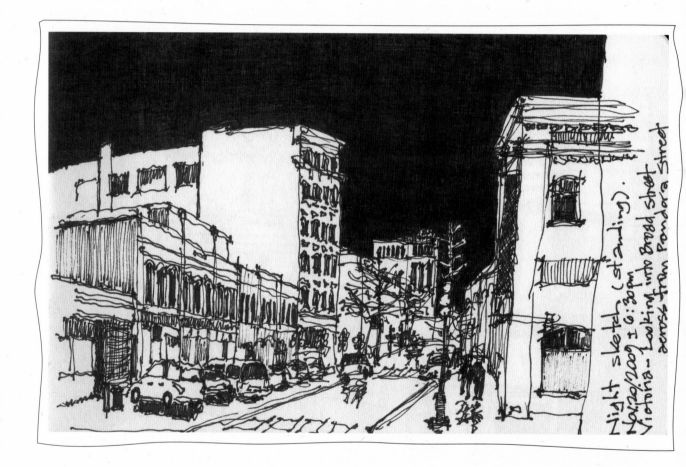

CAPTURING THE ATMOSPHERE OF THE NIGHT

'There's a different feeling about a place at night and it's interesting to try to sketch that', Matthew Cencich says. The best places to draw at night can depend upon the climate – warm evenings in hot countries are preferable to long winter nights in cold ones. Your experience is also reliant on where in town you are

drawing and whether the attention you attract is threatening, rather than interested and supportive. 'I drew this close to a couple of street people who had set up to camp out for the night, and one of them came over to talk. That's one of the things you can encounter when you are night sketching.'

PYROTECHNICS

Painting the night sky over Dodger Stadium, Los Angeles, during its firework display each July 4th has become an annual tradition for Virginia Hein. She drew most of this sketch parked on a hillside using an LED flashlight, ink, watercolour, and white gouache for the highlights. 'Fireworks blast off after the holiday game, and other fireworks go off all over the neighbourhood as cars stream by on the freeway below, and smoke obscures the view of downtown Los Angeles', she says.

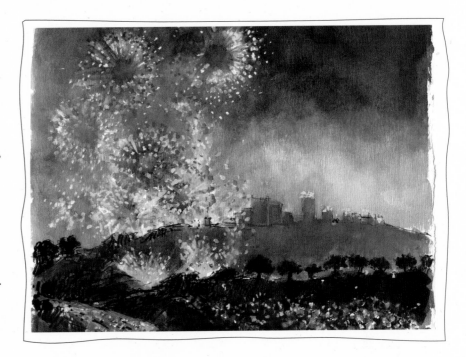

OIL PASTEL RESIST

Light was already beginning to fade when Anthony Banks started this drawing of St Pancras railway station, London, from the raised position of an old water tower. Onto a thin wash of black/brown ink, he worked with light grey oil pastels to create the station and its glow. The oil pastel resisted the subsequent layers of ink that were built up, leaving the form of the station buildings distinct despite more and more ink washes being added over it as the light faded. 'By the time I had finished, without my realising it, it was almost pitch black', Anthony says.

Opposite: Matthew Cencich. Broad Street, Victoria, Canada.

This page

Top: Virginia Hein. Fireworks in Los Angeles, USA.

Left: Anthony Banks. St Pancras station, London, UK.

PROFILE: MAX NAYLOR

Max Naylor's drawings reflect his interest in the borders where city turns into countryside, where nature gives way to an order imposed by human habitation. They sometimes also span another border, between day and night, as he works while daylight recedes into darkness: his night drawings in pen and ink, chunky marker pens and correction fluid show towns and cities in apparent silence and calm, the lights at the windows suggesting, but not showing, the people who live there.

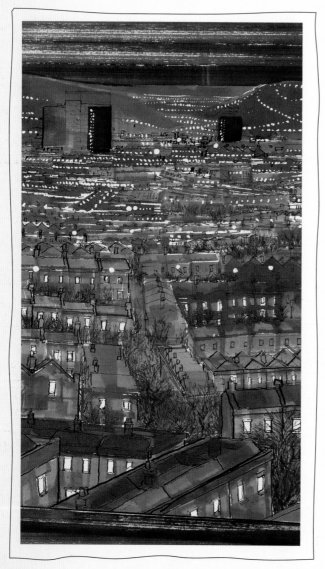

Max's walks in the countryside around the city of Bristol, UK, led to quick drawings on site in pencil, which he can also use to create imagined urban nightscapes. But drawings from his home overlooking the city offer a romantic vision of lights receding into the distance until they give way to darkness, and the hint of white showing through the ink to suggest light on the horizon.

'The mixture of drawing from observation and imagination is very important to my work', he says. 'I divide my time between studio work and working in the environment – these different approaches complement each other. For me working out in the world is as much about experiencing and remembering as it is about the drawings I make.'

EXPOSED PAPER
Left: The effect at the top of the page of this drawing of Bristol was created by quickly dragging a brush loaded with ink from right to left across the surface over a stencil protecting the horizon. As the brush unloads its ink, more of the paper shows through.

TONAL ADDITIONS
Opposite top: This view of a Welsh village was drawn as darkness fell, with the tonal elements added later.

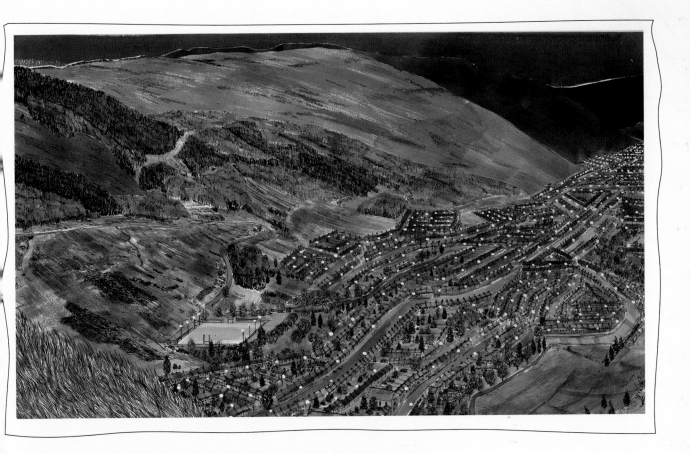

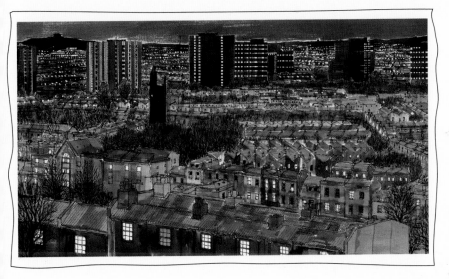

RANGE OF GREYS

Left: Max started this Bristol scene in daylight, drawing the buildings in the foreground with a black pen. He added layers of diluted Indian ink to produce a range of greys as night fell, with the white of the paper showing through to depict the nearest windows. Towards the background, Max intensified the blackness of the ink, and used stencils cut from tracing paper to create the straight edges of the high rises. The distant lights of Bristol are painted with correction fluid over the black ink.

'Working out in the world is as much about experiencing and remembering as it is about the drawings I make.'

CHAPTER 11
DIGITAL TOOLS

The rapid changes in digital technology have inevitably led to new opportunities for artists, and although the comforting squeaks, smells and rituals of traditional media may be lacking, there are times when a digital tablet or smartphone can let you capture a moment or scene that would otherwise have been lost, or perhaps lead you to find new and exciting ways of working.

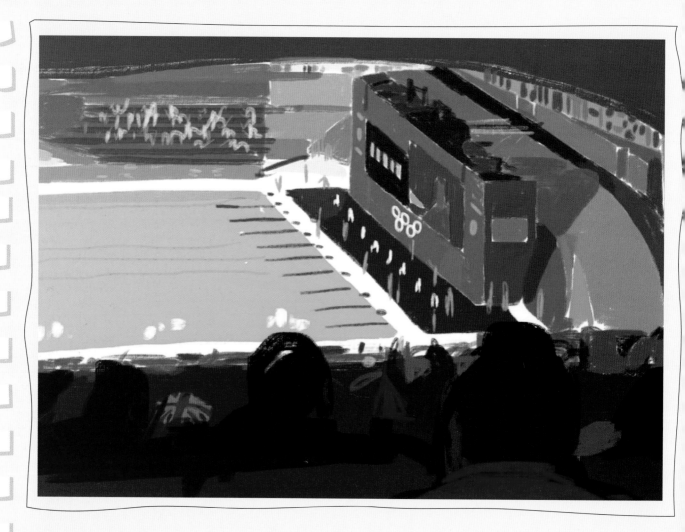

Above: Brendan Kelly. iPad painting of the Olympic Aquatics Centre, London, UK.
Opposite: Julie Bolus. Scanned ballpoint pen drawing with Photoshop Colour of Arnie's Landrover, Hillcrest, South Africa.

It is easy to try out digital painting and drawing: the chances are you could be doing it in a few minutes without having to move from where you are reading this, and at minimal cost. As our lives increasingly embrace the convenience that tablets can bring, they are what many people naturally turn towards to draw and paint, along with everything else: music, emails, photographs and social media.

There are advantages to using a tablet or smartphone: it is possible to zoom in on part of a drawing to focus working on it, there is an 'undo' button when things go wrong, and using layers lets marks be saved, moved about or deleted as the image develops. A fantastic array of tools and colours are contained within each application, making packing for a holiday simple and clutter free: it is all in the tablet. Their ubiquity means a smartphone or tablet may be at hand when a sketchbook is not.

But working on a screen is no shortcut to success: it is simply another medium to master, with all the ups and downs that that entails. Sketchbooks do not lose power, or need backing up, and become beautiful narrative objects in a way a file on a desktop never can. The low-techness of a sketchbook is one of its greatest joys, and there are places and situations where you may hesitate to take an expensive tablet.

Drawing and painting well is no easier on a tablet than in a paper sketchbook, and the tools it offers can take some getting used to. If you are looking to make images that emulate acrylics, oils or watercolour, you are likely to be disappointed, but treat it as a new medium with its own characteristics, and you can find it opens up new ways of working, a new look to your images and a wealth of possibilities.

WORKING ON TABLETS

There are choices to be made if you want to work digitally, such as which application is best for you, and if a stylus is worth trying instead of your finger. In time, painting and drawing digitally becomes as natural as reaching for a sketchbook.

APPLICATIONS

Art apps range from the cheap and cheerful – free, even – to the professional level capable of producing big, print-quality images. All are relatively cheap, and easy to download. Vector-based apps, such as Adobe Ideas and Inkpad, allow images to be printed large without the problems of pixilation. A simpler, more streamlined app that is designed for quick sketches, such as Adobe Ideas, may be preferable to some. Android-based tablets have a different range of apps. Ken Foster used his Samsung tablet with Photoshop Touch to finish the watercolour, above, that he brought home in fading light.

WHICH TABLET?

Things to look for in a digital tablet include speed, so there is no irritating lag between touching the screen and a mark appearing on it, and screen resolution for crisp, clear images. Storage size is important, not just for your paintings and applications, but to handle photographs, music and everything else that will be stored on a tablet: iPads come with up to 128GB of space. You can paint on a tablet without an internet link, but connectivity, through Wi-Fi at home or at, for instance, cafés, and more widely through 3G, 4G and their successors, is useful for downloading apps, and moving and storing images.

WORKING AT NIGHT

Disney animator Patrick Osborne's view of the Los Angeles skyline sidesteps some of the problems faced if using traditional media at night, such as carrying equipment and taking a wet painting home. 'Painting on the iPad solves these issues', he says. 'It has its own light source, and needs no power supply... it's incredibly portable, and requires no drying time. I still prefer to have a final piece of physical finished work to show, but for study and sketch, the iPad is fantastic.'

COLOUR RANGES

This image by Brendan Kelly is one of several he made of the Goan coast, India, using his iPhone. Working digitally lets you travel light with a palette range that can go well beyond what the average travelling watercolour set may contain. Some disadvantages of the small scale of works made using a smartphone are alleviated by an application's zoom feature. This allows you to enlarge areas that need to be more detailed, with the option of using a stylus to make even more precise marks, or move them to a place on the screen where they are more comfortable to work on: any contact with the screen as you work, intentional or not, will result in a mark being made. Using one of the many styluses on the market allows you to make more precise marks.

Opposite: Ken Foster. Backyard, Maine, USA.

This page

Top: Patrick Osborne. 8th Street, Los Angeles, USA.

Bottom: Brendan Kelly. Palolem Beach, Goa, India.

USING DIGITAL TOOLS

In many ways, drawing on a tablet is just like using any other medium – it has its strengths and weaknesses and it takes time to get used to. But if you haven't tried it yet – and you should – it may surprise you with its possibilities.

1 KEEP IT SIMPLE

Apps can offer an array of clever effects, brush styles and colours, and at first it is difficult to focus on making work that does the simple things well. Here, Marjut Rimminen has focused on capturing the rapidly changing sky over the city of London from her view from the top of Tate Modern, without using the panoply of effects that the Brushes app has available (fig. 1a). She has effectively managed to keep her work clean and simple while still capturing the subtlety and movement of the sky (fig. 1b). Just as, say, watercolour or charcoal works usually have an unmistakably distinctive look, so can a painting made with an app.

2 LIGHT ON DARK

Fraser Scarfe's study from a train at dusk shows the glow of London's lights through the fog. 'The ability to have access to the full colour spectrum and to quickly jot down notes as well as share them digitally is fantastic', he says (fig. 2a).

One strength of working digitally is that it is much easier to put intense, bright marks on a dark background while also adding darker marks on light backgrounds, without having to wait for the medium to dry in between (fig. 2b).

3 STYLUS OR FINGERS?

Whether or not to use a stylus rather than a finger is a personal decision: many screens are designed for fingers, but a good stylus will offer greater precision and recreate a more authentic sketchbook experience. As well as rubber and plastic tips, there are styluses with brush tips to enhance the painterly experience. Alex Raventós prefers to use his fingers rather than a stylus: 'I don't use a stylus on the iPad because there are a lot of shortcuts – to zoom, move the canvas, change the tool's size, undo and redo – that involve the use of two or three fingers'. (Fig. 3a)

Another advantage of working digitally compared to traditional methods is that sections of the image can be enlarged as you work, allowing fine detail to be added, even without a stylus (fig. 3b).

Knowing when to stop

Knowing when to stop is a common problem for painters, but the nature of working on a tablet means that it is possible in theory for a work to never end. The surface doesn't build up physically, the colours don't become muddied as they mix on the page, and the undo option is always there to suggest a new route. These things can be an advantage, but also a disadvantage. Set yourself limits on a tablet, with time, colour, brushes or whatever, if the works you make on it become laboured and overworked.

Opposite

Top: Marjut Rimminen. View from Tate Modern, London, UK.

Centre: Fraser Scarfe. View from a train, London, UK.

Left: Alex Raventós. Portraits.

1

a.
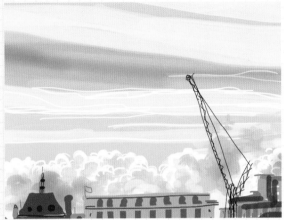

b.

2

a.

b.

3

a.

b.

PROFILE: BRENDAN KELLY

Brendan Kelly isn't just a digital artist. His commissioned portraits in oil paint of politicians and military leaders have a sobriety of colour and mood, and can take months to complete. When an area isn't working as he wants it to, it may need to be scraped back and even re-primed before he can carry on: his painting of a group of senior military figures in Afghanistan, for instance, took more than a year to complete.

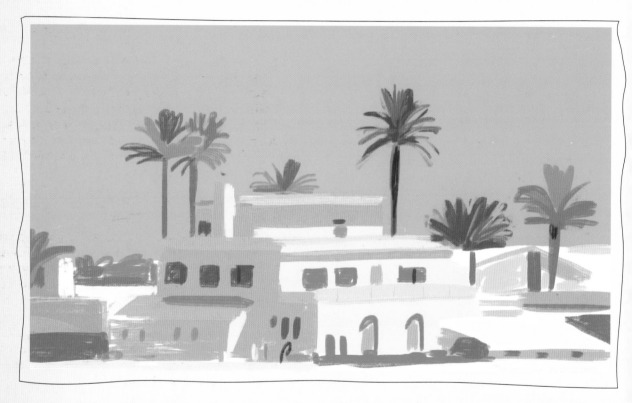

Working with a tablet or smartphone away from the studio, however, offers a contrasting speed, vivid colour and convenience. 'The fantastic thing about working with colours on a tablet', he says, 'is that you don't have to put all your traditional art equipment out in front of you. A tablet is really useful as a way of learning about how to put pictures together and make colours work. And if things aren't right, you hit "undo".'

Many of Brendan's digital works are made when he is travelling; he takes an iPad and an iPhone with Wacom Bamboo and Adonit Jot Pro styluses. He works with two applications, the downloadable software used to create the onscreen images: Adobe Ideas, a vector-based application; and Procreate, which he likes for its streamlined, gimmick-free interface and customised brushes.

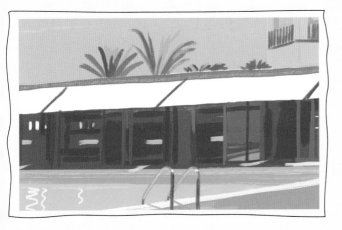

'A tablet is really useful as a way of learning about how to put pictures together and make colours work.'

Tablets do have disadvantages, in his opinion. 'The biggest problem at present is the lack of touch. When you draw on paper with a pen or pencil, your hand becomes sensitive to the vibrations you get from the page as you work. There's no drag on a tablet: it just slips across the surface.'

The digital works he makes vary from finished works to exploratory drawings done in the evening in front of the TV that help him solve problems he is facing with his oil paintings. 'Drawing is about getting down an idea or feeling, and finding a way to communicate that to yourself or to someone else', he says. 'I find an iPad can get me there quicker than with traditional media – although I still use those too.'

ENERGY THROUGH BRUSHMARKS

Opposite: Apps such as Procreate have a range of brushes – you can even create your own – that give the slightly broken effect that real brushes make as bristles spread, as in this painting of Portixol, Mallorca, Spain. 'I like the look of that despite its electronic origin', Brendan says. 'With colour, the brushmarks can have a real freshness about them. If, say, a blue goes down with energy, you can almost argue that it makes the blue brighter.'

WORKING WITH LAYERS

Above: Bright colours, as in this hotel swimming pool scene near Palma, Majorca, Spain, can sometimes jar when they are placed up against each other, and the large areas of white depicting the canopies have the effect of giving rest to the eye as it moves around the picture plane. The foreground steps into the pool were painted by Brendan on a separate layer so they could be moved along the pool's edge into a position where they work best, a nifty feature not available when working in a real sketchbook.

STRONG COLOURS

Left: The focus of this iPad painting of a dimly lit aquarium, inspired by Henri Matisse's interest in the tropical fish of Tahiti, is a pair of vivid, pink fish at its centre. Brendan has accentuated these by painting them against a background of pink's complementary colour, green (although the background was grey in reality), to create an image that has been constructed around areas of strong colour.

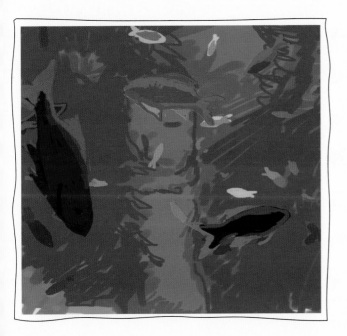

CHAPTER 12
BEYOND THE SKETCHBOOK

A finished sketchbook is a wonderful thing, and one that often improves with age. It is a very personal object, and because of that, it may well be private, too. We make them for ourselves, not to any brief or commission.

And there it may end, except that is has never been easier to show your work to a larger audience. With a scanner or camera, and an internet connection, the pages that we are happy to share can be opened up to an audience around the globe. And all without having to do the thing that feels like operating on a dear friend: tearing pages out of your sketchbook.

An online presence for an artist with work to sell is a necessity – it is where many buyers start their search – but even if your only artistic output is in sketchbooks that you would never dream of selling, there is still much to be gained from a website, blog and a variety of social media. It is how you can build ties with other artists who work in sketchbooks, and the ideas, support, encouragement, advice and friendship that comes with it. Drawing goes from being a solitary occupation to a social one.

Standing on windswept corners drawing, it is easy to assume we are alone in our unusual interests. But post the sketches online, or spend time on image-sharing websites, and there you will find proof that there is a huge international community with similar passions to yours. The artist Gabriel Campanario's dream of linking artists sketching the urban landscape has since blossomed into the popular Urban Sketchers network (urbansketchers.org), which has local groups around the world, an annual symposium, and a scholarship programme.

Above: Use social media to promote your work and connect with other artists.

Opposite

Top: There are various visual social media sites available to join.

Bottom: Network in person at a sketchcrawl. The illustrator Lapin draws in Barcelona. (Photo © Fran Fernández)

Rather than these links remaining virtual ones, it is a natural step to meet up with local artists, or perhaps to draw together at a 'sketchcrawl', a relaxed gathering best organised through the social media that brought you together in the first place, to compare sketchbooks, swap ideas and make friends. Drawing in a sketchbook doesn't have to be a solitary activity unless you want it to be.

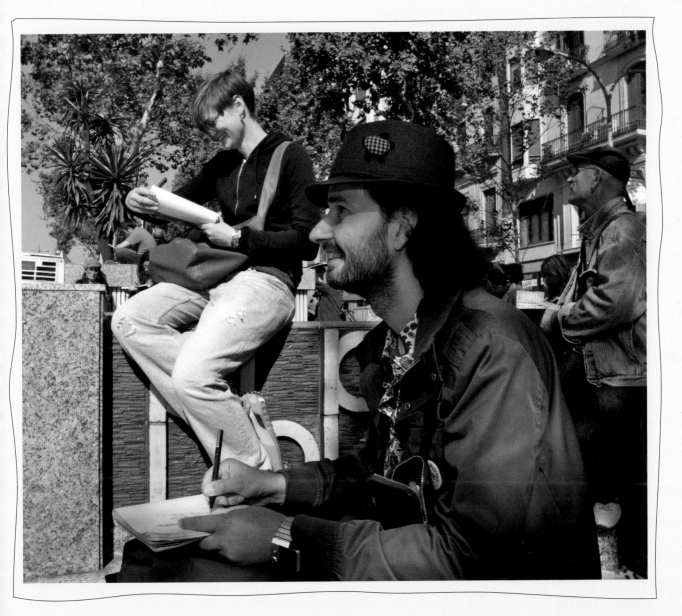

WEBSITES AND BLOGS

The case for having a web presence if you are an artist has been won for so long, there is no real need for a debate about it. So many people are now online that it is often the first point of contact for someone who wants to know more about your work. You need to provide the kind of information they are likely to want: examples of artwork, a résumé, an exhibition history, links to social media and contact details are all essential.

There are three options for getting your work online: an online gallery, a website or a blog.

ONLINE GALLERIES

Online galleries run by a third party promise a lot, but often don't provide the dedicated level of exposure that is possible with a website or blog. You will still need to market your work to generate traffic. Free group sites may seem easy and appealing, but if you are serious about it, you are better off getting your own domain name, such as yourname.com, and getting one that suits your own needs.

WEBSITES

Websites for artists range from basic and free designs to the professionally designed – and therefore perhaps expensive. However, you no longer need to spend a lot of money and many artists now create their own websites using templates. A critical consideration is how to host the website. Look for options that allow you to update it easily, add new galleries and images, and change how it looks as new work is produced. Keep it plain and simple. Fantastic drawings on a poorly designed, overcomplicated website will always suffer. Beware of Flash, which hides content from Google. A tired, standardised format suited to retailers will also do your work no favours.

Above: A blog is a great place to show your latest work with information about how it developed.

Opposite

Top: Keep your website uncluttered and informative.

Bottom: Gallery websites showing your work can lead to contacts and sales.

BLOGS

A blog is the perfect place to publish up-to-the-minute news about your work. Many artists are now opting to just have a blog, or a template that combines website and blog. All major blog platforms now allow static pages for viewing artwork as well as dynamic pages that update on current news. They also allow you to have a dedicated domain name if you wish.

If you are solely a sketchbook artist wanting to keep your books intact, a blog may be the only website you need. This is the place to show that you are active and creating. New posts go straight to the top, pushing earlier ones down, highlighting what is current. The tone and style of a blog is yours to develop over time, as is the regularity with which you update it.

Blogs need only minimal technological know-how to set up. A visit to the websites of the blog-publishing tools Blogger, WordPress or Tumblr will guide you through a process of tailoring both design and content for your needs. Once it is set up, the act of publishing new posts is quick and painless.

What to blog? Scanned images from your sketchbooks can make an interesting narrative, but they don't have to be brand new – space them out over time rather than in a great rush – but writing about the stories behind them, the process you use and what makes you tick as an artist will draw people back. Find a voice, and make it your own. Little and often is better than the occasional over-long post.

Blogs are about communication and networking, and making people come back again and again to see what is new. Getting lots of visitors requires time and energy, and the point at which you feel you are focusing more time attracting traffic at the expense of making new work only you can judge. Don't expect instant results – it takes time.

How to increase traffic to your blog

- Tag your posts and use keywords to make them more easily searched by theme
- Create reciprocal links with other artists' blogs that you like
- Leave comments on other artists' posts
- Respond to other people when they leave comments on your posts

SOCIAL MEDIA

Social media are a natural home for sketchbook images, a way to get them seen, and a way for you to get connected with other artists. New ones arrive, and established ones change, but everybody has their favourite.

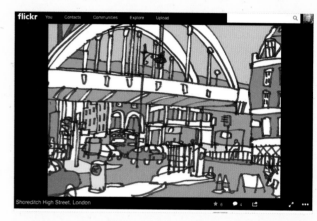

Shoreditch High Street, London

FACEBOOK

Left: If you are already a Facebook user and enjoy the way it lets you interact with people and share images, it is worth considering opening a Facebook Page for 'business marketing' purposes. If you want to market your art the rules of Facebook suggest you must use a Page rather than your personal account. Post links to your blog updates and images of your drawings. This lets a wider public see and 'like' your pages and allows you to keep your personal Facebook account private for friends and family.

FLICKR

Right: Flickr is about a lot more than a place to store your photographs: a lot of artists use it as a gallery for their work. These can be arranged in themed sets and in a range of privacy settings; they don't even have to be public. The images can be tagged to help users search for particular subjects, and can be marked as 'favourites' and commented on, which are invariably supportive. By sharing your images with interest-themed groups, you get into conversations and compare works with kindred spirits.

TWITTER

Microblogging – posting brief messages, or tweets, with fewer than 140 characters – is a useful tool for the artist. You can include photographs of drawings, or links to websites and blog posts. You choose whose tweets you want to follow, and get followed by those who are interested in what you have to say. Follow other artists and see what they are doing.

PINTEREST

Pinterest is a virtual pinboard, a digital networking tool with a focus on the visual. Images that you select are 'pinned' to themed boards created on your profile page: these themes could include your work for sale and latest sketchbook pages, as well as works by other artists that inspire you, but be aware of potential ignorance about copyright issues and the possibility of users pinning your work without linking to your site.

PROTECTING YOUR WORK ONLINE

Showing your work online, whether it is on a blog or on social media, opens it up to a potentially huge audience, but that carries with it some risks. Posting images with a high resolution will not only make pages slower to load, but enable unscrupulous people to download them at high quality to print and use as they want. Your work can also be re-posted on others' blogs, and social networks such as Pinterest. While having other people post your images on their site may seem like a compliment, copyright of your images – and your words – remains yours, and you should expect acknowledgement in the form of a link back to the website from which your work was downloaded. If you don't want people to post your work, you will need to state this clearly.

IF YOU ARE SHOWING YOUR WORK ONLINE:

- Post images no larger than 72dpi, or 600 pixels in any direction
- State clearly on your website if you want people to contact you before posting your images elsewhere
- Research Creative Commons, which helps you refine your copyright, or use a copyright notice to indicate the status of your work and whether people can share it online
- Check to see which of your images are being displayed on Pinterest by using http://pinterest.com/source/ followed by your website address minus the www. and confirm that they are linked back to your site. Contact Pinterest if they are not
- If you don't want other people to post your images on Pinterest and Flickr, both sites offer a code that can be added to your website that states you are opting out
- Consider adding a watermark of your name to the images you post online

Remember:

Get involved: comment on other artists' posts and join in the debates and conversations that follow.

Link your social media together – Facebook updates can be posted automatically on Twitter, for example – to create a buzz about your work.

JOIN A SKETCHCRAWL

Turning drawing and painting on the go into a social event is a natural step – working in a sketchbook with friends for a few hours or an afternoon turns it from a solitary activity into one in which strength of numbers adds to the occasion. Comparing work and ideas during breaks through the day can be an inspiring boost and encouragement. And if heading out drawing alone feels like an intimidating or frightening prospect, doing it in numbers is an excellent way of building confidence.

Sketchcrawls are an increasingly popular way of meeting up with bigger groups of sketchbook artists. These are relaxed events that take place throughout the year in many towns and cities around the world. A date, a time and venue are announced online and through social media, inviting artists to come along and draw, bringing their own materials with them. There is no charge, no need to book and no obligation to spend all day drawing.

The best venues for a sketchcrawl can depend on the season: having a museum or other indoor location nearby to draw in if the weather turns bad is a good idea, just as shade and refreshments are vital in summery conditions. Very busy places can mean that participants are lost in the crowd, dissipating the sense of community and making it hard for latecomers to join in. Arranging times to meet during the day for lunch, refreshments and an end-of-day review of work give a relaxed sense of structure. Drawing often continues into the evening in a bar or café.

Above: Artists with their sketches in Barcelona, Spain.
Opposite
Top and bottom: The end-of-day review and scenes from a sketchcrawl in Barcelona, Spain (Photos © Fran Fernández).
Right: Artist Liz Steel and a young sketchbooker friend in Sydney, Australia (Photo by Liz Steel).

Sketchcrawls are excellent ways of building confidence if you are uneasy about drawing in public on your own.

Sketchcrawls can start small, with just a few friends, but a few blog posts and messages on social media can widen the net if you want it to. Ability, age, sex, style of work, art school background – none of these affect your welcome at a sketchcrawl. There are no prizes and no critics are present, and at the end, when sketchbooks are laid out, the responses are invariably supportive and encouraging.

RESOURCES

GROUPS AND ASSOCIATIONS

Urban Sketchers
www.urbansketchers.org
A global community of artists who draw on location in cities, towns and villages, with regional blogs in cities and countries around the world, and which also organises symposia and workshops.

Sketchcrawls
www.sketchcrawl.com
News of regular worldwide gatherings to draw together as a group.

The Sketchbook Project
www.sketchbookproject.com
An international crowd-sourced, touring exhibition of sketchbooks.

The Big Draw
www.campaignfordrawing.org
The Campaign for Drawing's annual Big Draw festival, which aims to get everybody drawing, started in the UK but has spread around the world. Check online to find local events, or discover how to organise your own.

Reportage drawing
www.reportager.org
A website that supports, initiates and showcases projects involving drawing as reportage, visual journalism, documentary drawing and illustration as visual essay.

The Prince's Drawing School
www.princesdrawingschool.org
A school offering a range of courses aimed to raise the standard and profile of drawing through teaching and practice.

Making a Mark
www.makingamark.blogspot.co.uk
A fount of useful information for artists, covering competitions, blogging, copyright and much more.

The Drawing Center
www.drawingcenter.org
The New York institution that exhibits only drawings.

Drawing Research Network
www.drawing-research-network.org.uk
An affiliation of groups and artists that promote drawing and research into it, with links to drawing organisations.

BIBLIOGRAPHY

The Art of Urban Sketching: Drawing on Location Around the World, by Gabriel Campanario (Quarry Books, 2012)

Drawing Projects: An Exploration of the Language of Drawing, by Mick Maslen and Jack Southern (Black Dog Publishing, 2011)

Drawing Lab for Mixed-Media Artists: 52 Creative Exercises to Make Drawing Fun, by Carla Sonheim (Quarry Books, 2010)

Freehand, by Helen Birch (Hardie Grant, 2013)

iPad for Artists, by Dani Jones (Ilex, 2012)

London, You're Beautiful: An Artist's Year, by David Gentleman (Penguin Books, 2012)

One Drawing A Day, by Veronica Lawlor (Quarry Books, 2011)

Opposite: Miguel Herranz. Buenos Aires-Comte d'Urgell, Barcelona, Spain.

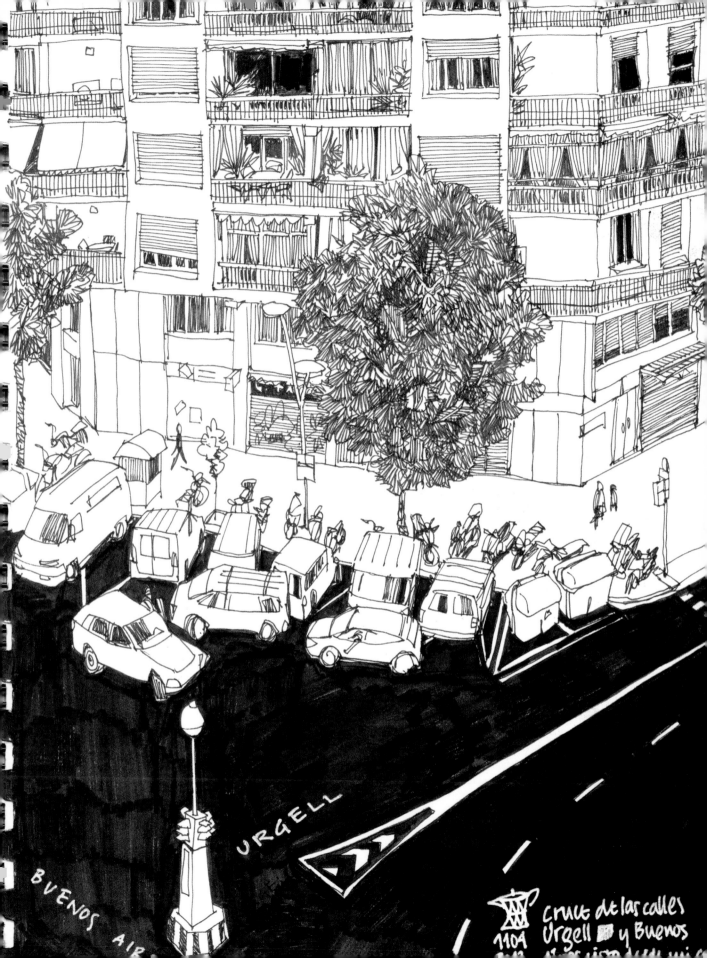

URGELL

BUENOS AIR

cruce de las calles
Urgell y Buenos
1104

CONTRIBUTOR INDEX

Amer Ismail
www.tendtotravel.com

Barry Jackson
www.idrisjackson.co.uk

Caroline Johnson
www.carolinejohnson.org

Asuka Kagawa
www.flickr.com/photos/21231337@N08

Brendan Kelly
www.brendankellyartist.co.uk

Merlyna Lim
www.merlyna.org

Maria Lopes
www.flickr.com/photos/maria_sketchs

Joan Mas
www.vectoralia.com

Don McNulty
www.donmcnultyurban.blogspot.ca

Mario Minichiello
www.eichgallery.org/mm2001

Colin Moore
www.colinmoore.uk.com

Max Naylor
www.maxnaylor.com

Patrick Osborne
www.bighappyaccident.com

Chichi Parish
www.chichiparish.co.uk

Alex Raventós
www.flickr.com/photos/araventos

Pippa Ridley
www.pipparidley.com

Simone Ridyard
www.simoneridyard.co.uk

Marjut Rimminen
www.marjutrimminen.com

Fraser Scarfe
www.fraserscarfe.co.uk

Rolf Schröter
www.rolfschroeter.com

Inma Serrano
www.dibujosypegoletes.blogspot.com

Craig Shannon
www.flickr.com/photos/craigsdrawing

Suhita Shirodkar
www.sketchaway.wordpress.com

Poppy Skelley
www.tothepasserby.tumblr.com

Naomi Strauss
www.naomistrauss.co.uk

Liz Steel
www.lizsteel.com

Paul Sutliff

Katherine Tyrrell
www.travelsketch.blogspot.co.uk

Lis Watkins
www.lineandwash.blogspot.co.uk

Steve Wilkin
www.stevewilkin.co.uk

Daniel Zalkus
www.zalkus.com

Toni Zhao
www.flickr.com/photos/tonibomb

INDEX

INDEX

ACKNOWLEDGEMENTS

Seoungjun Baek, Emma Carlisle, Angela Charlton, Juliet Docherty and Trudi Esberger are students and graduates of the MA Children's Book Illustration course at Cambridge School of Art at Anglia Ruskin University, Cambridge, UK, and Josephine Birch and Poppy Skelley are on its BA (Hons) Illustration course. My thanks to Martin Salisbury and Pam Smy for their kind assistance.

Liza Dimbleby's images are from her book *I Live Here Now* (Firework, 2008).

With thanks to Cass Art, London's leading independent art shop, for the loan of art materials for photography.

www.cassart.co.uk

Thanks to Katherine Tyrrell for her advice and assistance with the section on blogs and social media.

My thanks to the team at RotoVision, who have been great to work with: Isheeta Mustafi, Jacqueline Ford, Tamsin Richardson, Jane Roe, Lucy Smith, Jennifer Osborne, Rebecca Hawkins and the photographer Neil Grundy.

In appreciation of the support and solidarity of Urban Sketchers around the world and, most of all, my love and thanks to Naomi, Esther and Celia.

James Hobbs is a London-based freelance journalist and artist, and a former editor of *Artists & Illustrators* magazine. His work has been shortlisted for the Jerwood Drawing Prize, and is in a number of European collections. Prints of his work have been on sale in shops worldwide. He is a board member of Urban Sketchers, the global community of artists who draw on location, and a founding member of the London Urban Sketchers.
www.james-hobbs.co.uk
@jameshobbsart